Victorian Taste

A Study of the Arts and Architecture
from 1830 to 1870

'The century we live in is not more
remarkable for its railways and marvels of
science, than for a reaction from preceding
barbarism in matters of taste.'

Rev.H.Wellesley
Quarterly Review 1844

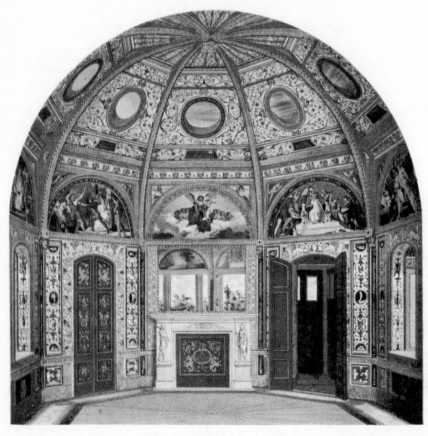

GARDEN PAVILION IN THE GROUNDS OF BUCKINGHAM PALACE:
THE OCTAGON ROOM.

Plate from *Her Majesty's Pavilion in Buckingham Gardens*,
L. Gruner, 1846.

Victorian Taste

A Study of the Arts
and Architecture from 1830 to 1870

JOHN STEEGMAN

with a Foreword by Sir Nikolaus Pevsner

The M.I.T. Press
Cambridge, Massachusetts

First published as *Consort of Taste 1830–1870*
in 1950 by Sidgwick and Jackson Ltd
First published in Nelson's University Paperbacks 1970
First M.I.T. Press Paperback Edition, April 1971
© The King's College of Our Lady and St Nicholas in Cambridge 1970
Foreword © Sir Nikolaus Pevsner 1970
ISBN 0 262 19094 X (hardcover)
ISBN 0 262 69028 4 (paperback)
Library of Congress Catalog Card Number: 70–148850
Printed in Great Britain

FOREWORD

by Sir Nikolaus Pevsner

Victorian Taste is not a new book. It is a re-issue of *Consort of Taste*, and the new title, agreed with the author before he died, is indeed a better description of the contents of a book whose re-appearance twenty years after its original publication is right and proper. It was a pioneering study when it came out; now, after general evaluation of matters of Victorian art and architecture has changed so rapidly, it can with confidence be called a classic.

John Steegman had brought out *The Rule of Taste*, his book on Georgian taste, in 1936, one year before the Georgian Group was founded. *Consort of Taste*, dealing with the Victorian taste, was published in 1950, eight years before the establishment of the Victorian Society. So it was well ahead of the turn from ignorance, antipathy and misunderstanding to just and balanced appreciation. Admittedly a fashion for Victoriana had set in already before 1950, but this book does nowhere pander to that. It is a serious work throughout, based firmly on a study of original material not previously used, especially the volumes of the *Quarterly Review*.*

To place John Steegman's book historically, the following are the facts to be kept in mind. Goodhart-Rendel's Slade Lectures at Oxford dealing with Victorian architecture in a wholly novel way had been given in 1934. That was the start. Here positive values were seen as positive values, architect after architect and building after building were succinctly and with brilliant insight analysed and characterised. But the

* These are now, together with other Victorian periodicals, completely indexed in W.E.Houghton, *The Wellesley Index to Victorian Periodicals*, London, 1966.

lectures were not published until 1953, and the book is marred by jaundiced asides against the style of the twentieth century from Mackintosh to the buildings of the early thirties. My own *Pioneers of the Modern Movement* was out by 1936, but if Goodhart-Rendel was biased against modern architecture, I was biased in favour of it, and so my book is a prehistory of that architecture rather than a treatment of the Victorian style for its own sake. This I only tried to do in *High Victorian Design* in 1951. By then the first strictly scholarly treatment of Victorian architecture had been available for thirteen years: the Reverend Basil Clarke's *Church Builders of the Nineteenth Century*, published in 1938. This is a classic like *Victorian Taste*, and it is good to see it back in the bookshops as a paperback. Finally in 1954 the two volumes of Henry Russell Hitchcock's *Early Victorian Architecture* appeared and set a new standard of exhaustive scholarship.

All these books deal entirely or predominantly with architecture. For Victorian painting no Russell Hitchcock has yet turned up, though very much has been written in the last twenty years and a good deal of it the result of original research and of a high standard of accuracy. For Victorian sculptors nearly everything remains still to be done. On Victorian design on the other hand much valuable work is now being done, but it is concerned with special aspects, and not with the totality.

So John Steegman was almost entirely thrown on his own resources when he worked on *Victorian Taste*. The book deals with the Early and High Victorian decades only, and to stress the boundary about 1870 is understandable. Art and especially architecture after 1870—Sickert, Oscar Wilde, Norman Shaw, Voysey—are for the layman hardly what he would spontaneously call Victorian, whereas all that John Steegman spreads out is Victorian to anybody and in every aspect, the alien as well as the familiar.

Here are a few instances of the alien aspects: the Reverend Henry Wellesley in 1844 (in the motto to John Steegman's book) praising the recent 'reaction from barbarism in matters of taste', and Joseph Gwilt in 1857 deprecating more explicitly the 'miserable taste of the Adams', and on the other hand Waagen, the great connoisseur of the art of the past, calling Wilkie in 1838 'the first painter of our times', and Lady Eastlake in 1846 praising Raphael's cartoons for Michelangelo's power, Rubens's energy and Wilkie's characterisation.

Lady Eastlake and her husband Sir Charles were John Steegman's major discovery, and they will not be more familiar to most readers of this re-issue than they were to readers in 1950. Nor will Sir Francis Palgrave be, nor Sir A.H.Layard and Lord Lindsay, nor William Bell Scott, nor Gervase Wheeler of New York. The Eastlakes have a chapter to themselves halfway through the book. They are preceded by chapters on the influence of the German Nazarene taste on England, the efforts of Prince Albert on behalf of historical and literary wall painting in England, the Government Schools of Design and the connoisseurs and collectors, both of contemporary art and art of the past.

In both fields, as in admiration for the Nazarenes and in the zest for the promotion of a serious moral art in England, Prince Albert led. He bought Italian primitives and Cranach and Overbeck and Dyce and Augustus Egg. Now, if on all these enterprises and the Arundel Society prints and the exhibition of 1851 and so much else John Steegman tells us as much as need be known and tells it so well and so knowledgeably, it must be remembered that the specialists' books which we now have were all written later: Mr Andrews's on the Nazarenes in 1964, Mr Boase's paper on the decoration of the Houses of Parliament in 1954 and his volume of the *Oxford History of English Art* in 1959, Professor Quentin

Bell's on the Schools of Design in 1963, and Mr Winslow
Ames's on Prince Albert's taste in 1967.

John Steegman was born in 1899 and died in 1966. He
came from a naval family. He studied at King's College in
Cambridge and at the age of thirty-one joined the National
Portrait Gallery. He stayed there till 1945, was then for
seven years Keeper of the Department of Art at the National
Museum of Wales in Cardiff, and after that for another
seven years director of the museum of Montreal. To his
friends, Cardiff and Montreal appeared strange choices; for
John Steegman seemed to belong to London or at least to
Georgian and Regency England. *The Rule of Taste* is the book
he was known by, though in his own domestic surroundings
he liked what is now called Victoriana. He was small, neatly
dressed and in all other respects fastidious too. This fastidi-
ousness is one of the reasons that make *Victorian Taste* such
enjoyable reading.

Contents

List of Illustrations

INTRODUCTION

It is now already a good many years since the present age began the process of re-discovering the 19th century. In turn all the major figures who passed across the Victorian stage have had the limelight redirected upon them. The poets, the scientists, the critics, the novelists, the social reformers, the painters, the architects, the statesmen, and the Queen and the Prince themselves, have been interviewed and cross-examined from the standpoint (whatever that may amount to) of the second quarter of the 20th century, and their certificates of greatness have been endorsed. Most aspects of the 19th century are now viewed in the perspective provided by the historic approach, and few people to-day will judge a Darwin, let us say, or a Peel, a Palmerston, an Owen or a Newman by the same standards that they would apply to present leaders of political or scientific thought. Yet in the fields of the Fine and the Applied Arts of the 19th century it is still common to find judgements being pronounced which are valid only in relation to our own contemporary experience, and which entirely ignore the conditions and standards prevailing at that time.

The period covered in the following chapters is that between the beginning of the 1830's and the end of the 1860's; that is to say, approximately twenty years either side of the Great Exhibition. The particular aspect of that period which is discussed is its art and its art criticisms, its Taste and its

1

tastes in painting, architecture, connoisseurship and collecting. The object has been, not to pronounce any particular style or state of mind good or bad, but to try to establish what was considered good or bad by critical and intelligent minds of that day, and why it was so considered. As will be seen from the footnotes, all the sources quoted (with about three exceptions) are contemporary with the period itself, and an effort has been made to avoid judging one age by the standards of another. It must, however, be admitted that now and then resistance has not been absolutely successful.

In general, it is true that each age dislikes and derides the art and the taste of its predecessors up to about a century preceding. The gentlemen of the 1760's threw out their Charles II furniture; the mid-Victorians banished their Chippendale to the servants' attics; in the 1930's everything later than the Regency was discarded. Now, however, almost a century has passed since the Great Exhibition. Although the taste which it conveniently symbolises has long been a subject for ridicule, the tide of opinion is now about due to turn and to begin flowing towards a more serious and sympathetic assessment. It will never flow freely in that direction, however, so long as it remains possible to write a treatise on the mid-19th century containing the premise, presented as an axiom, that its art was *bad*. It may well seem bad in the eyes of that particular writer, but such criticism is really as false and historically defective as to pronounce all art of the Italian Renaissance *good*.

The study of the history of Taste provides almost

2

no constant values by which the student can guide himself. A few works of art, literature and music have achieved permanent and universal acceptance, but everything else in the vast creative endeavour of the centuries is subject to the fluctuations of taste —as our own achievements will be. Each new age has to re-interpret the whole of the civilised past for itself, but it is useful now and then to allow some period of the past to explain itself in its own terms. In trying to appreciate the art of an age, we shall make a fairer estimate if we put ourselves through a double process: first, we may judge that art by our own contemporary standards; and secondly, we can modify that judgement by relating that art to the critical standards and social conditions of the period in question. The history of Taste can never be written by merely pronouncing the verdict of our own age on the actual work of another. Such a historian will have to consider the expressed opinions of each age on both its own art and also the art of its predecessors; and he should ignore opinions contemporary with himself.

The century and a quarter between the accession of Queen Anne and the death of George IV may be seen as an age in which Taste became steadily and progressively rationalised. Standards were established by the authority of a few highly critical minds in each generation, and their influence became paramount over the whole field of 18th-century art. This Rule of Taste was established and sustained almost entirely by the oligarchic control of wealth and by the extent to which aristocratic requirements and standards influenced society as a whole. The

3

Rule was showing signs of breaking down before the death of George IV in 1830, and during the reign of William IV it may be said to have collapsed. The passing of the Reform Bill in 1832 could be cited as the point at which the collapse began, for it is one of those convenient labels with which historians like to mark off an epoch. Equally, the Reform Bill can be seen as but a symptom of a change that had been gradually overtaking society since the end of the 18th century.

Whatever be the truth here about cause and effect, it is clearly evident that Taste, about the year 1830, underwent a change more violent than any it had undergone for a hundred and fifty years previously. The change was not merely one of direction. It lay rather in abandoning the signposts of authority for the fancies of the individual. The early and middle periods of Victoria's reign were undoubtedly the great era of individualism; either a golden age or else a dark age, according to the personal opinions of the historian. In whatever way we ourselves may view this change from the Georgian to the Victorian eras, it soon becomes evident that the mid-Victorians themselves realised that their Taste had somehow gone wrong and that somehow it must be reformed. From that realisation springs one of the chief differences between 19th and 18th-century æsthetics. The 19th century, afflicted with doubts, made conscientious efforts to educate popular taste through schools and museums, by precept, instruction and examples from the past. The 18th century, on the other hand, did not discuss whether its taste was good or bad, and 'education' in taste never occurred to it.

Its builders and craftsmen were, as the general rule, trained through the apprentice system in a series of commonly accepted conventions which were handed down and passed on through succeeding generations. The final disappearance of the tradition is often explained by the introduction of mass-produced machine-made goods; that may be part of the truth but, as this book attempts to show, it is certainly not the whole truth.

We are perhaps still too near to the mid-19th century to see it yet in proper perspective. Its æsthetic judgement seems to us confused and errant, wandering here and there simultaneously along half a dozen different paths. Our successors, from the farther hilltop of a generation hence, will probably detect order and a historic rhythm where we can see only confusion. It is, indeed, already possible to see a hint of such rhythm, of the counter-effects of action and reaction. If the 18th and 19th centuries be taken together as a whole, from the beginning of the one to the end of the other, we can find the sequence of Art for Intellect's sake, Art for Morals' sake and Art for Art's sake. The Æsthetic Movement of the late 19th century has been commonly presented by recent writers as a reaction against the stupidity and intolerance of Victorian middle-class philistinism. Philistinism, however, is not peculiar to any class in any age, and the Æsthetic Movement of Art for Art's sake may be more truly described as a reaction against the earlier-Victorian middle-class intellectuals who preached the doctrine of Art for Morals' sake. That doctrine, in turn, was preached in protest against the 18th-century tendency to

5

intellectualise art and to divorce it from general experience. Since that is a tendency which we see to-day, we are presumably due for yet another developement of the historical rhythm before long.

In every chapter of this book, sources of the period have been used, and in many cases quoted word for word. Obviously it was necessary from the outset to be somewhat rigidly selective, since that was an age when both the urge and the opportunity to express one's opinion in print were almost unlimited. Of the leading periodicals, the *Athenæum* and the *Quarterly Review* were the most suitable, but limitations equally of space and the readers' patience forbade the use of both together. It seemed better to use one of them consistently to the exclusion of the other, and it also seemed that the *Quarterly* addressed itself to a more liberal and humane section of educated society than did the *Athenæum*. This may be a disputable conclusion, but, for better or worse, the *Quarterly* has been chosen, and has been used here throughout as one of the chief sources. Some of the people who will be met repeatedly in the following pages are now quite forgotten, but as regular contributors to the *Quarterly* they were clearly people of standing in their own day. Others are familiar to students of the 19th century, but are not even names to anyone else; as, for example, William Bell Scott, whose autobiography is a quite indispensable source-book for the period; or, for another example, Lady Eastlake. Sir Charles Eastlake himself is still properly revered as the man who more than any other established the international status of the National

Gallery, but Elizabeth Eastlake has hardly yet had the recognition due to her.

The reader of this book will find Elizabeth Eastlake recurring so often that she becomes nearly as prominent as Ruskin. To-day she is almost forgotten, while Ruskin stands higher in esteem than at any time in the last forty years. In the middle decades of the last century, however, Ruskin had by no means reached the position of revered authority that he attained later, while the position of Lady Eastlake, though of quite a different kind, was a remarkably strong one. An intellectual in her own right, she was also the wife and in the fullest sense partner of a man who was both Director of the National Gallery and President of the Royal Academy. Lady Eastlake is given prominence here because she so well typifies that upper middle-class society, living chiefly on earned incomes, which contrived to keep one foot in the intellectual, and the other in the fashionable, camp, and which did so much to form Victorian culture.

As a symbol of that society, the Royal Institution in Albemarle Street will do very well. Mid-19th-century London was perfectly constituted to support such a body and to provide the setting. Society may have had an exaggerated respect for wealth and for successful money-makers, but it had a fully equal respect for eminent intellectuals; and, if it had a vigorous appetite for food, its appetite for serious discussion was quite as remarkable. When fashionable and cultured society flocked in evening dress to lectures by Faraday or Tyndall at the Royal Institution, it was because they were

beginning to realise the implications of increasing knowledge. Knowledge, however, proved to be of little help to them in their persistent and conscientious search for 'a truly national taste'. In the 18th century, when taste was so much a matter of intellect, knowledge was the prerogative of a small class. By the middle of the 19th century it was possessed by many and sought by all. The realisation that increased knowledge of material things did not by itself produce a culture explains the pessimistic tone of so much early and mid-Victorian criticism. In contrast with both the criticism and the achievement of the Georgians, secure in their convictions and firm in their principles, the criticism and the achievement of the Victorians, full of questions and conflicting answers, may well appear to us as errant.

One man, however, did not falter in his convictions and, though often depressed, was never pessimistic about the future, and never admitted defeat about the present. That was Prince Albert. Until his tragically early death he was the central figure in all that concerned the new and peculiar problems of art in industry. Had he lived another twenty years, his sane opinions and realistic judgement would have been an effective counterbalance to the doctrine of Ruskin. A great deal of that doctrine remains permanently valid, and very precious, now that we can see it in perspective. But we are still left with the conviction that much of Ruskin's preaching was both confusing and dangerous for those who first listened to it. The Prince, in the middle-age which he barely reached, would have been a surer guide for a public yearning for guidance.

The quotation on the fly-leaf of this volume nicely sums up the contempt which the Age of Individualism and of material Progress felt for the Age of Rationalism and of Sensibility. One other quotation will serve to show how little an age which was essentially one of revival and imitation of the past was able to assess its own æsthetic judgement. Of all people, it comes from Viollet-le-Duc, one of the most consistent counterfeiters of the 19th century: *le goût consiste à paraître ce que l'on est, et non ce que l'on voudrait être.*

THE OPENING SCENE

THE reign of William IV is not generally regarded as a period of elegant taste. Most people to-day look on it as marking the decline from the Regency to the Early Victorian. Certainly it is an interval of marking time between the creative energy of the Regency architects and designers, and the experimental ingenuity of the Early Victorians. However, if one is going to explore the arts and tastes of the mid-19th century, the 1830's are the point at which one must begin. And if one is exploring the arts and tastes of any period in England, one must consider the social and political background of that period not only at home, but also in France and Germany, if no farther afield. During that decade particularly there was a flow of ideas from England into France, and from Germany into England.

Discussion, therefore, of the arts at this period in England must begin with the text-book label of Reform. It seemed not unreasonable at the time to regard the Reform Bill of 1832 as the charter of a newly-powerful middle class, and as the herald of a new set of social conditions, quite different from those which had prevailed during most of the 18th century. Money and patronage had for some time already been passing out of the exclusive control of the old oligarchy, and the Reform Bill could be seen as the official recognition of that trend. It was,

among many other things, the signal for the arts to enter into servitude under a new set of masters. The arts must always be in service to some authority: the Church, the Prince, the Private Patron, Commerce or the State. Throughout the 18th century they had been in service to the aristocratic patron; now, while remaining as it were in private service, their masters were men without the familiar background of European and classical tradition and with quite different requirements. We shall see the direct effect of this on the arts when we come to look at the painters and architects of the period in subsequent chapters.

In the meantime, to get a fuller view of the opening scene itself, we must glance across the Channel to France. There, at the beginning of the 1830's, Liberalism and Reform were agitating men's minds as much as in England. The fall of Charles X and of the Clerical authority seemed to imply the beginning of a more liberal regime and to promise encouragement to the young and discontented Romantics. This is not the place for a discussion of post-Napoleonic French art, but the position may nevertheless be stated briefly. On the one side was ranged the still-powerful authority of Greece and Rome, established under the Empire by Jacques-Louis David, and now vested in his nominated successor, the Baron Gros. On the other side were the young Romantics, like Delacroix and Guéricault, inflamed by the example of Constable and the English *paysagistes* into rebellion against authority. This conflict was violent and prolonged, but differed from most conflicts in having its dramatic climax at the begin-

ning. That climax occurred in 1835, when Gros, tortured by his own growing romanticism and his fancied betrayal of David, drowned himself in the Seine. The violent end of Gros, however, did not mean immediate victory for Romanticism and Anglomania. Nor was it at all the end of Classicism. Ingres himself at once became identified with Authority, and beyond him there was to come Puvis de Chavannes. Nevertheless, the Romantics steadily advanced in contemporary French estimation during the later 1830's, until they themselves died from auto-intoxication induced by the colour and freedom which they took from England in injudiciously large doses.

The position, then, in the Paris of Louis-Philippe was a conflict between two states of mind; the violence of the conflict indicates the vitality of the arts there, the importance of the past, the responsibility of the present and the excitement of the future. In the Munich of Ludwig I, on the other hand, the position was not quite the same, although there, too, was a conflict between the still-surviving classical doctrines of Winkelmann and Mengs and those who revolted against those doctrines. But those who revolted chose, not the turbulence of Delacroix nor the naturalism of Constable, but a sentimentalised version of the Renaissance, with Raphael as their inspiration. The Renaissance Movement in Munich under Ludwig I was not so much a revolt as an attempt to bring back the whole art of painting into something of the importance it enjoyed in the days of Dürer and Holbein, but Peter Cornelius, the leader of the movement, is hardly more remembered to-day

than his classicist predecessors. Nevertheless, his achievement was important, for he and King Ludwig made Munich what it was for so long: the artistic capital of Germany.

The young Germans of the 1830's found their inspiration in Italy of the *cinquecento*, young Frenchmen found theirs, they said, in contemporary England. English painters found theirs in Nature, which they had discovered in the 18th century. The English painters to whom the French referred were then, as to a large extent they still are, Hogarth, Gainsborough, Morland, Constable, Lawrence and the horse-painter, Herring. They were not Wilson, nor Reynolds, nor James Barry, nor Haydon. The favourites were admired because they had explored and already exploited a territory which the French had as yet hardly entered; Hogarth was real, where Watteau and Lancret were only idyllic; Gainsborough seemed fresh, simple and lyrical, while Drouais and Nattier were stale and affected and smelt like dead gardenias. The milkmaids of Morland were innocent in the deodorised rusticity, while those of Greuze were no nearer to Nature than the Hameau of the Trianon was to a real farm. They found Lawrence not vivacious and flashy, but vital and sparkling, intensely exciting when compared with the David whom they already thought of as cold, grey and formal. Constable showed them the unsuspected beauties of the earth, and even the commonplace Herring inspired the romantic vision of Géricault. It is not surprising that the *Salon* of 1824—the *Salon des Anglais*—had a revolutionary effect on French painting. The combined impact of

13

Lawrence, Constable, Copley Fielding and Boning-
ton on young men discontented with their rigidly
classical masters made those young men think of
England as the romantic island and the home of free-
dom. There was, after all, considerable reason for
thinking thus of a country which had produced
Shakespeare, Ossian, Chatterton, Byron and Scott,
and which had had its revolution 180 years earlier.
And so the young Frenchmen of 1830 not only
looked towards England, but flocked across the
Channel to see for themselves. They found light
and colour, so that even Géricault felt his pictures
to be black beside those of the English; they found
their escape from the bondage of the Greeks and the
Romans and from the oppressive authority of Rap-
hael. And yet in one sense they missed the point of
it all.

The characteristic feature of English painting
from the 1830's through most of the century is that
for the first time portrait-painting was not the most
important field. Until after the middle of the cen-
tury genre-painting—that is, the painting of scenes
from everyday contemporary life—was one of the
three most widely practised forms of art in England.
The other two were illustration of the established
authors, Shakespeare, Molière, Cervantes, Fielding,
Scott; and such aspects of history as exalted 'liberal'
heroes, like Cromwell or the Covenanters, or roman-
tic losers, like Mary Queen of Scots, Charles I or the
Young Pretender. In France, however, the painters
continued principally to choose their subjects retro-
spectively. They ignored contemporary life, or, if
they drew upon it at all, did so with a social purpose,

making their pictures violent and propagandist. They did free themselves from the past to the extent of painting historical persons in historically correct costume, and not in the draperies or nudity of the classicists, claiming that Gros and Horace Vernet had taught them that; but their enthusiasm for England had not taught them that Benjamin West had already done it in 1771 with his famous 'Death of Wolfe'.

While Germany was imitating Raphael or thinking in an escapist way of Fra Angelico, and France was trying to paint Gallery pictures in a modern idiom, England was comfortably proceeding along her own special paths of sentimental narrative, realistic genre and plein-air landscape. This complacent attitude and this fondness for actuality and the rendering of agreeable facts were one of the results of that change in both the social structure and the national outlook that had taken place in England during the preceding half-century. The prosperous middle-class Englishman of the early 19th century was very like his Dutch equivalent of the middle 17th century. He had survived a long period of war, and was anxious to enjoy the peaceful and, for him, agreeable conditions that now prevailed. He was proud of himself, of his country and of the age in which he had the good fortune to be living. He was self-satisfied and optimistic. But also he was a realist, and imagination did not play a very active part in his composition. His favourite pictures, therefore, were those which either reproduced some familiar scene or else informed him accurately of the past.

English painting of the 1830's and 1840's has not,

15

as a School, survived the criticism of a century. Today much of it seems trivial and unimportant. Nevertheless, it knew what it was about. It was English and it was contemporary. It was concerned mainly with the actuality of the present and, since it was handsomely patronised, it had little reason to be doubtful about the future. Its concern with the past was limited to choice of subject-matter, and did not extend to dependence on any bygone Authority in Taste. In the 1830's there was no uncertainty, no nostalgia, no pessimism in the minds of either artists or their patrons. But it was not long before such doubts began to appear. Doubt and pessimism, when they did make their appearance, did not do so among the comfortably entrenched middle-class, but, as always, among the intellectuals. A generation whose childhood had been coloured by the savage satire of Gillray and the robust humour of Rowlandson was not likely to suffer from faintness or defeatism. It habitually asserted its views about everything with a directness entirely unhampered by doubts and greatly encouraged, after 1841, by the new comic and satirical journal, *Punch*. The standard of personal abuse reached by that journal in its early days is the written equivalent of Gillray's drawings in the days of Pitt and Charles Fox forty years before. A good example of this determination to stand no nonsense from anyone occurred in 1844. 'A company', said *Punch*, 'has just been formed in Paris for the purpose of destroying rats. If such a company were to be formed in England, Lord Brougham, Lord Stanley and Sir James Graham would be entitled to ask for protection on the plea of their lives being in

danger.' On the other hand, if the average Englishman enjoyed violent assertion of his opinions, he did not permit those with whom he disagreed to do the same. *Punch*, shortly after making the above-quoted remark, said wickedly 'Sir James Graham begs to announce that it is his intention during the Easter recess to give instruction in *Vulgar Abuse*. Lord Brougham is already engaged as principal assistant.'

It was not all complacency and cocksure-ness, however, in the arts or in any other activity. In the arts two major questions were beginning to cause uncertainty. One of these was the question whether the arts should not be considered as possessing utility, as well as spiritual values and decorative beauty. The other was whether the influence of new mechanical inventions was likely to prove good or bad. The first question was asked, long before Ruskin's voice was heard, by Eastlake as early as 1835.[1] The second was asked in 1840 by Francis Palgrave, in respect of such mechanical devices as the steam-engine and furnace, the steel-plate, the roller, the press, the daguerreotype, the Voltair battery and the lens. Both questions were destined to be asked by many other thinkers as the century grew older. Before considering these matters in further detail, we might at this point recall two expressions which, while in universal use to-day, only passed into general usage after about 1830. It is as well to realise their comparative newness.

The first of these is the noun 'æsthetic' or 'æsthe-

[1] C. L. Eastlake: 'How to Observe', 1835. Printed in his *Literature of the Fine Arts*, 1870, ed. by Lady Eastlake.

tics'. The observations of the *O.E.D.* may, to save the reader trouble, be quoted here. That high authority defines the word as meaning 'things perceptible by the senses, things material as opposed to things thinkable or immaterial'; that is, in the sense in which Kant used it, 'the science which treats of the conditions of sensuous perceptions'. But the German philosopher Baumgarten had already, by about 1760, narrowed it down to meaning 'criticism of taste', considered as a science or philosophy. Kant protested against this, but Baumgarten's use of 'æsthetik' found increasing popular acceptance, and began to appear in England soon after 1830, though its adoption was long opposed by those who had a care for English usage. In 1832, the influential and widely-read *Penny Cyclopædia* said, 'Æsthetics is the designation given by German writers to a branch of philosophical enquiry, the object of which is a theory of the beautiful.' Ten years later, in 1842, Joseph Gwilt's *Encyclopædia of Architecture* said outright, 'There has lately grown into use in the arts a silly pedantic term under the name of Æsthetics. . . .' However, Sir William Hamilton,[1] having observed that it was a century since Baumgarten had first applied the term *Æsthetic* to the Theory of the Fine Arts or the Philosophy of Taste, added, 'And this term is now in general acceptance.'

The other expression which, as an innovation, displeased some people in the 1830's and 1840's was 'the Fine Arts'. We need not here go back into the distinction made by the medieval theorists between

[1] Sir William Hamilton: *Lectures on Metaphysics.* Collected and published in 1859, after his death.

18

the Liberal and the Mechanical Arts; the emergence by the beginning of the 16th century in Italy of the ideas of Works of Art and of the Fine Arts coincided with the collapse of the authority of the Guilds and the rise of that of the Academies. Whatever the actual expressions subsequently used in French, Italian or English, the conception of Fine as opposed to Applied Arts is of Renaissance growth. In England the use of 'Art' implying 'the Fine Arts' is a 19th-century usage. The 18th century preferred 'the polite Arts', but John Stuart Mill, for example among other early 19th-century writers, expressed dislike of terms such as 'the polite arts' or 'the Fine Arts', and always used 'Art' in that sense alone. In 1845 Henry Cole used the expression 'Art Manufactures', meaning Fine Art applied to mechanical production. By that time 'Art' had dwindled in general usage from its medieval meaning of all the humane studies to what it means to-day.

Controversy touching the 'utility' or otherwise of the arts must be regarded as very much a part of the opening scene. To those who were thinking and writing about the arts in the 1830's and 1840's it was a matter of no small concern; were it not so there would be no need here to conjure up the ghost of Jeremy Bentham and his Utilitarian disciples. Should the Fine Arts be considered as possessing utility in addition to æsthetic beauty and spiritual value? Eastlake, in 1835, was not the first to ask this question, and it was to be asked often enough again until, indeed, the belief in Art for Art's sake towards the end of the century provided what seemed then to be the answer. Charles Eastlake gives the impression

that when he posed such a question he was by no
means sure of the answer. He seems to have tried to
remain in tune with the prevailing utilitarian beliefs,
without being possessed by any real conviction.
Although his essay did not pursue the matter very
far, it is yet valuable for one reason. It serves use-
fully to remind us of the barriers which the early and
mid-19th century deliberately erected between its
enjoyment of works of art and its social conscience.
The pre-Renaissance Church had already pointed
the way to using the arts as a vehicle for moral in-
struction, and even for popular education, and indus-
trial England saw something in that method which
itself might well use. But when it came to treating
even landscape-painting—the least didactic of all
forms of painting—as an appendage to history and
geography, even the serious young Eastlake was pro-
voked into exclaiming that the art was 'degraded by
this merely topographical taste'. Eastlake, whose
cultivated taste and critical scholarship place him
between the 18th-century *cognoscenti* and the 20th-
century experts, was, at any rate in early life, a child
of his age. With all his deep love of pictures for their
own sake, the Eastlake of 1835 could not quite free
himself of the didactic approach to what he admired,
however hard he tried. 'In the hands of English
landscape painters', he said, having in mind Gains-
borough and Richard Wilson, 'the useful capabili-
ties of art, however extensively cultivated, have never
been suffered to supersede its more tasteful attri-
butes.' That might possibly have been said as early
as the very end of the 18th century; but no contem-
porary of Wilson and Gainsborough would ever have

talked about the 'useful capabilities' of their art. It could only have been said in a generation whose values have undergone the change of the Industrial Revolution. That revolution, moreover, not only brought new moral values into what the 18th century had regarded as an intellectual field, but it also very quickly affected critical taste.

If critical approach to the Fine Arts was affected by the question of Utility, that to the Applied Arts was equally and simultaneously affected by the second question: whether the influence of new mechanical devices was likely to prove good or bad. Doubts about the mechanical infallibility appeared in thoughtful minds at the same time as the worship of mechanical efficiency began to possess the mind of the ordinary man. Sir Francis Palgrave [1] provides an instance of this. In 1840 he found an opportunity of publicly and authoritatively expressing his dread of mechanisation. 'Whilst we triumph', he wrote, [2] 'in the "Results of Machinery", we must not repine if one of these results be the paralysis of the imaginative faculties of the human mind.' Palgrave was one of the first to point out the deadening effect of mechanised mass-production on the Applied Arts. Admitting that there now existed the means of multiplying 'elegant forms' by moulds, dies, punches, squeezes and other contrivances, and even that these productions would satisfy the general fancy for ornament (which in 1840 was pronounced), he yet main-

[1] Born 1788, of Jewish family: son of Meyer Cohen, of the Stock Exchange. In 1823, on his marriage, he became a Christian, and took the name of Palgrave. Knighted 1832; d. 1861. His son was the compiler of *The Golden Treasury of Songs and Lyrics*.

[2] *Quarterly Review*, 1840, Vol. 66, pp. 324 et seq.

tained that the method of production was such as would kill all life and freedom of expression. 'A permanent glut of pseudo-art is created,' he warned his readers. Whether the products of the 1840's are a pseudo-art or possess a genuine rococo beauty is a controversial matter of taste to-day, as it was then. But Palgrave was wrong in attributing what he thought false to the mere fact of mechanical production and reproduction. Josiah Wedgwood and Robert Adam, had they still been alive, could have given him the lie there. Mass-production was a commonplace even in the 1780's, and Wedgwood, Adam and many other manufacturers and contractors were as widely respected by their contemporaries for the elegant beauty of their productions as for their enormous commercial success. The generation of the 1840's, pioneers both in large-scale industry and in popular education, produced many prophets who believed that machinery was going to be the means of enlightening the people by bringing beautifully designed objects within the reach of everyone. Palgrave, however, was determined to play Cassandra. 'Art can never again take root in the affections of mankind,' he predicted, 'though the masses will be quite easy without it.' Eleven years later the Great Exhibition was to put Palgrave's predictions to a test.

The ghost of Josiah Wedgwood was invoked a few lines back. Wedgwood is one of the few 18th-century manufacturers whose designs have been consistently admired in their own day, at the time of the Great Exhibition and to-day. But between 1830 and 1850, or, for that matter, both a little earlier and

a little later, some of the old 18th-century contro-
versies in matters of taste were still overlapping the
new 19th-century ones. The Classic taste was yet
fighting its losing battle against the Gothic, the Sub-
lime against the Picturesque, Beauty against Utility.
The previous generation—that which was mature
when George IV was Regent—had been so avidly
classical in its tastes that a reaction against it in some
direction or another was inevitable. On a popular
plane this was evident when *Punch*, in 1845,[1] chose
to describe the Parthenon as being of the exact
colour and mouldiness of a ripe Stilton cheese. A
more serious enemy of the classical was William Bell
Scott, who about 1840[2] wrote of a connoisseur, Dr.
Frank Sibson, that he was given to the collecting of
Wedgwood ware, which was, said W. B. Scott, 'a
kind of *æsthetic* culture only enjoyed by cold-blooded
animals with high shirt collars'. All the same Scott
had to admit that many years later, after Sibson's
death in 1876, this 'elegant' Wedgwood trumpery
was sold at Christie's, where one piece brought £600.

Punch, though of fascinating interest to us for the
light it throws on popular opinion a century ago, was
hardly a weighty critic. Nor was William Bell Scott,
whose value for us lies in the facts he recorded rather
than the opinions he expressed. But Sir Francis Pal-
grave is a very different matter. In the decades that
preceded the emergence of Ruskin he exerted as
much authority as anyone in matters of taste and
appreciation. To the arguments for and against
classicism and romanticism he gave a twist which,

[1] Vol. 8, 1845.
[2] *Autobiographical Notes of William Bell Scott*, 1892.

whatever its dialectical shortcomings, took the whole controversy on to another plane and vastly confused the issue. Palgrave had no quarrel with the art of Antiquity, though evidently he cared little for it; but he had a violent quarrel with the modern imitation. He obviously detested 'the Greeks and the Romans' in painting and, as represented by Canova, in sculpture; presumably he also disliked the English modern classic, John Gibson, at that time the most eminent sculptor in Rome.[1] Having remarked that the early Renaissance painters regarded the Antique as a free auxiliary rather than as a pattern to be copied, Palgrave then gave it as his opinion that when, in the early 19th century, exact resemblance to the Antique became the only test of merit, invention and imagination simply became torpid. Italian art of that period was, he exclaimed, 'as empty as the cenotaph and as dead as the bones and ashes in the sepulchre'. But there was, in Palgrave's view, a further reason why the modern classicist taste had caused the downfall of Italian art—morals. He argued that, while it was not possible to acquit the Greeks of sensuality in their art, they were at any rate not debased, according to the highest standards of their own day. But that same art, and equally its modern imitations, judged by modern standards, was, to Palgrave's austere way of thinking, nothing short of an offence against propriety.

In this attack on classicism Palgrave found a supporter in Henry Drummond, the rich and enthusias-

[1] John Gibson, *b.* Conway 1790, *d.* Rome 1866. Son of a landscape-gardener. R.A. 1838. Lived and worked at Rome for fifty years.

PLATE 1

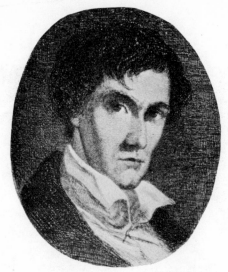

British Museum.

WILLIAM BELL SCOTT
Etching by himself, 1831

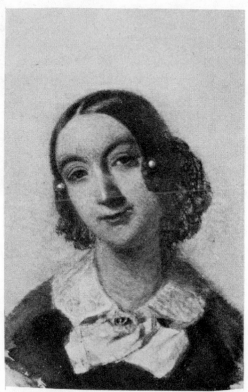

National Portrait Gallery.

ELIZABETH RIGBY (LADY EASTLAKE)
Watercolour by C. Smythe

PLATE 2

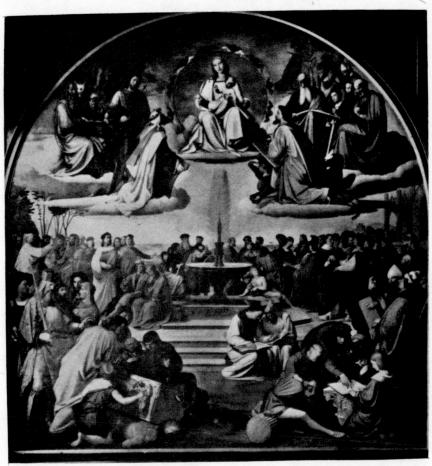

TRIUMPH OF RELIGION IN THE ARTS
Painting by Friedrich Overbeck

tic founder of the Irvingite sect.[1] Drummond also believed firmly in the decadence, and even in the licentiousness, of contemporary Italian art, though he attributed this not to the example of Antiquity but rather to the neo-Paganism of the Renaissance. Lorenzo de' Medici was the culprit. He may have brought the arts to the point where they attained their greatest elevation, but at the cost of bringing the artists back to paganism. The effect of the arts on society in Italy ever since, said Drummond in a pamphlet of 1840,[2] 'has been exactly the contrary of that produced by them up till that time'. Instead of making holy men and women, they had tended to habituate the eye and taste to scenes of indecency, which was one of the causes of the open dissoluteness of Italian society; and therefore, presumably, of the decadence of Italian painting.

From this point, since the period was 1840, the controversialists of the art-world could rapidly advance into the field of religious doctrine. Drummond implied, or at least some of his readers thought he did, that if the decadence of the Renaissance painters was due to their paganism, the excellence of their predecessors was due to nothing less than direct inspiration; and that could only mean that excellence in art was attainable solely through the doctrine of the Church of Rome. Palgrave courteously but vigorously dissented from such a theory, and pointed out that if this relation between Rome and artistic excellence were the only true one, then many artists

[1] Henry Drummond, 1786–1860. A singular political figure and a vigorous pamphleteer.

[2] *A Letter to Thomas Phillips, R.A.*, 1840.

25

would have to become converts, or, in his own words, 'pass over to the Roman communion'. This confusion of religious doctrine with æsthetic criticism was in due course, as we shall see, to involve such highly intelligent writers as Lord Lindsay and Lady Eastlake, to say nothing of Ruskin. In contemporary estimates of the modern German School and of the Pre-Raphaelites, religious controversy provided the most valuable ammunition of argument.

Such, briefly, was the opening scene as William IV gave place to Victoria. In æsthetic, as in ethical thought, moral conviction was in conflict with philosophic doubt, optimism with pessimism, the assurance of the present with the forebodings of the future. With that we may pass to the several aspects of the story—a story with many plots and hardly a single thread of continuity.

PAINTING IN GERMANY AND ENGLAND, 1830–50

A MARKED feature of the intellectual scene during the 'thirties and 'forties was a pronounced admiration for German literature and art. It was cultivated, or at least professed, by the majority of intellectuals in London and Edinburgh and at the Universities; but it had its dissenters—notably Elizabeth Rigby, whom, as Lady Eastlake, we shall meet many times in these pages. Because of this general admiration, a discussion of painting in England involves first some consideration of German painting, even though the aims of painters in the two countries were widely different from one another.

German painting, however, in this connection does not at first mean the same thing as painting in Germany. The German School, so much admired in England, was born in Rome of German expatriates, refugees from the French Occupation authorities under Napoleon. The origin of this School, known as 'the Nazarenes', was early explored by English writers,[1] when many of the founders of that School were either still active or living in distin-

[1] *Quarterly Review*, vol. 62, 1838. Rev. Henry Wellesley, ibid., 1844. Director of the Academy of Perugia, *Art Union*, May 1844. Sir A. H. Layard, ibid., vol. 104, 1858. But see especially Elizabeth Rigby, 'Modern German Painting', ibid., vol. 77, 1845–6.

guished retirement. The facts can be put together without much difficulty.

About the year 1803 some German art-students at the Academy of Vienna were expelled for disobedience to the newly imposed regulations, and settled together as a community in Rome, where they took over and occupied the derelict Convent of S. Isidoro, behind the Trinità dei Monti. This passage to Rome was not merely physical, for these youthful exiles together abjured Protestantism and adopted the pre-Reformation creed of Rome. They sought, moreover, in their own lives and ideals to revive the monastic principle of work and prayer. Within the fraternity, praying and the practice of art came together as a ritual. Practising personal sacrifice and self-denial, they were called derisively 'the Nazarenes' on account of their almost fanatical piety, and formulated a creed, according to which the loftiest aims of Art can only be achieved through the strictest moral training. The leaders of this exile sect were Cornelius and Overbeck[1]; with them were associated Vogel, Veit and von Schadow.

It is probably true that the Nazarene Movement was not merely the result of a university purge. It must have had its real origin in the wider political and social movements which surged through Europe, as the awakening of the French Revolution turned into the stupor of Napoleon's dictatorship. To many of their contemporaries, at any rate, the Nazarenes

[1] Peter Cornelius, *b.* 1783, *ob.* 1867. Friedrich Overbeck, *b.* 1798, *ob.* 1869. Karl Christian Vogel, *b.* 1788, *ob.* 1868. Philipp Veit, *b.* 1793, *ob.* 1877. Wilhelm Friedrich von Schadow, *b.* 1789, *ob.* 1862.

seemed to be intimately connected with the struggle, not only in Germany, but everywhere in Europe, for political independence. But if they were, in fact, concerned with that struggle, they seem to have set about it in an oddly unconstructive way. Instead of making their lives and their work an active element of the times they lived in, they adopted a deliberate primitivism in their religion, in their painting technique and even in their dress. The 'primitivism' was in fact medievalism, which at that time was often considered as synonymous with the primitive. Clearly, if art and prayer are to be associated in a ritual way of living, some repudiation of modern conditions will be necessary. If one holds the view that the modern world has gone wrong, and at the same time is impelled by the desire to set it right, it is not illogical to go back to a point in time before that at which error crept in, and to begin afresh from there.

The Nazarenes believed that this point occurred with Raphael. Some of them still felt that the Master himself was not actively poisonous, though his example was; others felt that even Raphael must be rejected, and even Perugino, and that Fra Angelico and Dürer were the last of the great Masters; yet others believed that painting had perished with Giotto. All, however, agreed that the Renaissance had ruined painting and the world. It was necessary, therefore, to reject all technical progress since the beginning of the *cinquecento*. The Romans laughed at them, and called them derisively not only 'Nazarenes', but also 'Pre-Raphaelites'. Nevertheless, this German–Roman sect found converts in the scholarly circles of Rome, and their new

principles were widely discussed. This was especi-
ally the case after King Ludwig I of Bavaria, as
Crown Prince, and aged only eighteen, visited Rome
in 1804 and constituted himself the champion of the
equally young Cornelius.

By 1820 the Nazarenes had substantially helped
in elevating Rome to the position which, for a short
time, she held as the international capital of the world
of art. The leaders of this world in Rome, in addi-
tion to Cornelius and Overbeck from Germany,
were Ingres and Granet from France, the young
English sculptor John Gibson, and Brülow and
Kiprenski from Russia. As some German said at the
time, 'der Fisch gehört ins Wasser, der Künstler
nach Rom'.

The recorded facts of the Nazarene Movement are
reasonably clear, although they do differ on one
small point. One authority says that the students
were expelled from Vienna and went to Rome in
1809; another says that they were already there be-
fore Crown Prince Ludwig's visit in 1804.[1] But this
matters very little; of far deeper and more serious
obscurity is the direction in which the Nazarene
Movement was hoping and trying to move. All
contemporary and immediately post-contemporary
English observers seem to agree that the Nazarenes
and their issue, the School of Düsseldorf, strove to
express the highest religious sentiment. Perhaps
these observers were too near to the subject they
were discussing. Some held that the German School

[1] Respectively the Director of the Academy of Perugia, quoted
by *The Art-Union*, May 1844; and Elizabeth Rigby in the *Quar-
terly Review*, vol. 77, 1845–6.

was trying to express the Christian ideal in the archaic language of Giotto; others that they were trying to recall the innocence of Fra Angelico or the sweet serenity of Perugino. At least one observer, Layard,[1] saw them as German through and through, despite their adoptive Italian parentage. It is worth noting, incidentally, that Layard expanded this observation by saying that it is a grave mistake to believe that art can be transplanted from one period to another without reference to the foundation upon which it originally rested. Another, rather earlier, critic,[2] discussing the Roman parentage of the contemporary German School, stressed the accepted belief among the young expatriates living in Rome that conversion to the Roman faith was itself a prime necessity before any achievement in art could be hoped for. Casting aside any nice distinction between Schools, this critic described the young Nazarenes as 'trying, as it were, to establish their right to drink at the common fount which refreshed and inspired the giants of old, from Giotto and Van Eyck to Perugino and Raphael'. From the point of view of subsequent developments in England, however, the main thing about the Nazarenes is that they did not remain in Rome, as did John Gibson, but, like Ingres, returned to their native country and founded native schools.

This was due to the fortunate co-existence in the 1820's and again in the 1840's of patrons in search of a School, and a School in search of patrons. The patrons were the two brothers-in-law, Ludwig I of

[1] A. H. Layard, *Quarterly Review*, vol. 104, 1858.
[2] Ibid., vol. 62, 1838.

Bavaria and Frederick-William IV of Prussia.[1] To the former Munich owes not only the classic dignity given to the city by such buildings as the Walhalla, the Glyptothek and the two Pinakotheks, but also its establishment as the art capital of Germany. To the latter Berlin owed the heavy form of classicism that once distinguished its centre. Frederick-William perhaps rather protected than promoted the Fine Arts, but he was no mean architect himself, and was an accomplished pupil of the great Schinkel. As such, he no doubt applauded Schinkel's remarkable project for converting the whole Acropolis of Athens into a royal palace for Otto of Bavaria, King of the Hellenes. Although this project may seem to us to have been injudicious, it was not thought so then, except by the Greeks themselves. Similarly in Munich, Ludwig's Walhalla, which was much disliked by later taste, was applauded by most critics at the time. The important fact is that both these neighbouring rulers were passionately devoted to the arts and were uncommonly well situated to indulge their passion.

Ludwig's great influence on the arts in Germany and, indirectly, in England, began, however, long before his accession to the throne of Bavaria. It began probably with his visit to Rome while Napoleon was overrunning Germany; but in any case it must have begun with his experience of the Nazarenes

[1] Ludwig was *b.* 1786; acceded as King 1825; abdicated 1848; *d.* 1868. The immediate cause of his abdication in that year of abdications was his passion for the dancer Lola Montez. He continued his patronage of the fine arts during the years of his retirement. Frederick-William was *b.* 1795; reigned as King 1840 till 1857, when his mind became clouded after a stroke.

when they were still the new and exciting element in the art-world of Rome. In them, if he could entice them back to Germany, lay the means of reviving the spirit of German art and of founding a new German School. That was Ludwig's deliberate project, and he succeeded in carrying it out.

Cornelius was the first of the Nazarenes to return to Germany, with Ludwig's direct encouragement. That was before 1820. After Ludwig's accession in 1825, Cornelius and the other returned Nazarenes were lavishly employed on the painting of frescoes in countless new buildings in Munich, Frankfort and even Dresden. Then came the important development of the founding by Cornelius of the fresco-painting School of Düsseldorf. From 1830 onwards Düsseldorf and Munich were quoted in England with awe by the majority of art-critics, while by a small number of very weighty authorities they were criticised adversely with a seriousness which in itself implies an attitude approaching one of awe.

In 1829 the young but already influential Charles Eastlake set down his opinion of Cornelius and of his influence.[1] So far as concerned technical mastery of the art of fresco-painting, Eastlake had a high opinion of Cornelius, and was later, in 1841, to invoke him as an authority before the Royal Fine Arts Commission. But of the use to which Cornelius applied his technical skill, at any rate in 1829, Eastlake had a lower opinion. His opening description of Cornelius as 'the so-called German Michael-

[1] Letter quoted fully by Lady Eastlake (Elizabeth Rigby), *Memoir of Sir Charles Eastlake*, printed with her edition of his *Contributions to the Literature of the Fine Arts*, 1870.

33

Angelo' was at once both derisive and a tribute to the position occupied by the Master of Düsseldorf. 'Cornelius', he continued, 'has departed from nature without rising to a *general* idea: manner, caprice, vulgarity and ugliness are often the consequence . . . the painter is lauded by his brother-artists (with some few exceptions), and of course the connoisseurs and the public follow.'

For a young Englishman to have adversely criticised Cornelius at that time shows a remarkably independent mind. But an even higher degree of independence was needed to attack, as Eastlake proceeded to do, the validity of all art that is purely narrative or descriptive; for such was the form of art most admired in both the England and Germany of the 1830's. 'I have observed', wrote Eastlake, 'that Germans and Italians are always glad to harangue and describe their pictures. . . . It would be wiser if they calculated what effect these pictures would have when they are left to tell their own story, which they must do sooner or later. . . . His [Cornelius's] depth of thought excites admiration among those who judge of paintings by their *descriptions*.' It is true that Eastlake modified his verdict by agreeing that the works of Cornelius had a grand conception, but he maintained nevertheless that that painter's talents were of the kind which told better in words than in painting. Eastlake alone, of all the younger critics of his day, was sufficiently deep-rooted in the history of his subject to mistrust the growing tendency towards a literary use of painting.

This literary art in the England of the 1840's shared with the arts of decoration and with much

poetry of the day a marked tendency towards the medieval. Much of the German School also was medievalist. But the more serious critics were quick to see that the literary and anecdotal medievalism of England was not at all the same as the religious-romantic medievalism of Düsseldorf. Common opinion did not realise the distinction, and, while recognising the medieval as being the new fashionable idiom for their enthusiasms about art, thought that anything worth-while in that line must come from Munich and Düsseldorf. In 1845 *Punch*, having observed that the best models for an earnest and diligent medievalist to choose were the Germans, announced jocularly a few weeks later [1] that 'Mr. Punch begs to acquaint Bishops, Priests, Commissioners of Fine Arts and Patrons of Pure Art, that he has opened a manufactory for every article in the medieval line at very reduced prices'.

In the opposite camp, William Bell Scott may again be quoted [2] as maintaining that what was thought good in Germany was not necessarily suitable for transplanting to England. He admitted great merits in the Overbeck–Cornelius doctrine, which he saw as a systematic renaissance engineered by a noble band of idealists, religious and romantic, yet academically intellectual; they had deliberately trained and disciplined themselves in set ways of thought and expression, and had succeeded in conventionalising their art into lines of great dignity. But for that kind of art, thought William Bell Scott, there could be no public at all in England; the

[1] *Punch*, 1845, vol. 9.
[2] W. B. Scott, *Autobiographical Notes*, op. cit.

Bavarian School had thrown off their individuality. Realities were not good enough for them, they were in danger of perishing, of losing their manhood—of becoming, in short, an artistic aristocracy. 'It was clear to me', he wrote, 'that the attempt to create such a school in this country was simply out of the question.'

Elizabeth Rigby went much farther than that;[1] and in 1845 she was speaking with an authority higher than William Bell Scott's. She found German art not only unsympathetic to the English idea, but bad in itself. It was bad because it was synthetic. It had many of the external signs of being a great period in art, but in fact was merely parading the incidentals of such a period, with a great deal of enthusiasm and argument and pedantic reasoning about the sources of inspiration. 'But', said Miss Rigby tartly, 'the signs are got-up.'

Before turning to the English contemporaries of Cornelius, Veit, Schadow and Overbeck, we might have a personal glimpse of the prodigiously eminent Cornelius himself. One of his great admirers, Comte A. Raczynski,[2] quoted the great man, in 1841, as saying of himself that his creative power was not quite sufficient for him in his lifetime to elevate German art to its greatest height; but he could at any rate set it on the right road. Cornelius also was rather afraid that posterity might have some difficulty over placing him in history, since his nature, he felt, was so complex that it would be difficult to fit him into any category. Miss Rigby, it may

[1] *Quarterly Review*, vol. 77, 1845–6.
[2] Raczynski: *Histoire de l'Art Moderne en Allemagne*, 1841.

be here noted, magnificently dismissed Raczynski's criticism as 'a work of detestable pedantry, with pages of the most witless affectation'.

Miss Rigby herself (by then Mrs. Charles Eastlake) has provided another personal glimpse of the Master. In her journal, in September 1852,[1] she recorded that in Dresden she and her husband drove to Cornelius's studio. 'We expected', she wrote, 'to find him a hoax of uncommon magnitude but he surpassed all our expectations. . . . He is the great gun of German art, but a mere pop-gun in reality. . . . He says of himself that he stands alone in art. Waagen hates him enthusiastically, and was overjoyed to hear us denounce aloud what he dares not breathe a word of, even in a whisper.' Waagen, of whom we shall hear more later, was then a very high authority in the rapidly growing world of German art-criticism.[2]

While many people in England were admiring German art, in spite of Miss Rigby and Mr. Scott, many people in France were admiring English art. But, as we have already seen,[3] the English painters most admired by the French were not those admired by the English themselves. It was not Turner nor Constable who were in highest favour in their own country, but the painters of narrative and genre. To repeat a remark made earlier, the pictures most in demand in England of the 1840's were those which reproduced some widely familiar scene, or gave more or less convincing information about selected

[1] Lady Eastlake: *Journal and Correspondence.*
[2] See pp. 41–2.
[3] See Chapter I above.

aspects of history or were literal illustrations of widely read authors. Delacroix and Bonington in France were fond of painting scenes out of Sir Walter Scott or episodes from the life of François I^{er}. But they would not perhaps have admired very highly their fellows across the Channel, had they been aware of them, who were also illustrating history and literature: Daniel Maclise, C. R. Leslie, William Hilton, and E. M. Ward.

When people in England talked about the benefits to be derived from following German precepts, they were probably thinking more of the popular German genre-painters than of the grandiloquent painters of large frescoes like Overbeck and Cornelius. The genre and narrative painters, connected rather with Düsseldorf than with Munich, men like Sohn, Bendemann, Köhler or Hildebrandt, were made familiar in England through their engravings, and the requirements of the purchasing public in both countries seem to have been much the same. Whether a picture were genre or straight narrative, to be successful it must have either humour or pathos, but neither vulgarity nor tragedy; it must be accurate and minute in detail; its point must be easily perceived and quickly comprehended. These requirements could be, and were, readily supplied by Thomas Webster and William Mulready, by Gilbert Stuart Newton and Sir A. W. Callcott; and by Sir David Wilkie, the only one of them at all seriously to be regarded as a painter, separated from the narrative content of his pictures.

Extreme verisimilitude was demanded, supplied and admired. Verisimilitude in the rendering of

38

objects, and in depicting the obvious reactions to common experiences, was the measure of a picture's merits. And even then it was often, indeed usually, thought necessary to drive the point home by the printed word. A contemporary description of a once well-known picture by Mulready illustrates this. The picture, called 'The Wolf and the Lamb', represents one village lad bullying another, with the victim's widowed mother emerging anxiously from the cottage. It was bought by Queen Victoria. The description [1] begins, 'The narrative is pointed, perspicuous and comprehensive', yet, even so, the writer was not deterred from describing the picture in minute detail. There is a whole page of such elaborate description that it might almost be inferred hat the picture tense of its purpose. It emphatically did not, but the commentator was only anxious that the spectator should not overlook a single point.

The collection of pictures in which this passage occurs consists of ninety engravings after paintings considered to be of importance. The artists represented include most of those just mentioned, and also Lawrence, Etty, Landseer, Stothard and even Richard Wilson; Constable and Turner are each represented by one picture; Reynolds, Gainsborough, Hoppner and Romney are all excluded, which is not altogether surprising, as they had all been dead long enough to be considered yesterday's fashion. But the total exclusion of Benjamin Robert Haydon is more significant, and demonstrates un-

[1] *The British Schools of Art*, pubd. by J. S. Virtue; n.d. but shortly before 1850. 2 vols. of engravings with descriptive text, anon.

mistakably his fatal handicap of having been born either in the wrong country or at the wrong time. In the England of 1780 he would have been more successful than Copley, in the France of 1820 he would have rivalled Gros. But his own England was no longer likely to be impressed by his Sublime and Grand heroics, and the longer he continued to paint them the more surely was he condemned to failure, especially as he happened to be quite unsuited to paint in that particular language. Only the wild imagination of a John Martin[1] could carry off the Sublime in that age. Taste, as indicated by the purchases of collectors and the popularity of engravings, undoubtedly preferred the Maclises and the Mulreadys. But it is of essential importance to add that it did also sometimes try to perform the difficult task of admiring Constable and Turner. Of the latter, the previously quoted author said, 'We find in this painter a greater diversity of impression than in any landscape-painter that has ever preceded him', and talked of his blazon of light and air. Of Constable it said, 'To his labours our school of landscape art is deeply indebted for its naturalism . . . his axioms and practice have not only changed the character of our landscape-school but operated sensibly on the French School, through the exhibition of some of his works in Paris in 1824'. Here is an early statement of what is now a recognised historic fact.

In the 1830's visits were paid to England by two eminent German critics, J. D. Passavant in 1832 and

[1] 1789–1854; painter of 'The Fall of Babylon', 'The Fall of Nineveh', 'Belshazzar's Feast', 'Illustrations to the Apocalypse'.

PLATE 3

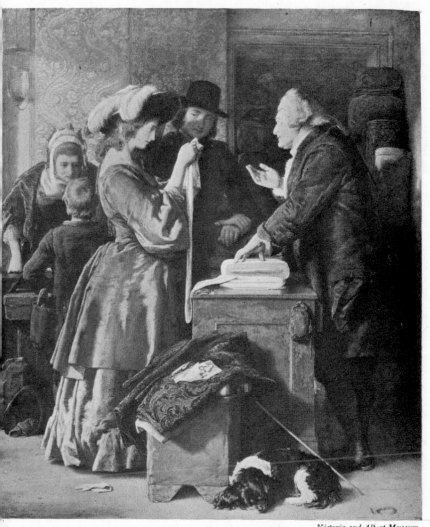

SCENE FROM *The Vicar of Wakefield*
Painting by William Mulready, 1846

PLATE 4

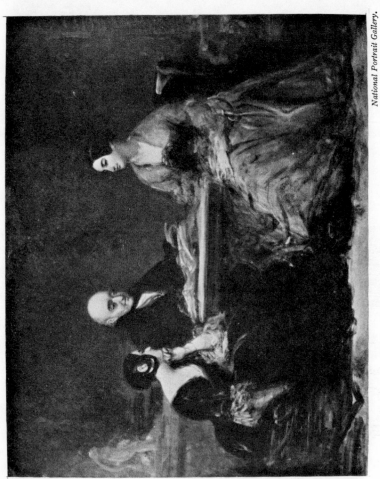

SAMUEL ROGERS, WITH MRS. PHIPPS (*l.*) AND THE HON. MRS. NORTON (*r.*)

Painting by Frank Stone, *c.* 1850

G. F. Waagen in 1838. These visits resulted in two books [1] which are of great value in assessing the reputations of the most notable painters then working in England. The omissions and silences are as significant as the inclusions and comments.

To take Passavant first; he made a close friendship with the 'celebrated artist' Sir A. W. Callcott and his family [2]; and with them visited Apsley House to see the Duke of Wellington's collection with its Correggio and its Velasquezs. 'A lovely picture by Landseer,' he carefully noted, 'must not be passed over . . . it represents a Highlander just returned from the chase.' On another occasion, Passavant was illuminating about B. R. Haydon, who evidently had a higher reputation in Germany through paragraphs in the press than he enjoyed in England through the exhibition of his works. He was not, thought Passavant, devoid of talent, but the high estimate he had formed of his own powers had so paralysed his efforts that his later works were totally devoid of truth. Of David Wilkie, Passavant said that in representation of common life he approached nearer to Hogarth than any other, while in execution and colouring he far exceeded him. The painstaking, but most admirable, Etty was oddly described as 'eccentric', though later this was modified more understandably to 'licentious'. Even odder was Passavant's note on C. R. Leslie; having not improperly described him as next after Wilkie among

[1] Passavant: *Tour in England*, 1832. Waagen: *Works of Art and Artists in England*, 1838.

[2] Lady Callcott (Maria Graham) wrote a life of Nicolas Poussin and an account of some of the ancient monuments in the West Indies.

the English subject-painters, he then observed that he appeared to have taken Paul Veronese as his model. Among other painters mentioned, John Martin was condemned for his extravagant imagination, and Charles Eastlake for not being imaginative enough.

Waagen, six years later, noted most of the artists whom Passavant had mentioned, but his opinions were by no means always the same. The much-discussed John Martin, for example, whom Passavant had called a perverted genius, possessed in Waagen's eyes 'grandeur and originality'. Both these Germans agreed in placing David Wilkie at the top. For Waagen, Wilkie was 'the first painter of our times and the most spirited and original master of the whole English School'—and that includes Hogarth. He was, in Waagen's opinion, nearly on an equality with Teniers and Jan Steen.

Most German, and probably most French, observers of the English School would have agreed with Waagen when he wrote that the moral humorous department was the only one in which the English have enlarged the domain of painting in general. 'Portrait-painting', he said, 'is the branch which they have cultivated with the most success, but they are weakest in historical painting.' This last sentence, from a foreigner, must have angered Sir Martin Archer Shee, P.R.A., who had pronounced his predecessor in the Academy Presidency, Benjamin West, to have been the greatest historical painter since the time of the Carracci; a period, it may be remembered, which included Rubens, Vandyck and Rembrandt, to say nothing of Velasquez.

42

A further illuminant on English artists of the late 1830's, and their repute, was provided by the *Quarterly Review*[1] in its notice of Waagen's above-quoted work. The reviewer, Lord Francis Egerton, took the opportunity of expressing his own opinions rather than of discussing Waagen's. He agreed, in a spirit of resignation, that the English School was desperately weak in the direction of religious and historical paintings. 'We do not complain,' said Lord Francis. And continued, 'What we do complain of is that the nature we have around us is misrepresented, that we have no Ruysdael for our skies, no Cuyp for our sunshine.' Here Lord Francis corrected himself; there was, it appeared, at least an English Hobbema. 'If anyone be likely to rebuke us for this complaint it is Mr. Lee[2]—who indeed bids fair to become the Hobbema of his time and country.' This, we may remind ourselves, was written in 1838. Constable had been dead hardly a year; it was barely seventeen years since the death of Crome; Turner was still in the full vigour of his late manner. There was no mention of Constable, not a word about Crome. Turner, however, was rather more than mentioned, for the reviewer profoundly disapproved of him and feared his influence, although admiring his early works. 'Those strange patches of chrome, ultramarine and whiting which Mr. Turner is wont to exhibit in these days,' ex-

[1] *Quarterly Review*, vol. 62, 1838. Lord Francis Egerton, 1800–57, younger son of the Marquess of Stafford, later became 1st Earl of Ellesmere.

[2] Presumably Frederick Richard Lee, 1799–1879, who is recorded as having exhibited at the Royal Academy from 1824 till 1870.

claimed Lord Francis. 'That these extravagances have their admirers (purchasers we believe they have few), especially among professional men, we are well aware, and we believe that none but artists can fully appreciate the difficulties which this Paganini of the palette deals with.' Developing this attack, the reviewer observed that when such were the examples set to younger men by their most distinguished elders, it was not surprising that the mass of our artists should afford constant instances of the struggle for effect and the scorn of labour and finish. The above-quoted passage ends with the words, 'If there be one painter of our own time who deserves praise for the example of labour united with genius, it is Mr. Landseer.'

The *Quarterly Review*, at this time and for many years after, had an article on the Fine Arts in nearly every number. Its regular readers, who were serious-minded men and women, no doubt regarded its opinions as authoritative. When the editor himself, J. G. Lockhart (though admittedly writing anonymously), said [1] that the two greatest artists of the time were Wilkie and Chantrey, they might well be forgiven for not remembering Constable and Turner; it is true that the former had now been dead for as long as six years, but the latter was still alive and still exhibiting at the Academy. It was Wilkie and Landseer who jointly ruled in the world of English art. Landseer's admirers were perhaps even more numerous than Wilkie's, and he had the already considerable authority of the young Ruskin to increase their number. In a passage in *Modern*

[1] J. G. Lockhart, *Quarterly Review*, vol. 72, 1843.

Painters, Ruskin described 'The Old Shepherd's Chief Mourner'[1] as 'one of the most perfect poems or pictures—I use the words as synonymous—which modern times has seen'. This is what Lady Eastlake sharply condemned as the fallacious identification of poetry and painting.

Finally, some of the opinions of Constable himself must be quoted. As expressed in his correspondence with C. R. Leslie,[2] they show very clearly who, in the late 'twenties and the 'thirties, were the great guns of the art-world. Towards these Callcotts and Pickersgills and others his attitude was one of respectful, and to us astonishing, humility. Only occasionally was he ironical, and only for a very few fellow-painters did he permit himself something like contempt; Etty and Landseer were among them. The last he ridiculed. Of the first he approached as near to jealousy as his great and noble character could do; with some justification, moreover, since in 1828, when Constable and Etty were joint candidates for full Academicianship, Etty, five years junior to Constable as A.R.A., was elected. Constable had to wait another year.

The high reputation enjoyed by the now forgotten Sir Augustus Callcott was shown when Constable, in 1826, thanked Leslie for a good word on his behalf to the great man. Constable was assured by Callcott that he had risen much in his esteem, and he was fully aware of the professional value of his backing. Whatever may have been his real opinion of the

[1] Exhibited Royal Academy 1837.
[2] *Letters of John Constable to C. R. Leslie*, 1826–37. Edited by Peter Leslie, 1931.

45

landscapes of Callcott, Constable profoundly ad-
mired those of Turner, especially his earlier work.
That is not surprising. What is surprising, and un-
explained, is his dislike of Linnell, who today stands
for us as one of the most intense and moving of the
romantics. Even more surprising is it that Con-
stable could compare the slight and empty talent of
a man like A. E. Chalon[1] with the genius of Veronese,
of all masters. There is no limit to the surprises
which the tastes of great men provide for posterity.
'Alfred Chalon's Samson', wrote Constable to Leslie
in 1832, 'is just what Paul Veronese would have
done if he could—it is full of power, full of splen-
dour.'

By contrast, Constable's pen gave poor Etty some
sharp stabs. He wrote, for instance, of an exhibition
in 1830: 'I recollect nothing in the Gallery but some
women's bums by Etty R.A.' And at the end of his
life, in 1837, he repeated to Leslie a wonderfully
humourless letter from Etty, which admirably com-
plements the earlier remark. 'Dear Constable,' Etty
had written, 'a young figure is brought to me, who is
very desirous of becoming a model. She is very
much like the Antigone and all in front memorably
fine. Yours etc. W. Etty.' Others who got stabbed
were the official portrait-painter, Sir George Hayter,
'a very prosperous, disagreeable personage'; John
Linnell, whom Constable describes as being seen
speaking to Landseer in Regent Street with his hat
off all the time and being snubbed for his obsequious-
ness; and Landseer himself, described at an official

[1] Alfred Edward Chalon, R.A., 1780–1860. Chiefly celebrated
in his day for his agreeable portraits in watercolour.

46

dinner with 'shirt-frills reaching from his chin to below his navel and his head beautifully decorated with a thousand curls'.

In writing to Leslie of his own art, Constable was wistfully resigned to the neglect which sometimes angered but never embittered him. In 1829 he wrote, 'I have received a commission to paint a *Mermaid* for a sign for an Inn in Warwickshire . . . no small solace to my previous labours at landscape for the last 20 years. However, the Lady may help to educate my children.' In 1831, again to Leslie, he wrote that the papers 'speak highly and very properly of your pictures and, perhaps fairly, of my "chaos" as they term my Salisbury—they say, after much abuse, it is still a picture from which it is impossible to turn without admiration'. A letter of 1832 can wring the heart of a modern reader with its mixture of pathos and dignity: 'The Great', he wrote, 'were not made for me, nor I for the Great . . . my limited and abstracted art is to be found under every hedge and in every lane, and therefore nobody thinks it worth picking up; but I have my admirers.' In 1833 Constable described a visitor who undoubtedly intended that his visit should be regarded as an honour; Constable had then been a Royal Academician for four years. He wrote to Leslie, 'I have had a friendly visit from a much greater man than the King, the Duke of Bedford, Lord Westminster, Lord Egremont or the President of the Royal Academy—Mr. Seguier.[1] He was

[1] William Seguier, 1771–1843. In turn an agent, restorer and professional expert. In this last capacity he was employed by many of the great collectors, including George IV and Peel. In the

much delighted, and rather astonished, to find so much good, or rather so far beyond his expectations. He bestowed much extempore praise—such as 'Did you do this? Reely! Who made that drawing? You, reely, very good indeed!'

Here then, summarily, are the views generally held at the time about the English painters of the 'thirties and 'forties. Constable was neglected; Turner was reviled as one fallen from grace; but their examples were being most profitably pursued by the *avant-garde* in Paris. Wilkie, Leslie and Landseer, Callcott and Stanfield, Webster and Mulready were the bright stars. In the immediate future lay the Pre-Raphaelite revolt and the experiment of the Westminster Palace frescoes; in the background lay Overbeck and Cornelius, Munich and the Nazarenes.

second he was continually employed by Wellington, who always called him 'Seago'. He became Conservator of the Royal Collection, and was the first Keeper of the National Gallery in 1824, where he enjoyed full scope in all his capacities.

COLLECTORS AND CONNOISSEURS

HAD this book been dealing with the 18th instead of the 19th century, it would have been necessary to draw a distinction between collectors and patrons, for in the former century the activity of forming a collection seldom coincided with the patronage of living artists; in the 19th, however, the two could be, and in most cases were, synonymous. This is not to say that in the 18th century no connoisseur of the arts ever patronised the work of his own contemporaries and fellow-countrymen. But those of them who set out either to form new collections or else to extend inherited ones followed in almost all cases the dictates of established Taste.[1] It was not very easy to set up successfully as a connoisseur in that small, exclusive, aristocratic world whose god was Taste. Connoisseurship, and also patronage, so far as they went, were the privilege of the 'nobility and higher gentry', to use words of the period. That is to say, of men who had had the opportunity in youth of travelling and of forming a more or less critical taste for the approved Old Masters. Such men, conscious of the gulf which separated them from those less cultivated, were not likely to concern themselves very much with living artists, whose works could be had for the asking by anybody with a few guineas to spare.

[1] Cf. Introduction; also the author's *The Rule of Taste*, 1936.

It is hardly ever possible to assign definite dates to changes in taste. All that can be said here is that the standards that prevailed among collectors during the 18th century were still applicable in the 1820's; and that during the 1830's a very marked change took place. This change was the combining of patronage with collecting. It was no longer necessary to claim connoisseurship in the field of Old Masters in order to form a collection that should be highly esteemed even by quite exacting critics. Contemporary painters of genre, history, landscape or narrative suddenly found themselves enjoying a lavish patronage which had hitherto been bestowed on the portrait-painters alone, and saw their names in print along with those of Raphael, Claude or Teniers. Their golden age had begun.

It has been so often repeated as to have become a truism, that this new phenomenon of the patron-collector was a result of the rise to power of the middle-class. Lady Eastlake herself provides contemporary authority for this,[1] in saying that during the years between 1830 and 1840 the patronage which had till then been the privilege of an exclusive few was 'now shared, and subsequently almost engrossed, by a wealthy and intelligent class chiefly enriched by commerce and trade'. This is undoubtedly true. Yet such a class was a notable element long before 1830, and was indeed as old as the Industrial Revolution. In those days, however, the 'new' man hardly ever appeared as a patron of the arts except, like Alderman Boydell, for business or commercial reasons. If he wished to acquire a

[1] Lady Eastlake: *Memoir of Sir Charles Eastlake.*

status in society which he had not inherited by birth, he was generally able to do so by securing a seat in the House of Commons. This cost a very great deal of money, but was usually held to be worth it. Thus directing his aim, the 'new' man was content to leave the arts to those who had the education and the traditions to understand them. The Reform Bill of 1832, while not exactly the liberating affair that the majority of Englishmen hoped it would be, did facilitate entry into the House of Commons for many of those who lacked family, Court or territorial influence. It was therefore no longer so desirable for the socially ambitious, who as a result began to turn their attention to the other former preserve of the aristocracy, the arts.

Obviously England was not so precisely divided into art-loving aristocrats and philistine parvenus as this rather facile argument suggests. But it is demonstrable that after the Napoleonic wars many newly-enriched men did begin to form collections, while not ceasing to be business-men. And being business-men they soon realised that forming a collection has its pitfalls. Some of them bought so-called Italian masters and quickly regretted it; others contented themselves with expensive copies of well-known pictures, playing rather dully for safety; while others again, who began by buying copies, tired of these and developed a wish to own original works of art, and combined this desire with safety by buying modern pictures. There are exceptions to this generalisation who fit into none of these categories. John Julius Angerstein, who made a fortune in the city, formed a collection of Old Masters

51

mainly on his own taste and partly with the help of Sir Thomas Lawrence, which was of a sufficiently high standard to be bought by Government in 1824 as the nucleus of the National Gallery. On the other hand, Sir John Leicester,[1] who was the heir of an old-established Cheshire family, an intimate friend of the Prince Regent and a widely travelled man, collected almost exclusively contemporary English pictures.

Of those collectors who became rich through the intensive phase of the Industrial Revolution or as a result of the Napoleonic Wars, John Sheepshanks and Robert Vernon were most characteristic. The former, a Yorkshire woollen manufacturer, bought pictures by Turner, Constable and Bonington, Stothard and Linnell, Landseer and Mulready, Wilkie, Crome and Nasmyth, and presented the entire collection to the nation in 1857, six years before his death. The latter, of very humble birth, became a horse-dealer, and made a large fortune out of army contracts during the Napoleonic Wars; he, like Sheepshanks, bought exclusively the work of his contemporaries, and was therefore not only a collector but in the true sense a patron as well, for he aimed throughout his collecting life at founding and endowing a school of modern art. He bought entirely on his own initiative, without the intervention of any dealer,[2] deliberately to benefit the artist as much as possible, and continually weeded out his collection, each rejected picture being replaced by a

[1] 6th Baronet; cr. Lord De Tabley, 1826; *d.* 1827.
[2] Vernon Heath: *Memoirs*, 1892; he was the nephew of Robert Vernon.

better example of the same artist, until in 1847 he judged it complete enough to be presented to the National Gallery, where and at the Tate Gallery most of it still is.

This, then, was the attitude of the average collector of pictures in this country a century ago; and by collector is meant a man beginning to form a collection, not an inheritor of an ancestral collection formed in the 18th century. The incentive to collection was often, as it may be in any age, the desire for rivalry and emulation. The choice of object to be collected was dictated by common-sense, since antiquities and Old Masters are dangerous and often unsatisfactory things. Many even of the 18th-century collectors had made expensive mistakes, and those who now took their place were not inclined to run the same risk; having generally made their own money, they did not wish to spend it on things they did not thoroughly understand. Contemporary painting, however, as Lady Eastlake pointed out, they could understand, and it had the additional advantage of being unassailably genuine.

An ever-increasing number of collectors abandoned the Old Masters and followed the new fashion of patronising their own contemporaries; both the Queen and the Prince did their duty in this respect, by buying the work of Wilkie, Frith, Landseer, Callcott, Francis Grant and a good many other modern painters year after year. Even so, *The Times* saw fit, in 1843, to criticise the Queen for her failure to encourage the arts and sciences. 'There is too much room', said *The Times*, 'for those frequently-heard remarks on Her Majesty's remiss-

53

ness.' And *Punch*, which repeatedly attacked the Palace,[1] even went so outrageously far as to accuse the Queen and the Prince of taking advantage of their position in buying from artists at less than the normal price. Whether the Court led or followed the new fashion, there was pretty general agreement among the collector-patrons about whom to patronise; and about whom not to patronise, also. They nearly all refrained from buying either Turner or Constable, for example. Eminent those painters might be, but that did not prevent them from seeming unsound, wrong-headed and extravagant. It was with relief and almost with unanimity that the patrons turned away from these eccentricities to purchase the landscapes of Sir Augustus Callcott, which were felt to be so much more elevating and ennobling.

The new fashion, however, though so widely followed, never quite ousted the old. While many rich men, whether peers or army contractors, began forming collections of modern pictures, the collecting of Old Masters, and especially of Old Master drawings, was still a flourishing pursuit among the descendants of the 18th-century *cognoscenti*, as well as being found occasionally among exceptional members of the new industrial or commercial rich, like Angerstein or Sir Robert Peel. The German, J. D. Passavant, whom we have already noticed, gives us a good deal of information about the public and private collections of England in 1832.[2] His obser-

[1] See esp. *Punch*, vols. 4, 6, 8, 10; 1843–5.

[2] J. D. Passavant, *Kunstreise durch England*, 1832. Translated by Elizabeth Rigby (afterwards Lady Eastlake), 1836; no translator's name appears on the title-page, but see her *Journal*, I, 216–17.

vations, though unleavened by any hint of humour
and not distinguished by accurate scholarship, are
still valuable as evidence. The primary purpose of
his visit was to examine such Raphaels as were still
in this country, since he was projecting a work on
that Master. He was, as he tells us, able to visit
most of the first collections in the country—collec-
tions which then were of an almost incredible rich-
ness. Rich though they were, however, the visitor
even at that date uttered the now familiar lamenta-
tion that within the last sixty years so many pictures
had quitted the English shores.

At a time when the masses of the people were be-
coming the objects of more attention from educa-
tionists and reformers than they had ever been
before, Passavant was very much alive to the
importance of the great private collector and to his
responsibility towards the public. He noticed that
several exhibitions had been arranged in London to
excite public interest in the work of living painters,
which was no doubt meritorious enough. But,
thought Passavant, it might also prove dangerous if
public taste should ever come to determine the
direction of art. So unformed was public taste that
in his opinion these exhibitions tended to keep the
state of art at a low ebb. He was not among those
who believed that the voice of the public was the
voice of true taste. On the contrary, he believed
that that voice was confined to a few individuals,
guiding the public and even, rather vaguely, appeal-
ing to them for co-operation; meaning, presumably,
patronage of those whom the voice of taste had
indicated as being worthy of it. 'The fact is estab-

lished', said Passavant with undeniable truth, 'that to the fostering influence of a few noble individuals the world is indebted for the finest productions of genius.'

The collecting of Old Masters might very likely have died out, and the voice of the few individuals no longer have been heard, had not the Revolutionary and Napoleonic upsettings of Europe provided a fresh stimulus; such a stimulus, for example, as the sale of the Orleans Collection.[1] After 1815 a further impetus was given by a few great importing dealers in London like Colnaghi, Buchanan, Neuwenhuys and, especially, Samuel Woodburn. Woodburn was the greatest dealer of the 19th century, and one of the most acute connoisseurs of his day. He had a leading hand in forming the collections of the Duke of Hamilton and Lord Fitzwilliam, and a large share in forming Sir Thomas Lawrence's unparalleled collection of Old Master drawings. The Antaldi collection of Raphael drawings at Urbino was bought by him, and he is said to have given £14,000 for the Dijonval collection of Old Master drawings at Paris; all the best things from both these collections were bought from him by Lawrence. This was before 1830, and therefore the history of those princely dealings is outside the scope of this book. But

[1] Sold by the Duke of Orleans in Paris, 1792. The French and Italian pictures were bought by M. Le Borde for 70,000 louis, and sold by him in London to Mr. Jeremiah Harman for £40,000; he in turn disposed of them to a syndicate composed of the Dukes of Bridgwater and Sutherland and the Earl of Carlisle. These three divided the cream of the collection among themselves, and sold the residue in London during 1799; this residue alone made about £80,000 for the syndicate.

Woodburn continued his great career till his death in 1853, with splendid establishments in London, first in Park Lane, and after 1846 at no. 134, Piccadilly. Success also enabled him to join the ranks of the country gentlemen, with the estate of Coedwgan Hall, in Radnorshire. The collectors for whom these and their confrères ransacked a devastated Europe represent the intermediate stage between the rather undiscriminating accumulations of the 18th-century Grand Tourists and the more austere *expertise* introduced by the Prince Consort and Sir Charles Eastlake. They shared certain steady and pronounced tastes, inherited from their fathers, for Guido Reni, Domenichino, the Carracci and Nicolas Poussin; and, in addition, they developed a newer taste, formed in the days of their own youth, for the masters of the Dutch School. George IV had collected these with scholarly discrimination and an unfailing eye for quality, and there is no doubt that Hobbema, the Ruysdaels, Cuyp and all the Dutch painters were more popular by far in England than anywhere else in Europe, and so indeed they remain.

In the National Portrait Gallery there are four little pictures which form a pleasant survey of connoisseurship at the end of George IV's reign. These are four studies by Peter Christoph Wonder,[1] called 'Patrons and Lovers of Art'; being dated 1826, they are a little early for this survey, but not so early that they should be ignored. These eminent connoisseurs include some, like Lord Egremont, Sir Abra-

[1] Peter Christoph Wonder, 1777–1852. *B.* at Utrecht; worked in England 1823–31, painting portraits and conversation-pieces.

57

ham Hume and the Rev. William Holwell Carr, who belonged to the older generation; while the newer generation is represented magnificently by Sir Robert Peel, that prince of collectors and of statesmen, by the Duke of Sutherland and by Lords Westminster, Aberdeen, Dover and Farnborough. All these were collectors of Old Masters, either Italian of the 16th and 17th centuries or else Dutch. Since Robert Vernon, Sir John Leicester and John Sheepshanks were all excluded from this selection of Art Lovers, it is reasonable to assume that in 1826 modern painting had not yet become a collector's affair; or rather, perhaps, that collectors of modern art had not yet been admitted to the hierarchy of connoisseurs. Yet Sir David Wilkie, the most eminent of modern painters after Turner, was included in this group.

The collection of Sir Robert Peel, the Prime Minister, and a product of the newly-industrialised north, was one of the very finest. When Passavant saw it it had just been enriched by the acquisition of Rubens's 'Chapeau de Paille'; this picture and several of the other plums of the Peel collection in due course found their way to the National Gallery, along with the Angerstein and Holwell Carr pictures. Alexander Baring, afterwards Lord Ashburton, was a notable Old Master collector. So was Lord Garvagh, who bought the 'Aldobrandini' Raphael Madonna from one of the great London dealers.[1] So also was Jeremiah Harman, of Woodford, who was concerned in the Orleans Collection

[1] National Gallery, no. 744. Bt. from Lord Garvagh 1865, and known as the Garvagh Raphael.

transaction and was interested mainly in the Dutch School; among other things, he owned Reynolds's 'Age of Innocence', which by 1840 was almost of Old Master standing. So also were Lord Northwick at Northwick Park; Blundell Weld at Ince; Lord Ward, Fuller Maitland, Davenport Bromley; Samuel Rogers, the banker and poet, with whom all the world used to go to breakfast and who bought the little Giorgione 'Man in Armour';[1] and, to extend the list no farther, George Vivian, who owned the Mantegna 'Scipio'.[2]

Few, however, were the Old Master collectors who turned their critical attention to the pre-Renaissance painters, the painters of the 15th and earlier centuries; what Lady Eastlake called 'not only the fruits of art but the germs'. No 18th-century connoisseur had ever bothered himself very much about them. Reynolds did bestow a word of qualified praise, in his *Discourses*, on Dürer (who, despite chronology and despite the 'Melancholia', is Gothic rather than Renaissance). But down to the 1830's nobody in England considered the Early Masters, as they were called before the foolish word Primitives came into use, as having any beauty or technical merit whatever. And in an age of militant Protestantism such pictures were not likely to be thought of as Improving.

The first person to show appreciation of these Early Masters was William Young Ottley, certainly one of the most perceptive connoisseurs of his day.

[1] National Gallery, no. 269. Bt. by Rogers at Benjamin West Sale 1820, and by him bequeathed to the Gallery.
[2] National Gallery, no. 902.

From about 1805, when he was thirty-five years old, till his death in 1836, Ottley was accepted as a leading authority on taste, especially with regard to Old Master drawings. In fact, his collection of drawings formed a very substantial part of Sir Thomas Lawrence's own collection, in due course and at the price of £8,000. Ottley, who became Keeper of Prints and Drawings at the British Museum, wrote much which, though to-day superseded, had considerable influence in forming scholarly taste at the time. Hard on the heels of Ottley followed Prince Albert. His collection would be remarkable even to-day, when the Early Masters are more highly esteemed than those of the Renaissance. In the 1840's, when the reverse was the case, not only was it even more remarkable than it would be now, but the very fact of its being formed at all marks a definite point in the history of taste. Admittedly, in the history of English taste, Ottley, as an Englishman, is more to the point than Prince Albert; but in the history of taste in England the Prince played a part of the first importance.

The history of the Prince's collection is partly that of his relation's, Prince Ludwig-Kraft-Ernst of Oetingen-Wallerstein. When, in 1848, the latter found himself compelled to sell his collection, he sent the pictures to London on Prince Albert's advice, and they were put on view at Kensington Palace. A catalogue was compiled by Waagen; and the admirers of Carlo Dolci, Parmigianino and the Carracci, of Teniers, Cuyp and Brouwer, found themselves contemplating the Schools of Cologne, Van Eyck and Roger van der Weyden. There were

no purchasers. The Prince thereupon bought the entire collection himself. He may in part have been impelled by the wish to help a poor relation whose hopes he had so vainly raised. But he certainly had a stronger motive than that: to educate the taste of his adopted country in a direction of which it was yet ignorant. After his death, the Queen carried out his wishes by presenting the best of his pictures to the National Gallery.[1]

The Prince's collection [2] consisted by no means only of the pictures from Schloss Wallerstein. He occasionally bought at Christie's, as for example the Cranach triptych, now in the National Gallery on loan from the King, which was then attributed to Grunewald. But the most important of his purchases were those of the early Italian Schools; the famous Duccio triptych, the Fra Angelico 'St. Peter Martyr', and 'Madonna and Child', the central panel of the Gentile da Fabriano altarpiece and several other extremely important early pictures which hardly anyone else at that time would have dreamt of buying. These Italian purchases were made shortly before the Prince bought the Schloss Wallerstein collection. The years 1846 and 1847 saw the most important acquisitions, most of them bought by the Prince, but a few bought by the Queen and given to him by her in August, 1847, as a birthday present of which he was probably not ignorant beforehand. The Prince's chief agents in Italy seem to have been

[1] See *National Gallery Annual Report*, 1863. The pictures included in the Queen's gift are nos. 701–22.

[2] See Sir Lionel Cust : *Pictures in the Royal Collection*, 1911. Also Catalogue of Exhibition of the King's Pictures, Royal Academy, 1946–7.

Grüner, who afterwards acted as Eastlake's travel-
ling agent for the National Gallery, and Warner
Ottley, a relation of William Young Ottley.

The collector collects, and the patron patronises
or, in Passavant's words, 'fosters'; but the con-
noisseur need do neither. There have been persons
who combined in themselves all three functions, but
they are exceptional; they are met with most fre-
quently during the first three or four decades of the
19th century, but even then they were not common.
One could be either a collector or a patron or both,
and not necessarily possess connoisseurship. In a
world through which dealers such as the Buchan-
ans or Woodburns were there to act as guides to the
would-be collector, the only essential requisite was
money. Taste in addition was, of course, as desirable
in a collector as it had been in the 18th century, but
it was, as it always had been and always will be, the
birthright of a limited number. The man of taste
could be a collector if he chose, but the collector
need not necessarily be, in the 19th century, a man
of taste. The man of taste was the man with an eye
for quality, who knew a good picture or a good
building when he saw one, whoever might be the
painter or the architect. The collector was the man
who, knowing one School from another and knowing
the styles of the Masters, knew also what to buy—
what fashion to follow.

The connoisseurs, in the form of the professional
art-historians, are a 19th-century product. In their
present highly specialised developement they are a
product of the German 19th century, but they were
invented in England; they were invented, in fact, by

Eastlake. Descending from the 18th-century *cogno-scenti* and *dilettanti*, they at first differed from them only in degree, and not essentially in kind. The *cognoscenti* looked at a picture either as being the visible manifestation of a line of thought or as arousing certain emotions. The Eastlake type of connoisseur continued to do either of those things, and in addition brought to bear on the picture a new apparatus of scholarship. He was interested in facts as well as in traditions, but, though becoming a scholar, he remained a humanist. Eastlake, Lord Lindsay and the earlier Ruskin are examples of the humanist-connoisseur. But in the next generation connoisseurship began to lose its humanistic quali-ties and became scientific; Morelli, Cavalcaselle and Joseph Archer Crowe are examples of the type.

It was quite early in Eastlake's career, when he was still primarily a painter, that he became con-cerned to make connoisseurship a more exact study than it had hitherto been. His views on this first took shape as early as 1835, in his paper 'How to Observe'. Eastlake professed two purposes in this essay: first, to define the connoisseur, and, secondly, to determine his functions. His answer to the first was simple and clear: the connoisseur is he who professes to *know*, the man who is concerned with facts rather than with truths, with results rather than causes. His functions, put equally clearly by Eastlake, are to direct his knowledge so that he can not only recog-nise excellence when he sees it but also discover the nature and principles of that excellence. Using *connoisseur* in that sense, and *amateur* in the sense of a lover of art, Eastlake formulated the law which

63

was to govern the whole of his public career: that the knowledge of the connoisseur and the imagination of the amateur will, when combined, form a judgement making the nearest approach to a truth which questions of Taste permit.

The terms in which this law is expressed were further defined, and their definition gives a deeper insight into the young Eastlake's mind and reveals the foundation of his later authority. Knowledge, he insisted, is factual and must be based on what appear to be dry and uninviting researches. Imagination, the quality of the amateur, he believed to be derived from the associations of Tradition and History—it is typical of Eastlake to commit himself no farther than that. Judgement, he admitted, may equally be influenced by authority; either by the concurrence of many,' ratified by time; or by the admiration of men whose opinion posterity has agreed to accept.[1] The basic Eastlake in all this lies, surely, in the contention that only a close and erudite acquaintance with facts can lead towards an understanding of truths.

Eastlake combined in himself his own connoisseur and his own amateur. As the latter and as a painter, he had already spoken in 1828,[2] when he stated views on the relation between Art and Nature which were far ahead of his age; they were, indeed, more in tune with the 17th century. There was, he believed, a necessity for generalising in art and for omitting all useless detail. In the painting of Nature, therefore,

[1] Eastlake's examples of such men form a curious short list: Horace, Catullus, Michael Angelo and Byron.
[2] Quoted by Lady Eastlake in her *Memoir of Sir Charles Eastlake*, 1870.

the great question he asked was, What is the general character of the impression received, and what are its chief causes? The admirable picture is that which translates a feeling, not that which copies Nature in detail, a point which he drove home with the words, 'An imitation so close as to produce illusion to the eye would be precisely that which should be considered defective'. As the connoisseur, Eastlake was to speak with notable authority in later years, when he showed himself a master of all the erudition he demanded in others.[1] As the connoisseur combined with the amateur—that is, as the man of judgement —he emerged into authority in 1841. In that year, according to Lady Eastlake, Sir Robert Peel, as a Trustee of the National Gallery, proposed that a Committee of artists should be consulted before important purchases were made. Peel realised that, while some of his fellow-Trustees possessed knowledge and experience of pictures, those who did not had as yet no consciousness of their ignorance; and he felt evidently, if rather oddly, that painters would necessarily make reliable connoisseurs. The committee thus appointed consisted of Sir Martin Archer Shee, as President of the Royal Academy, Etty, Henry Howard, Callcott and Eastlake. All were chosen for their eminence as artists, but Eastlake gave his opinions as an experienced scholar, and not as an artist. The result was that Eastlake became at once, and remained for the rest of his life, the recognised expert. He came to the notice of the Prince, and very soon had to give up painting alto-

[1] Eastlake, *Materials for a History of Oil-Painting*, 1848. Reviewed by Ruskin, *Quarterly Review*, vol. 82.

gether; possibly this may have been a loss to British art, but it was certainly to be of incalculable future benefit to the National Gallery.

Unfamiliarity with early Italian painting was not limited to the board-room of the National Gallery. Apart from a few collectors who were also *cognoscenti* of unusual perceptiveness, such unfamiliarity was almost universal even among professed students in the 1820's, 1830's and well into the 1840's. As late as 1857, the taste for the early Italians could be described as 'comparatively new'.[1] One of the first serious collectors of the Early Masters, both Italian and Flemish, had been Thomas Roscoe, of Liverpool, the historian of the Medici. The most important of his pictures, including the famous Simone Martini, after his death in 1831 became the nucleus of the Liverpool Royal Institution collection. Another of the pioneers, as we have seen, was William Young Ottley, whose collection was dispersed in 1847, much of it being bought for the Gallery of Berlin. Of him, the anonymous authority of 1857 quoted above said, 'Ottley, himself an earnest student of the earlier periods of Italian art, had formed a small but very authentic collection of primitive works'. This early use of the unfortunate word 'primitive' does not make it the more respectable. It does, however, illustrate the spirit in which the connoisseurs then approached the early Schools, and in which many people still do.

[1] *Handbook to the Paintings by Ancient Masters in the Art Exhibition*, Manchester, 1857. Published first as articles in the *Manchester Guardian*, and later as a handbook brought-out by Messrs. Bradbury and Evans.

This theory of art presupposed a continuous progress in the direction of scientific conquest, in which each stage was an improvement on its predecessors; it completely ignored the relation between art at any stage and the spiritual, mystical or intellectual demands which it served. The mid-19th century, judging history by its own standards, saw those demands as constants and not as variables. Since the constant by which excellence was judged by most people was fixed in the Renaissance, anything earlier than that seemed primitive and could have no absolute merit of its own. Even the most austere and majestic Byzantine mosaic or Sienese altarpiece could, as we have seen, be described by Lindsay, Palgrave or the Eastlakes as 'child-like', and was really perhaps thought of as not only child-like, but also childish. The very use of such expressions as 'the dawn of art' or 'the childhood of art' shows a concept of art as a process continually advancing towards perfection and to be judged by one hall-marked standard. Of all his contemporaries, Lord Lindsay came nearest—nearer even than Eastlake—to seeing that art is not a continuous process, but a continuous series of processes, each having a full developement and each to be judged by a standard proper to itself; to be judged thus, that is to say, when it was a question of assessing the merit or excellence of a particular work of art. When, on the other hand, it was a question of interpreting a work of art in relation to human experience, spiritual or material, then both the particular-variable and also the general-constant standards might be applied. This was seldom done, but Lindsay attempted it and

Ruskin knew enough about it to make a very fair estimate of Lindsay's attempt. Lindsay's constant was the spiritual yardstick of the Christian faith, and it may be added, incidentally, that he was among the few English writers in the 'forties who did not regard pre-Reformation and post-Reformation values as essentially different; his variables were standards based on his own experience and erudition in works of art all over Italy.

There are plenty of instances which show how profoundly the effects of the Reformation were apt to affect art-historians in the 'forties. Ruskin himself is, of course, full of the violence engendered by a strictly Protestant upbringing. But he, partly by the violence of his feelings, partly by the splendour of his eloquence, is immortally justified. A more commonplace and, for that very reason, more important illustration is provided by Mrs. Merrifield.[1] She was one of those early-Victorian women who, having a taste for learning, chose to defy convention by avowing it in print; she was certainly not a Mrs. Grote; she was not an Agnes Strickland nor an Elizabeth Eastlake. Mrs. Merrifield, however, was the first English translator of Cennino Cennini's *Treatise on Painting*. The manuscript had been discovered in the Vatican Library in 1822, and had been published that year in Italian; Mrs. Merrifield's translation appeared in 1844. The Treatise was known in the Italian edition to Eastlake and also,

[1] Mary Philadelphia Merrifield, 1789–1877. In addition to her translation of Cennini, she wrote a two-volume work on the techniques of oil, fresco, mosaic and miniature-painting, 1849. She also produced a *Handbook to Brighton*, 1857.

more surprisingly, to Benjamin Robert Haydon.[1]
Mrs. Merrifield was a highly-educated woman, and a
cultured student of her subject, but even she could
only think of a 15th-century Italian in terms of
19th-century English ritualists; and when discussing
the Florence of the Medici, had to drag in a hit at
Newman and the Oxford Movement. Of Cennini's
personal character, she wrote, 'An artist, an enthus-
iast, a mariolater with Roman Catholic piety enough
for Lord John Manners or the hagiologists of Little-
more, but no mystical discourser on æsthetics'.
That odd outburst is remarkably interesting. Ad-
mittedly, the ritualistic tastes of Lord John Manners
are now of interest only to those who are interested
in Lord John himself. But the reference to the com-
munity at Littlemore, and their notorious devotion
to saints, is a direct link with John Henry Newman
and is therefore a part of 19th-century history. Mrs.
Merrifield's denial that Cennini was a mystical dis-
courser on æsthetics means practically nothing; but
it shows the mistrust with which the newly-imported
science was regarded and the faintly derogatory
flavour which the word itself still carried. As to
mariolatry, there is no doubt that the majority of
educated people then, and for a couple of decades to
come, were quite unable to dissociate a picture of,
say, the Virgin Mary or the Immaculate Concep-
tion from their own Protestant prejudices on those
subjects. Doctrines which only appeared at the
Reformation were extended to have a retro-active
effect, so that adoration of the Madonna in 15th-

[1] Both of them quoted it in evidence before the Royal Com-
mission on the Fine Arts.

69

century Italy was felt to be as impious as it would be in 19th-century Birmingham. Even Lindsay sometimes found it necessary almost to excuse an early-Italian master for not having been a Protestant.

Lord Lindsay [1] published his great work on Christian Art in 1847, when he was aged thirty-five and was already acknowledged as an historian and as an expounder of Christian philosophy. The importance of this work was immediately recognised, and the editor of the influential *Quarterly Review*, J. G. Lockhart, entrusted the task of reviewing it to Ruskin, who was then aged twenty-eight.[2] The book must have been formidable even in that age of substantial intellectual appetites, and it is now almost forgotten.[3] But it is, nevertheless, an essential document in mid-19th-century literature, as illuminating the metaphysical aspect of æsthetic criticism and presenting another side of the new connoisseurship. Further, it reveals to us that profound belief in Christianity which inspired at least as much of mid-19th-century thought as did religious doubt and scientific scepticism. The *History of Christian Art* is in form a fusion of historical narrative with metaphysical interpretation; it is classified according to Schools and Masters from the 4th to the 19th centuries, and is arranged on a system of analogies drawn from the spiritual life and from Christian dogma.

[1] Alexander Lindsay, Lord Lindsay and later 25th Earl of Crawford; *Sketches of the History of Christian Art*, 3 vols., 1847.

[2] *Quarterly Review*, vol. 81, 1847.

[3] For a detailed discussion see a paper by the present writer in the *Journal of the Warburg and Courtauld Institutes*, vol. X, 1947.

The classification of Schools and Masters adopted by Lindsay contained little that could have upset any student of history or any connoisseur. What did seriously upset his critics was the philosophical principle by which the facts were interpreted or, as Ruskin thought, twisted. This general principle can, though it is rather unfair to do so, be summarised. The argument was based on an analogy between the Trinity and the evolution of the human spirit, which implied, in Lindsay's own words, 'the union of Beauty and Strength in the body; the balance of Imagination and Reason in the intellect; and the submission of passions and pride to the Will of God in the spirit'. Out of these three elements of Sense, Intellect and Spirit, Lindsay compounded his own intricate theory of man and his art, by which the three Arts of architecture, sculpture and painting, considered as a manifestation of God through the intellect of man, are presented as a shadow on earth of the Trinity.

Ruskin's long and analytical critique is of equal importance with the book itself, especially if the two be taken together as parts of a whole; it also has a more general interest as an unfamiliar piece of early Ruskin.[1] He did not at all approve of Lindsay's philosophy, or rather of the analogies by which it was presented. Indeed, Ruskin called it Lord Lindsay's three-masted vessel, and exclaimed in exasperation, 'We are utterly tired of this triplicity'. So, it must be admitted, would the modern reader become quite soon. By far the most interesting parts

[1] Reprinted in the volume of miscellaneous articles by Ruskin called *On the Old Road*, 1885.

of the *History of Christian Art* to us are not Lindsay's Christological theories, but his critical estimates of Schools and Masters. They are the views of a scholarly and widely travelled man, who was ahead of most men of his day in perceptiveness. The opinions of such men are always valuable as checks on our own, and a hundred years is about the right interval for reopening old cupboards and revaluing their contents.

Lindsay's place was undoubtedly in the advance-guard of connoisseurs and critics, along with the Prince, Ottley, Fuller Maitland, Woodburn and the Eastlakes, especially in his approach to the Early Masters. Although he was among those who still regarded such painters as 'Primitives' and not as mature masters of their own convention, Lindsay nevertheless could dissent courageously from the accepted views of his day. For example, he took a far more seriously considered and favourable view of Byzantine civilisation than was then generally held, maintaining that the influence of Byzantium on modern Europe was always under-rated. Again, Lindsay was at first almost alone in regarding Giotto, instead of Cimabue, as the fountain-head of Florentine art; and in regarding the later Giottesque followers as trying to re-animate a faith which had become dim and corrupted, and to elevate it once more to the high 12th-century level.

Lindsay's work had the immediate effect of attracting far wider attention to early Italian painting than had been paid before. And the result of that, in turn, was the discovery that most of such painting as still survived in Italy was perishing from

PLATE 5

H.R.H. Prince Albert
Lithograph by R. J. Lane, 1840

National Portrait Gallery.

John Ruskin
Drawing by G. Richmond, c. 1843

PLATE 6

CHARLES J. MONTGOMERIE LAMB, AS HE APPEARED AT THE EGLINTON
TOURNAMENT
Painting by Sir F. Grant, 1846, in possession of his son, Sir C. A. Lamb, Bt.

neglect. Lindsay himself had pointed this out in the Postscriptum to his work, appealing to the several rulers of the Italian States to rescue their treasures before it was too late. The important part of Lindsay's indictment is that he accused of vandalism not only the 19th century, but the past three centuries as well. 'These frescoes', he wrote, 'either perishing unheeded or lying entombed beneath the whitewash of barbarism . . . slumbering beneath the daubs of the Bronzinos and Zuccheros, the Vasaris and Perino del Vagas.' Past destruction was perhaps fully realised only by the historians and students of art, but present neglect was only too evident to every traveller.

As the result, largely, of Lindsay's work, the Arundel Society was founded in 1848, its founders including Lord Lindsay himself, the Marquess of Lansdowne, Lord Herbert of Lea, Samuel Rogers, Layard and Ruskin. The objects of the Society were to preserve some record of early paintings, chiefly Italian frescoes, and to diffuse a knowledge of them, in the hope that 'greater familiarity with the severe and purer styles of earlier Art would divert the public taste from works that were meretricious and puerile, and elevate the tone of our national School of Paintings and Sculpture'. Here is the first authoritative protest against the state into which modern art had fallen in the 'forties, and, looking forward one year, it might be regarded as heralding the birth of the Pre-Raphaelite Brotherhood. Probably it had no direct influence on the Brotherhood to start with, for that had come into being before the first publications of the Arundel Society appeared.

Those first publications were the Fra Angelico frescoes in the S. Lorenzo Chapel of the Vatican; these appeared between 1849 and 1852, and were followed by the Giotto frescoes in the Arena Chapel at Padua between 1852 and 1856; these were in turn followed by the Masaccio frescoes in the Carmine at Florence. The method of record was by water-colour facsimiles, of astonishing fidelity, made by various artists specially commissioned by the Society, which were reproduced for subscribers by the process of chromo-lithography.[1] Although this great and important undertaking had little, if any, effect on English art beyond the short-lived Pre-Raphaelite Movement, it certainly had immense influence in drawing attention to the neglected beauties of the earlier Masters—to what Lady Eastlake called 'the fast-vanishing remains of Giotto, Botticelli and Orcagna'.

[1] The Arundel Society was voluntarily wound-up on 31st December 1897, having come to the conclusion that its usefulness was achieved; also because chromo-lithography no longer enjoyed public favour. In the fifty years of its existence the Society issued chromos of 119 frescoes and sixty-eight panel-paintings, representing fifty-eight different Masters, the great majority Italian. Not all the facsimiles made were ever published, but all were deposited in the National Gallery when the Society was dissolved. Drawings made down to 1855 were exhibited that year at the Crystal Palace at Sydenham.

ARCHITECTURAL CRITICS AND
THE OLDEN-TIME

THE students of art-history might well have become
confused by the zeal with which controversial
writers praised or condemned a School. It could
hardly be otherwise when they found Lord Lindsay
describing early Italian painting as Christian, and
Palgrave describing it as not Christian at all but
simply Marian. So, too, the student of architectural
criticism, eager for guidance, soon found himself
pulled hither and thither by the warring critics.
There were plenty from whose writings he could
choose; the now-forgotten George Vivian, for in-
stance, or Palgrave, again, who could seldom keep
away from cultural controversy. George Vivian was
one of several men of means and of taste, with in
addition scholarly and critical minds, who wrote
much criticism in the 1830's and early 1840's that
is very well worth reading, but whose words have
long since been drowned in the flood that was to
pour from the pen of Ruskin. J. S. Morritt, Henry
Gally Knight and Thomas Hope of Deepdene
were others, and, in addition, there were the pro-
fessional critic-historians, like Gwilt and Fergusson,
to say nothing of the professional critic-architects,
like Pugin or Barry. When professional architects
themselves were disputing vigorously in the Battle
of the Styles—that long dispute between the Classical

and its alternatives—the critics found an audience both ready for and interested in their arguments for and against this or that style in the past and this or that revival in the present.

The familiar 18th-century gentleman of Taste, as might be expected, survived freely into the Materialist Age. He was generally a strong character, marked by strong characteristics, and if his early-19th-century son was not quite so pronounced a figure on the scene he yet put up a vigorous fight for survival. Thomas Hope of Deepdene, for example, born in 1770 and dying in 1831, and thus dividing his life exactly in its span between the two centuries, belonged in spirit more to the 18th than the 19th. As the Earl of Burlington, belonging to the aristocracy of blood, had taken to architecture as an amateur and had acquired a professional reputation, so Thomas Hope, belonging to the aristocracy of commerce, had taken to furniture-designing in the same way and had also acquired a professional reputation. Further, having travelled as a young man in Egypt, Greece, Turkey and Syria, he had acquired the obligatory qualifications for setting up as a consultant in Taste and an occasional writer on affairs of architectural controversy.[1]

J. S. Morritt, two years younger than Hope, was another landed gentleman of taste. More fully described as John Bacon Sawrey Morritt of Rokeby Park, Yorkshire, he differed from Thomas Hope in being of ancient lineage, but resembled him (and indeed many other of his rich young contemporaries)

[1] Thomas Hope's *Historical Essay on Architecture* was published posthumously in 1835.

76

in having travelled much in Greece and Asia Minor during the mid-1790's. That experience enabled him to indulge later in fierce controversy with the classical historian Jacob Bryant about the position, and even the existence, of Troy. It was probably due to his long friendship with Sir Walter Scott that Morritt became so frequent a contributor to the *Quarterly Review*, but he really did speak with some authority on architecture and ancient sculpture; doubtless, also, he fully earned his membership of the Dilettanti Society. Henry Gally Knight, another much-respected writer on architecture from among the ranks of the landed gentry, a fellow-Yorkshire squire with Morritt, and fifteen years his junior, also conformed to type by travelling in Spain, Greece, Egypt and Palestine. He achieved, however, a different kind of fame by being made, while sea-sick, the subject of a brilliant punning application of a Horation tag by that great scholar and procon-sul, Lord Wellesley, Wellington's brother.[1] Gally Knight's tastes were wider than those of Hope or Morritt, ranging from late-classic to the 15th century, and as a critic he probably carried more weight than either of them.

Gally Knight wrote an important history of Ecclesiastical Architecture in Italy, which received the compliment of a long critique in the *Quarterly* by Sir Francis Palgrave.[2] The review was less tolerant

[1] '. . . *Decedit aurata triremi, et*
 Post equitem sedet atra cura.'
As *trireme* means a galley, and *eques* a knight, this is not a bad pun.
[2] *Quarterly Review*, vol. 75 (1845). Review of Henry Gally Knight's *Ecclesiastical Architecture of Italy, 1842–4*.

than the book itself, for Palgrave here was evidently all for the medieval and the late-romanesque, and had but little use for the later classical; and as for modern revivals, the Gothic was the only permissible style for churches, while the Grecian was clearly abhorrent. 'The Basilica', wrote Palgrave, 'is the remote lineal progenitor of the Gothic style of all ecclesiastical architecture, properly so called, of modern times—for we exclude such monstrosities as the Madeleine at Paris.' George Vivian, by contrast, was far less narrow in his views. He was no Grecian to the exclusion of the Palladian; he was no hater of the Gothic, though he hated the Gothic revivalists; he did, however, dislike 'Norman ugliness' as much as Jacobean, that 'bastard style of King James'. More important than Vivian's personal likes or dislikes was his diagnosis of the disease which afflicted the architecture of the 19th century in all but its major achievements. This was lack of authoritative guidance, the absence of control by an enlightened few over both the practice and the economics of the profession, by whose example a Correct, whatever form it might take, would impose itself on the general. 'At present', wrote Vivian, 'all is unsettled—each professor has his idol.' Norman ugliness, King James, the Hindoo and the Egyptian were cited, and then he continued, 'A large class are for the re-establishment of Gothic, blind to the fact that the spirit of the style and the ability so to build have departed from us. There are others who can endure the ravings of Borromini.'

The confusion deplored by Vivian can be illustrated by published opinions of two of these pro-

fessed arbiters. A. W. Hakewill[1] could see in West-minster Abbey, Westminster Hall and Henry VII's Chapel but a collection of noxious weeds, while the passionately Gothic Pugin could only regret the colossal mistake of Sir Christopher Wren in recon-structing St. Paul's Cathedral. Thomas Hope[2] up-held Palladio, for the purity and simplicity of his style, as the only architect to emulate. But George Vivian, on the other hand, when confronted with the last English adaptation of Palladianism, as in the great Brighton and Regent's Park Terraces, found himself unable to speak of them with too much reprobation. 'Such an exhibition as these present', he exclaimed, 'is a positive disgrace to the country and to the age in which they have been reared.'

In critical theory, as we thus see, and in architec-tural practice, as we shall see in a later chapter, the Battle of the Styles was beginning to cause a con-fused welter of different tastes to spring up. On the whole, the only point on which all critics agreed was that architecture was in a bad way and that the only chance of evolving a style worthy of the age lay in an appeal to the past. This makes a sharp contrast with the attitude towards painting. However trivial in content the art of the 1830's and 1840's may seem to a later age, it did possess a considerable feeling for the present and the actual, and the critics were con-tinually praising in the highest terms the modern school of painting. They never talked in such terms about the modern school of architecture, and indeed

[1] Arthur William Hakewill, 1808–56: *An Apology for the Architectural Monstrosities of London*, 1835.
[2] Thomas Hope: *History of Architecture*, op. cit.

they were prone to mention it only to point out its non-existence.

Throughout the reign of William IV, and for about the first decade of that of Victoria, there was on the whole a measure of agreement as to what periods of the past ought to be revived for what purposes. It was generally felt that for large public buildings the Grecian, for domestic buildings the Jacobean and for churches the Gothic, were the most suitable tastes. Despite the growing taste for an all-purpose Gothic, and the survival of the early 19th-century Picturesque taste, the flavour of the 1830's was more neo-Classic than Gothic. Sir John Soane died in 1837, and so did William IV. But while the death of the latter brought forward a new personality that was to dominate her own particular stage for the next sixty years, Soane's death meant the disappearance of an established authority that had, in successive personalities, been dominant for a century. Soane was the last of the great architect-disciplinarians. Since discipline is founded on reason (though not always rational in its application), its disappearance leaves the stage free for emotion. The stage, in other words, was ready to be cleared for the appearance of Ruskin's *Seven Lamps*.

That appearance, however, did not occur until more than ten years after the death of Soane. The classic discipline continued, though transformed and borrowed from other sources, in the practice of William Wilkins and, in his early work, of Charles Barry; also notably in George Basevi in such achievements as the Fitzwilliam Museum at Cambridge and Belgrave Square in London. It was

80

preached, as we have seen, by Hope, J. S. Morritt and George Vivian; and also by Joseph Gwilt.[1] Gwilt, who came of a family of architects as dynastic as that of the Wyatts, but less celebrated, himself practised as an architect with considerable success. He increased his reputation by translating Vitruvius in 1826, but he really lives in the history of his art by his *Encyclopædia of Architecture*, a work of immensely wide reference and great learning intended solely for professional study. His *Architectural Criticism*, generally described as a minor work, was addressed to a wider public. Avowedly controversial, one of its objects was to counteract what he considered the bad influence of the German classic school.

Gwilt's *Architectural Criticism* was concerned mainly with contemporary architecture, and, moreover, with the neo-classical aspect of it almost to the exclusion of the Gothic. Indeed, a modern reader might easily assume that no Gothic-revival buildings of any kind were being erected during the 1830's. The particular interest that his little book has for us lies in the passages where he discusses the architects of the 18th century. As most people of the 1930's and 1940's find any taste of the 19th century later than the Regency to be ugly, and even ludicrous, precisely so did most people of the 1830's and 1840's find any taste of the 18th century later than Wren to be ugly and boring; particularly boring. What to the 18th century seemed to be elegant, harmonious, well-proportioned and correct, seemed to the 19th

[1] Joseph Gwilt, 1784–1863: *Elements of Architectural Criticism*, 1837.

81

century, by an inevitable and indeed natural re-
action, to be poor, flat, repetitive and depressing.
It is unusual, therefore, to find a critic as early as
1837 who could not only discuss seriously the
domestic architecture of the entire preceding cen-
tury, but who had a good word for quite a lot of it.

Gwilt had a good word to say not only for Wren,
but also, and far more surprisingly, for Vanbrugh,
Lord Burlington, Sir William Chambers and 'Cap-
ability' Brown. On the other hand, he worked in a
sharp attack on Robert Adam and his brothers,
which is salutary reading for us at a time when those
great decorators tend to be somewhat undiscriminat-
ingly admired. 'If this age', wrote Gwilt, 'has not
produced such specimens as graced the beginning of
the last century, it must be confessed that a mighty
stride has been made since the miserable taste of the
Adams was the object of unbounded patronage by
the fashionable world.' To most men of the 1830's,
except the 'praeter-pluperfect Goth' Pugin, the
great Terraces and the Villas of Nash, the Belgravia
of George Basevi, the Pimlico of William Cubitt
and the then-recently demolished Carlton House
of Henry Holland did indeed constitute a mighty
stride forward from the Adelphi of the Adams.

Surprising though it may be to find Gwilt de-
fending, say, Vanbrugh, it is even more surprising to
find him defending Horace Walpole. Remembering
how different the structure of 18th-century society
already was from that of the late 1830's, we should
hardly expect to find the distinguished amateur
hailed as a welcome intruder into the professional
world, or to see Horace Walpole, Lord Burlington

and Dean Aldrich described as 'men of learning, who gave to the world assurance that they were something more than mere prattlers on art'. As a critic of painting and architecture, both of the present and of the past, Horace Walpole has not even yet been given his full due, and it is therefore the more remarkable to find that he had a defender over a hundred years ago and about forty years after his death; that period at which men's posthumous reputations tend to be at their lowest valuations. Gwilt, however, was compelled to admit that the distinguished amateurs were no longer as conspicuous as they used to be. 'The fact is', he said, 'that the all-absorbing influence of party and politics in this country abstracts them too much from all other pursuits.' That point has been made also by several modern writers on the 19th century. It is not altogether convincing, since it may be urged that party and politics absorbed the gentlemen of the 18th century at least as much as those of the 19th. However, though the reason may not be that put forward by Gwilt, it is evident that neither the Burlington nor the Walpole types of amateur exercised influence any longer; though both, of course, existed as they always have done in England.

When Gwilt discussed contemporary architecture he was peculiarly harsh towards the much-admired German neo-Classic of Berlin and Munich. He admitted that Schinkel had some merits, but maintained that when compared with the work of English or French architects there was not a building by him in Berlin nor by Klenze in Munich worth noticing, either for design or in execution. Gwilt

probably had in mind, for French architecture, the Madeleine and the Bourse in Paris; among the English architects he was certainly thinking of George Basevi and Charles Robert Cockerell. Gwilt supported that opinion by a detailed, pedantic and destructive criticism of Klenze's Glyptothek and Pinakothek in Munich, which he found barbarous in detail and lacking any proper relationship of the parts.

It is amusing to compare this Englishman's opinion of the architect who created the Berlin of Frederick-William III, with a German's opinion of the architect who created the London of George IV. Passavant, in 1832, said of John Nash that, being the favourite architect of the late King, he wasted enormous sums of the public money in a manner greatly detrimental to the beauty of the capital. Passavant, however, admired the restoration, addition and improvements at Windsor Castle carried out for George IV by Jeffry Wyatt (afterwards Sir Jeffry Wyatville). 'These', he exclaimed, 'are executed on a scale of the greatest magnificence and in such perfect keeping with the antique character of the building, that Windsor Castle may now be considered as the finest royal residence in England.' Not content with that, Passavant further avowed that Wyatville had succeeded in restoring Windsor Castle with a magnificence and purity of taste which even its earlier period had never equalled. By contrast with this foreigner's enthusiasm, all that J. S. Morritt could say of the same work was 'the dull pranks of Mr. Wyatt at Windsor Castle'.

It is perhaps a little difficult to know exactly what

J. S. Morritt did like. Classical purist though he was, he yet greatly disliked uniformity, that chaste uniformity of Bath and the growing watering-places where 'long rows of shops and houses are tortured into strict uniformity, exactly of the same height, with the same thin slices of pilasters, the same little flourishes of ornament'. Passavant, incidentally, greatly appreciated these English watering-places on the sensible ground of their undoubted physical comfort. One has only, he thinks, to visit such a place as Bath to appreciate the inconvenience suffered by an Englishman in exchanging his own home for the inferior accommodations of the Continent. Dislike of uniformity in urban architecture was becoming general during the 1830's, and did not necessarily either conflict with a taste for the classical or imply a taste for the varieties of the romantic. For example, Richard Ford[1] greatly admired the architectural feeling of the later 18th century, but bitterly deplored the war-time necessities of taxation and controls, which, after 1793, 'defined the size of bricks and narrowed our windows, rendering it imperative to consult economy in form, size and ornament'. This resulted in what Ford described as the melancholy dullness of Baker Street.

Thus the critics criticised and analysed; and the architects, until the century was half gone, went on building Grecian for public buildings and Medieval for churches. Both modes, since they were revivalist, contained plenty of sham, but that, in the age of the Utilitarians and the Materialists, was not by itself

[1] Richard Ford, 1796–1858; famous as author of the *Handbook on Spain.*

in any way to be condemned. Since in the end the Materialists had their will, and since it is easier to be effective in sham Gothic than in sham Grecian, it was the Gothic that prevailed. And it was these same victorious Materialists to whom the young Ruskin addressed his *Seven Lamps*.[1]

In 1849, as in 1835, there were many would-be arbiters, but none who had yet succeeded in making himself listened to above all others. Nobody had yet managed to convince his readers or his listeners that art and architecture really and fundamentally mattered; that it was useless for theorists to squabble about styles in art if most people remained indifferent to the very existence of art itself. In 1849 the Pre-Raphaelite Brotherhood set out to convince the world that painting was a serious task of the spirit, and not merely an ornament on the surface of life; and Ruskin in the same year set out to convince the world that in architecture man made his nearest approach to the Angels and might almost justify his claim to have been created in the likeness of God. If we think to-day that his Lamps shed a distorting light which misled two generations, we are making the facile mistake of estimating the thought of one age from the standpoint of our own. There is no getting away from it, Ruskin's earlier thought did profoundly impress and affect his own and the succeeding generations. It impressed by the minuteness and detail of his instances, and made its effect by the extraordinary intensity with which, it seemed, he actually experienced every object he saw; an equal intensity, whether it were of admiration or of

[1] Ruskin: *The Seven Lamps of Architecture*, published 1849.

abhorrence. As if he were himself one of the Pre-Raphaelite Brothers, Ruskin was captivated by symbolism. The lamps, therefore, which were to guide the Builder up to the spiritual heights of Architecture were of the sacred number, seven; they were those of Sacrifice, Truth, Power, Beauty, Life, Memory, Obedience.

Each of these seven virtues was defined by Ruskin in terms of Architectural criticism. Sacrifice, for example, meant a devoted use of ornament for its own sake, and not for the sake of the building ornamented. Truth meant a candid use of materials which were in fact what they proclaimed themselves to be and were not imitations. Power meant using the interplay of light and shadow to emphasise mass and size. Beauty, which is the longest and most involved of the Lamps, was an elaboration of Ruskin's central doctrine that beauty in architecture derives from the imitation or adaptation of forms common in Nature. With the fifth Lamp, Life, there appeared a hint of that pessimism which was to be much more evident in the next two Lamps. Life was defined as vitality, imagination and sensibility, but only as they were to be found in the architecture of the past. There was no reference to original contemporary work beyond one sentence which expressed grave doubt as to whether contemporary architecture was really anything more than 'a rattling of bones'.

The sixth and seventh Lamps, Memory and Obedience, continued this mood of pessimism about the present. Memory was perhaps the less despondent of the two, since it more or less ignored the present and linked the past directly with the future

in its two main contentions: the necessity of building to last for centuries, and need for preservation of the monuments of the past. The first duty was to be performed by no less a means than remembering that a building is not to be considered as in its prime until four or five centuries have passed over it. Ruskin allowed himself no half-measures in his views and allowed none to architects or builders. He could not, he said, but think it an evil sign of a people when their houses are built to last for one generation only. As to the second duty—towards things of the past— that meant, in simple language, take proper care of your monuments and you will not need to restore them; whereas, as Ruskin saw it, the modern principle seemed to be to neglect buildings first and restore them afterwards. That, though very true and needful to be said, is a truth unfortunately not limited to the 1840's. Obedience, the seventh and last Lamp, is to us the most interesting and revealing of them all. It preached obedience to some universally enforced rule; Uniformity, in other words. But this Lamp is also a confession of Ruskin as a revivalist, hopeless of evolving any new or specifically contemporary style. It is profoundly pessimistic.

Architecture, Ruskin at this time believed, would languish until an universal system of form and workmanship be everywhere adopted and enforced. This in turn meant that both architects and the public must choose a style and use it universally. Choose a style, not evolve one. 'We want no new style of architecture,' proclaimed Ruskin; 'the forms of architecture already known are good enough for us.'

88

PLATE 7

HARLAXTON. HALL, LINCOLNSHIRE
Manorial-Gothic design by Anthony Salvin, 1830–1837

PLATE 8

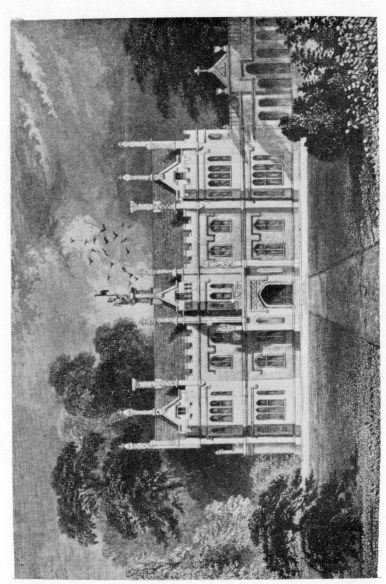

MANOR HOUSE IN THE TUDOR STYLE
From *Domestic Architecture*, by Richard Brown, 1841

But it was not enough only to choose a style. The style, when by common consent one had been selected, must become universally established and as commonly current as the language or the coinage. Further, its establishment must depend on its becoming the work of a School, undisturbed by individual caprice. This now seems to us to be especially true of Georgian architecture, which we find satisfactory very largely by its uniformity of character and by its obedience to rules. Yet that School displeased Ruskin, and so many of his contemporaries, by those very qualities of obedience and uniformity which in practice they found dull to the point of meanness.

Having stressed Ruskin's insistence on revival (provided, of course, that it was Christian–Gothic and not Pagan–Grecian that was revived), this short analysis of the Seven Lamps ought fairly to end by indicating that Ruskin was perfectly aware of the danger inherent in revivalism. This is clearly shown in his warning that 'it is no sign of deadness in a present art that it borrows or imitates, but only if it borrows without paying interest or if it imitates without selection'. To carry fairness even farther, it might be added that Ruskin himself, years later, described the *Seven Lamps* tersely as 'wretched rant'. Whether this contains more ranting passages than most of his other works is a matter of individual opinion. But it is at least certain that it had a deeper effect on public taste than anything he wrote later. The first of his complete books to be published, though not the first that he had composed, the *Seven Lamps* taught for the first time the spiritual and

historic importance to a nation of its architecture. Its influence on the progress of Mid-Victorian Gothic revivalism was immense. Had Ruskin written nothing else, even *The Stones of Venice* or *Modern Painters*, his position in the history of taste would have been established.

The very explicit criticism by George Vivian, Morritt, Gwilt and Ruskin had its counterpart in a kind of implicit criticism, not literary, but pictorial. Disbelief in the present and nostalgia for the past were both clearly implied in such publications as Joseph Nash's *Mansions in the Olden Time*,[1] which held up to public admiration the architecture of two or three centuries earlier; with, moreover, the further implication that such styles were most worth emulating. The special taste exemplified by Joseph Nash is that contained in the title of his work, and is best described as 'Olden Time'. It meant pre-eminently the buildings of the 16th and early 17th centuries and, despite Vivian's strictures on 'the bastard style', was immensely popular during the 'forties and 'fifties, before Ruskin's medievalist doctrine had had time to permeate public taste.

No fewer than fifty-three houses were included among the Mansions of the Olden Time, in lithograph illustration, and almost all are either Tudor or Jacobean; none is later, and very few are medieval. Names chosen at random from among these show the character of the whole: Audley End, Bingham's Melcombe, Ightham, Montacute, Holland House, Bramshill, Cranborne, Haddon, Hatfield, Speke Hall, Burghley, Compton Winyates or Wollaton.

[1] J. Nash: *Mansions of England in the Olden Time*, 1838–49.

A rather earlier note was struck by Knole and Kenilworth, but they were included, no doubt, chiefly for their Elizabethan associations. As to that, however, the manner in which every house in the series was depicted is associational. It was a sentimental, rather than an historical, evocation of the past. Each house was represented with architectural accuracy, though without pedantry; small details, such as mouldings, cornices and interior carving, were enough to satisfy any architect who might look at them, yet not such as to repel the unlearned lover of the picturesque. The necessary information was always provided by the drawings, but they were not diagrams. They were animated, to the extent of being got-up in what to the 1840's was a fancy-dress. Here, indeed, lies an important difference between the 18th- and the 19th-century ideas of depicting Stately Homes, and their respective approaches to this ever-popular art: let us call it house-portraiture.[1] To the 18th-century house-portraitist the actual present would be the most important of all moments in the history of his subject; at whatever date the house might have been built, its true significance was now, for now its present owners lived there, and it had waited through all these years and generations for its final fulfilment through them. If the artist wished to animate his view, he invariably did so by putting in figures and accessories of his own day, as he saw them there, rather than figures dressed-up in fashions of the past. To the mid-19th century, on the other hand, both for the house-

[1] See *The Artist and the Country House* (Country Life, 1949), by the present author, for a fuller discussion of this subject.

portraitist and his patron, who romanticised the past because they were rather doubtful about the present, a fancy-dress house-portrait was infinitely more agreeable than a mere topographical record; and the costume of the past was more attractive than that of the present. It was necessary, of course, that the right period of the past should be selected, and that it should be neither too remote nor too recent.

The admired Tudor taste was well described in Disraeli's *Coningsby* of 1844. Hellingsley, the home of Mr. Millbank, was depicted as 'One of those true old English Halls, built in the time of the Tudors. . . . It stood a huge and strange blending of Grecian, Gothic and Italian architecture with a wild dash of the fantastic in addition. The lantern watch-towers of a baronial castle were placed in juxtaposition with Doric columns employed for chimneys, while under oriel windows might be observed Italian doorways with Grecian pediments.' Satirical this description may be, but it was hardly exaggerated; indeed, it was clearly based on close observation, and the house was by no means too preposterous to have been built in 1540 and admired in 1840. T. L. Peacock might also be quoted very much to the point, especially from *Crochet Castle* with Mr. Chainmail.

Olden Time, this popular taste for Elizabethan and Jacobean architecture both genuine and revived, marched side by side with a taste that may perhaps be described as Merry England. Beginning as a literary taste, it gradually invaded the minor arts, and before long had its effect on architectural thought, and thence on actual practice. In a sense, both the Olden-Time and Merry-England phases

of a taste that was both fashionable and popular were 'invented' as a deliberately artificial contrast to the reality of Present Time. Most ages have invented means of escaping from their own most salient features. The 18th century had chosen to escape from its Augustan formality into a fanciful Cathay, and perhaps *chinoiserie* bore about the same relation to Imperial China as did Merry England to the Middle Ages; both were consciously a fancy-dress, and Merry England was the fancy-dress of Chivalry. So elaborately assumed was it, that it became a part of the arts of the period, of architecture no less than of the others. It began by invading the field of social life and manners during the Romantic decade of the 'thirties, through the influence of Sir Walter Scott; it ended by affecting domestic architecture and winning critical approval for the Baronial style, at the moment when Olden-Time Jacobean was winning equal approval. Only a short time was to elapse before both were obliterated by the pure Gothic doctrine of Ruskin and Gilbert Scott.

There was one notable manifestation of the escapist Merry-England state of mind, which combined literature, architecture and æsthetic-emotion in one superb Gothic outburst, and so impressed itself on the imagination of the day that it is not yet wholly forgotten. This was the Eglinton Tournament, and it is not wholly irrelevant to digress for a moment in that direction. It was the fruit of revolt against Utilitarian philosophy, against money-getting realism and, on the æsthetic side, against the severely practical architecture of the previous two generations. We, to-day, may also see it as a defiant

93

if unconsciously made answer to such architectural criticism as that of Gwilt.

The Eglinton Tournament took place at Eglinton Castle in Ayrshire on 28th August, 1839. It was magnificently extravagant and not at all utilitarian, and it made many earnest people very angry. But it gave great pleasure to the man who organised it, the scores who took part in it, the 80,000 who witnessed it and, no doubt, the hundreds of thousands who read about it in the newspapers. Archibald Montgomerie, 13th Earl of Eglinton, was a characteristically Romantic young man of the 1830's. With almost the wealth of a William Beckford, he had the impulse to Medievalism that had resulted in Beckford's case in the building of Fonthill Abbey, and that in his own case came out in the elaborate pageantry of the Tournament. Inspired by the ballads of his own country and by the novels of Scott, and probably disgusted by the growing industrialism of near-by Glasgow, Lord Eglinton conceived the idea of a pageant which would recapture the gallantry and chivalry of Merry England.

Fortunately we can reconstruct a picture of the Tournament from two sources, one factual and the other imaginative. The first is the Press of the day, the second is Disraeli's *Endymion*.[1] The Press had evidently decided that this would make a story of the first magnitude and, in the words of one of the reporters present, 'the gentlemen of the Press were there in droves from all quarters of the globe for the purpose of witnessing and wafting its fame from pole

[1] Disraeli: *Endymion*, vol. 2, caps. 22–4.

94

to pole and handing its glory and unrivalled brilliancy down to ages yet unborn'. As to *Endymion*, although the young Mr. Disraeli does not appear to have been present at the Tournament, the aged Earl of Beaconsfield, when he came to write *Endymion* forty years after that event, remembered all he had heard and read about it at the time, and described it in great detail as the Montfort Tournament. The actual Eglinton Tournament took place on a field near Eglinton Castle, round which was a covered Gothic stand for the nobility and gentry, and open stands for the public, who flocked to the number of 80,000 from Ayr, Dumfries, Kilmarnock and even Glasgow. The Grand Procession with which it opened was made up of men-at-arms, musicians, trumpeters, banner-bearers, Heralds, the Judge of Peace, more halberdiers, the Knight-Marshal and his attendants, the Ladies Visitors, the King of the Tournament (Lord Londonderry) and his halberdiers, the Queen of Beauty (Lady Seymour, afterwards Duchess of Somerset) with her attendants, the Jester, archers and archeresses, the Lord of the Tournament (Lord Eglinton himself) and his banner-bearer, and the Knights, each with his esquire and halberdiers; the Black Knight, the Knights of the Griffin, of the Dragon, of the Black Lion, of Gael, of the Dolphin, of the Crane, of the Ram, of the Swan, of the Golden Lion, of the White Rose, of the Red Rose, of the Stag's Head, of the Border, of the Burning Tower and of the Lion's Paw.

That description is from a reporter's eye-witness account. It may be compared with Lord Beacons-

field's description of the Montfort Tournament.
To begin with, the inventive genius and romantic
taste of Lord Eglinton were transferred to Lady
Montfort; it was to be thought of as a woman's
business, evidently. Otherwise, with one important
exception, the account is factually exact.

'At present', the passage begins, 'Berengaria had
two great objects; one was to sustain the Whig
Government[1] in its troubles, and the other was to
accomplish an unprecedented feat in modern man-
ners, and that was no less than to hold a tournament,
a real tournament, in the autumn at the famous
castle of her lord in the north of England. . . . Day
after day the guests arrived; the Knights of the
Griffin, and the Dragon, and the Black Lion and the
Golden Lion, and the Dolphin and the Stag's Head;
they were always scrupulously addressed by their
chivalric names, instead of by the Tommys and
Jemmies that circulated at Whites, or the Gussies
and Reggies of Belgravian tea-parties. . . . Irrespec-
tive of the railroads which now began to affect the
communications in the north, steamers were charter-
ing from every port for passengers to the Montfort
Tournament. The jousting-ground was about a
mile from the Castle, and a hundred thousand people
could witness the procession. . . . The sun shone,
and not one of the breathless multitude was dis-
appointed.'

'The sun shone', wrote Lord Beaconsfield. Un-
fortunately it did not, and that was the great
tragedy of the Eglinton Tournament. Rain began

[1] Melbourne had come in as head of a Whig administration,
1835, and was defeated by Peel in 1841.

to fall soon after the arrival on the field, and quickly became a torrential downpour which lasted for the rest of the day. The tilting was bravely proceeded with, but by six o'clock the Knights, Ladies and all the 80,000 spectators were drenched to the skin, and Lord Eglinton, 'much to the satisfaction of those present', brought the proceedings to a close.

In the words of one of the reporters, 'the light and fantastic costumes were completely soaked, and the representatives of the 14th and 15th centuries marched home through the mire under the cover of modern, unromantic umbrellas. Men, women, horses and omnibuses hurried helter-skelter through the avenues, and the railway station was besieged by a host of applications for seats to Ayr, many of them being compelled to wait for four or five hours. . . .'

Lord Eglinton had arranged to have a ball that night, in a specially constructed pavilion, but the rain poured through the roof, and the entertainment had to be postponed. The storm continued all night and all next morning, and although it cleared up a little in the afternoon, there was no Tournament that day. The time was spent in drying and repairing the costumes and getting the rust off the armour. Mr. Charles Lamb and the future Emperor of the French, Prince Louis-Napoleon, amused their fellow-guests by holding a series of tilts on foot in the ballroom of the Castle. Naturally enough, the two most fashionable painters of the day, Edwin Landseer and Francis Grant (afterwards respectively Sir Edwin, R.A., and Sir Francis, P.R.A.), have left visual records of the Tournament. The one painted the 7th Duke of Beaufort, then Lord Worcester, and the

97

other painted Mr. Charles Lamb, and both were depicted in the armour which they wore. The Queen of Beauty at the Tournament, Lady Seymour, continued to bear that title for many years after. In July 1846, seven years after the jousting, Lady Eastlake noted in her Journal, 'Dined in the evening with the Vivians, going afterwards to Lady Lovelace's . . . there I met Lady Seymour, the Queen of Beauty, who had a long talk with me.' Even in the following year, 1847, the 'medieval mania' which had been so magnificently demonstrated at Eglinton Castle and was now being rather more timidly experimented with in the new Houses of Parliament, was still thought sufficiently topical by *Punch* to be the subject of a paragraph. Somebody says the history of a country is to be read in its monuments, said *Punch*; 'if by monuments are meant works of art, and if our history is to be read in those, we shall be treated by posterity as people who live in the Middle Ages, for everything around us partakes of the medieval character'. The mania, it must be repeated, was not altogether new. In one curious direction, indeed, it appeared at least as early as the last quarter of the 18th century. People whom Mr. Pitt found it expedient to ennoble occasionally adopted titles with a resoundingly Norman or Plantagenet air to them; and, later, when a Mr. Morres of Dublin was created a Viscount in 1816 he chose the title of Viscount Frankfort de Montmorency.[1] The ancient house of Montmorency in France, it may be added, most strongly disapproved

[1] See G. E. C. *Complete Peerage*, ed. Doubleday, vol. VI, Appendix A.

of this procedure. The architect of Windsor Castle, Jeffry Wyatt, whose family name had immense professional prestige, deliberately and with the encouragement of George IV obscured it by becoming Sir Jeffry Wyatville. Later still, the distinguished, if rather dangerous, ambassador Sir Stratford Canning, when elevated to the peerage in 1852, chose to call himself Viscount Stratford de Redcliffe. The same reverence for the age of chivalry turned the simple and not uncommon names of Mullins and Wilkins into, respectively, de Moleyne and de Winton. Finally, *The Times*, turning the Thunderer's bolts into an arrow-tipped joke, announced that a Mr. Bunn wished in future to be known as De Bohun.

It may appear contradictory, having regard to the Eglinton Tournament and the medieval craze, to say that the Middle Ages were a little too remote to arouse admiration at that time. But it is not really untrue, because, although a taste for the Middle Ages was very fashionable, and for a variety of reasons, the one valid reason was, in the opinion of the young Ruskin, absent. Admiration was based on superficial aspects of the epoch: on little Gothic chapels, on ogee-windows inserted here and there, on got-up tournaments and Plantagenet masquerades. It was not yet fully or comprehendingly extended to the great architecture of the epoch, in which alone could still breathe the true spirit of the Middle Ages. Both John Ruskin and Augustus Welby Pugin, in their very different ways, saw that such comprehension could only come if the beholder were first lost in the wonder of such marvels.

And that, Ruskin found, no longer happened. He wrote in 1847 [1]: 'We do not perhaps enough estimate the assistance which was once given, both to purpose and perception, by the feeling of wonder which with us is destroyed, partly by the ceaseless calls upon it, partly by our habit of either discovering or anticipating a reason for everything.'

The Gothic revival had once already played its part in the lives of men of taste, and was conspicuously about to do so again. At the moment, however, in the 1840's, it was the Jacobean Revival which occupied so many people's minds. Countless almshouses, lodge-gates and institutions bear witness to it still. Since the immediately preceding age of the Grecian Revival had insisted on purity of style, it was natural, and indeed inevitable, that this age should be bored by pure standards and have preferred to breed hybrids. Granted that, it was probably easier to hybridise the Elizabethan, Jacobean and Carolean styles, of which so much survived, than to re-invent the medieval, of which so little survived but cathedrals and ruins. That, indeed, would be difficult, and Ruskin had yet hardly arisen to explain it all. If one is to have a revival, one needs a literature to support it; one needs either the inspiration of a past literature, of a Chaucer, a Spenser or a Scott; or one needs contemporary interpretation or illumination. It was not enough for the Vivians, Gally Knights, Palgraves, Gwilts or Fergussons to be respected and much read by highly-educated and critical readers, for, with all their learning and experience, they lacked the power

[1] *Quarterly Review*, vol. 81, 1847.

either to inspire or illuminate the general. It was left for Ruskin to do that. The immense force of Ruskin's critical authority could have turned the whole of English mid-Victorian building in a Classical and Renaissance direction, had it been his wish to do so. Whatever general trend there was, and indeed it was a strong one, towards admiration of the true Medieval and of revived Gothic, it might not have been able to survive had Ruskin chosen to be a neo-Grecian.

ARCHITECTURE, 1830–50

THE critics of architecture, writers of substantial volumes or of ephemeral pamphlets, contributors to the *Edinburgh* or the *Quarterly*, waged, as we have seen, their internecine battles whenever and wherever the architecture of any past period came up for discussion. An exactly similar form of warfare was also waged whenever it was a question of present building. Architects harangued each other, laymen harangued architects, and the only point on which almost everyone seems to have agreed was that the architecture of the immediate past, of the first years of the century, was at the best boring and at the worst common. The Regency had few advocates to speak for it. At this point it should be observed that the style we call in England 'Regency'—always a misleading label—appeared long before George, Prince of Wales, became Prince-Regent in 1811; and that it continued for a good many years after the Prince-Regent had become George IV in 1820. But although Regency is a chronologically vague term, its character is pretty clear: simplicity of statement, avoidance of all but the minimum in external ornament and decoration, a classical discretion in line and spacing, a reticence rendered telling as a positive quality by the judicious placing of an emphasis here and there.[1] And these were the

[1] The Royal Pavilion at Brighton built for the Prince Regent is not, it must be admitted, conspicuous for the qualities of simplicity,

qualities which a great many people, by the 1830's, were beginning to detest.

They are the qualities which distinguish what its enemies derided as the 'Baker-Street' style—a style which was a clearly-thought-out attempt to provide a street architecture of sufficient dignity for a capital and yet suitable to the climate and atmosphere of London. The precise point at which dignity becomes dullness, and the degree of dullness which can be supported under the plea of dignity, are largely matters for personal opinion. But there is little doubt that most people regarded the classical severity and brick-built or stucco-fronted uniformity of Bloomsbury and Pimlico as being no more than mere speculators' commonplaces. The taste which was invented by John Nash and George IV, and developed with variations by Decimus Burton and Thomas Cubitt, was certainly a speculator's taste, if only because its followers were themselves real-estate speculators. Among that following it spread far beyond London and its suburbs, to Cheltenham and Clifton, to Brighton and St. Leonards. When it spread to Herne Bay in Kent at least one critic thought it time to protest.[1] He did not protest at the developement of what until then had been, as he called it, a wild place on the coast of Kent, but at the opportunity which had been missed. 'It is indeed', he wrote, 'a matter of wonder that variety in the appearance of houses and in the style

plainness, discretion or reticence; nor, for that matter, was the Regent himself. Regency silver-work can also be exuberant.

[1] Anonymous writer in *The British Almanac of the Society for the Diffusion of Useful Knowledge* for 1834.

of architecture generally is not attempted in some such case as this, if it were only for the additional attraction which novelty affords.' As it was, he felt, Herne Bay, despite its new pier by Telford and its service of swift steam-packets to London, was now never likely to acquire even the smallest degree of interest; it was but a section of the many repetitions of Regent Street.

The same critic disliked, for the same reason, the new Duke of York's Column near Carlton House Terrace, designed by Matthew Wyatt. It may have been meant to recall the Column of Trajan in Rome, but that, he pointed out, is sculptured all over its surface with figures in low-relief, whereas the London column is quite plain—not even fluted; it was therefore condemned as heavy, dull and unmeaning. Its nicely-calculated proportions, and the admirable relation between the column and the surmounting statue, escaped this critic's notice. It was simple and undecorated, therefore it was dull. Rather oddly and unexpectedly, the same critic praised another public work precisely because of its plainness. This was the new Hungerford Market, near Charing Cross. 'The Hall', he said, 'assumes the form of the old Constantinian Churches in and around Rome and will afford a better idea of the originals than anything else in London. . . . The details of the architecture, it must be understood, are not strictly adhered to but are very properly made more plain and perhaps more rude, in character with the nature of the structure generally.' Here is the historic appeal which few critics, from Ruskin down to this humble anonym, failed to make. The building was admirable

PLATE 9

MANSION IN THE SOUTHERN STATES
Gervase Wheeler, 1855

FLOATING CHURCH, PHILADELPHIA
C. L. Dennington, 1851

PLATE 10

By permission of Country Li

DORCHESTER HOUSE, LOND

Lewis Vulliamy, 1848

not because it was a good market-hall for London, but because it gave a good idea of a 4th-century Basilica.

The Grecian simplicity which had characterised orthodox Regency taste, as in Wilkins's University College and Alresford Manor, was the result of a taste formed by scholarship. And even the dramatic departures from that orthodoxy, as in Nash's Brighton Pavilion and in parts of his Regent's Park Terraces, were also controlled by intellectual experience. But during the 'thirties and 'forties the qualities deriving from scholarship were gradually sacrificed to those deriving from sentiment and association. One of the results of this was that the issues in the inevitable Battle of the Styles became thoroughly confused. The professional architect-critics, if left to themselves to argue the purity or impurity of some new piece of Grecian or Early-English, might possibly have forced the professional architect-builders to evolve a style that was truly contemporary; a style, that is, that would have been in tune with the general progressiveness of the age. But they were not left to themselves. The situation was made very complicated by the intrusion of influential writers, and of anonymous writers in widely-read journals, who were only too ready to criticise architecture from every point of view except the architectural. Sentiment, either that of the Picturesque or that of the Past, was for these the prepotent element in their taste. That taste developed along lines inescapably influenced by sentiment.

A humble example of this is the already-quoted anonymous writer of 1834. He disapproved of Carl-

ton House Terrace, recently built on the site of the
Regent's palace of Carlton House, because it blocked
the view from Lower Regent Street of the pictures-
que mass of Westminster Abbey and the refreshing
scenery of the park. A more illustrious example is
Disraeli, in his novel *Tancred*, which was published
in 1845. *Tancred* is more concerned with Syria than
with England, but nevertheless it is a vehicle for
Disraeli's opinions and feelings about a vast variety
of subjects. Among these, in Chapter X, is recent
London architecture. To quote even a few lines
from this highly significant passage shows what Dis-
raeli, vividly aware of contemporary opinion and
with pronounced views of his own, thought of the
town-architecture produced in the previous genera-
tion, under the Building Act passed by Parliament
when Pitt was Prime Minister and the Napoleonic
wars had made controls inevitable. Speaking in his
own right, as Disraeli the author, and not through
the mouths of any of the characters in the novel, he
asserted that it was impossible to imagine anything
more insipid, tame and tawdry than the new dis-
tricts like Belgravia and Marylebone that had
sprung up within the last half-century, dictated, even
as to their façades, by Act of Parliament. This, said
Disraeli, indicating Westminster, was the power that
produced Baker Street as a model for street architec-
ture; and, he added, appealing to the common
sentiment of Olden Time, that prevented Whitehall
Palace from being completed for Charles I. Lon-
don, in fact, only became interesting in Disraeli's
eyes east of Charing Cross, and that by reason of its
being a medley of styles and periods. He made this

quite clear in the passage which followed his con-
demnation of Belgravia and Marylebone. 'Looking',
he wrote, 'towards Northumberland House and
turning your back upon Trafalgar Square, the Strand
is perhaps the finest street in Europe, blending the
architecture of many periods.'

The blending of many periods did not only
characterise in this picturesque way the survivals
from the past. It was a chief characteristic of most
new building. Whether in the work of any indivi-
dual architect, or in the sum of their achievement,
there was to be seen only a confused medley of
periods, with no dominant style emerging to signal-
ise the age by its authority and ubiquity. Neither
architects nor their clients seem to have debated the
suitability of reviving an ancient style for a modern
and quite different purpose. Such an idea had long
been lost sight of. Inwood had faithfully imitated
the Parthenon and the Erechtheum for St. Pancras
parish church; a Gothic cathedral had been recalled
by a nobleman's mansion in modern Cheshire;[1]
and another great mansion had recalled the fortified
castles of the warring Plantagenets in industrial
Staffordshire.[2] The possibility of building a house
reflecting modern conditions was not very often
contemplated; Decimus Burton was one of the few
to think in that direction. There was another,

[1] Eaton Hall, Chester, built 1804–12, for the Marquess of West-
minster by William Porden. Passavant praised it for reminding him
of York Minster. This earlier Eaton Hall must not be confused
with the present building by Waterhouse.

[2] Alton Towers, built for the Earl of Shrewsbury. Passavant
described it as being in 'a simple Gothic style with an armoury
eighty foot long containing fifty Knights in armour'.

George Vivian. He was not an architect, but had he been so it is possible that he would have anticipated Paxton, for he was able to recognise the architectural beauty of great modern engineering works. To him it was one of the obvious forms of his beloved classical tradition, and he felt strongly that far too little notice was taken of it. 'The aqueducts,' said Vivian,[1] 'the harbours and the seaport moles of modern times—the gates and towers and other parts of military architecture—the docks of Ferrol and Sheerness, Smeaton's Eddystone Lighthouse and such grand architectural enterprises, are equal in their kind to the most celebrated of antiquity.' Sixteen years later, Joseph Paxton was to achieve in the Crystal Palace one of the century's great triumphs of architectural engineering and to see it acclaimed equally for its originality, its suitability and its beauty.

To return to Decimus Burton; known to-day chiefly for his youthful work at Hyde Park Corner in an elegant Grecian revival manner of 1825, he achieved fifteen years later a house that was both traditional and really contemporary. This was Grimston Park,[2] in Yorkshire, for the 2nd Lord Howden. The design was traditional in that it was Italianate influenced by late Grecian revival; but it was contemporary in that it used modern materials and methods of construction for modern purposes. The conservatory, for example, was built with cast-iron columns. That these were designed as conventional

[1] Anonymous review of Hope's *History of Architecture*, *Quarterly Review*, 1835.
[2] See *Country Life*, vol. 87, p. 252.

palm-trees was to follow the example of John Nash in the kitchen of the Brighton Pavilion; but whereas to place iron palm-trees in a kitchen shows a rather badly-controlled sense of humour, to place them in a conservatory shows a well-developed sense of what was appropriate. The importance of Grimston Park is that it showed, in 1840, a full awareness of contemporary conditions while retaining the simplicity of the classic tradition, and, moreover, avoiding revivalism. If Decimus Burton in middle-age had carried as big guns as he had done in his brilliant early youth, the whole developement of Victorian architecture might have been along the original and rationalist lines of himself, 'Grecian' Thomson and Joseph Paxton. As it was the developement was along the revivalist and emotionalist lines of Cockerell, Barry, Pugin and Gilbert Scott. Highly individualist though the architects were, certain precepts had come to be more or less generally accepted. Public buildings were still expected to follow the Grecian mode; churches were to be Gothic, and should no longer recall pagan temples; country-houses might now be Plantagenet, Ecclesiastical-Gothic or Tudor, but should no longer be Grecian. But when we turn from the architecture of great houses and public works to that of villas and small houses, we find an even more pronounced taste for the eclectic and the revivalist, an even greater determination to ignore the road pointed out by Decimus Burton.

Whatever the state of opinion among the leading architects may have been, the builders of small houses were still farther from having made up their

minds about which of the paths through the past they should follow. Even here there were one or two guiding precepts; parsonages must be Gothic; while cottages, lodge-gates, toll-houses and the like were best suited by the Picturesque style with porches, latticed windows and curling eaves. But for the small villa which was more than a cottage, and for the large villa which was not a big house, there was no one style which seemed the obvious choice. The small villa, like any other house, must of course be either Gothic or not Gothic. If Gothic, there would be no real difficulty, for there were already well-defined rules of design applicable to any scale of building from Alton Towers to an ice-house. But if not Gothic, the choice was bewildering. Builders could and did supply designs and plans drawn from almost every country and almost every period, from ancient Egypt to 19th-century Switzerland.

A typical purveyor of such designs was Richard Brown, of Exeter.[1] He is not among those ever likely to be regarded as important in the history of architecture in this country. He was, on the other hand, one of a crowd of commercial designers in London and the provincial centres who partly followed and, in the aggregate, partly formed the taste of their generation. Many of their designs can never have been carried out, yet these volumes of projects were not likely to have been published if their authors were not sure of attracting at least a few clients. Any clients consulting, for example, Richard Brown as a result of his publication would

[1] Richard Brown: *Domestic Architecture*, 1842.

be shown a wide variety of designs, among which they would be fairly certain to find something suitable to both their fancy and their purse. If such clients were bewildered by the variety offered them, they were reminded that every style suggested was based on actual practice, in England or elsewhere, at some moment in history. Villas could be designed to recall the Plantagenet castles and the Tudor manors of England, the country-houses of Flanders and the châteaux of France, Chinese pavilions, Italian casinos, Grecian temples or Swiss cottages. It may be difficult to believe that designs for suburban villas in the Egyptian, Hindoo or Hispano-Mooresque tastes could have been intended for actual carrying-out. Yet the architect attached to each design a detailed plan with such modern requirements as a dining-room, drawing-room, pantry, water-closets and scullery; and accompanied these with over thirty dissertations on technical and general questions connected with practical building. However few of these designs were ever commissioned, it is evident that any of them could actually have been carried out, and that all of them were intended to be. Perhaps the most striking thing about Richard Brown's work is that, although published in the early 1840's, it included not a single design in the ecclesiastical Gothic taste. Richard Brown disagreed with most of his contemporaries on the suitability of Gothic for private houses, whatever their size or importance. 'All styles are given,' he said in his preface, 'with the exception of the Gothic, which exclusively belongs to sacred architecture and not to domestic.'

Although we are discussing English domestic architecture of the mid-century, it is not irrelevant to consider the American of the same period. The United States had reached the stage where 'Colonial' architecture was regarded as old-fashioned and dull, but had not yet evolved a modern style of its own. Taste was formed on English practice, with considerable modifications for the climatic differences and in accordance with the Americans' already more advanced ideas about heating, ventilation and plumbing. In Philadelphia or New York, as in London, a host of designs were published by architects with a view to catching clients. One such volume may serve as an example of them all. This was by Gervase Wheeler, a New York architect whose office, in 1855, was on the corner of Nassau and Beeckman Streets.[1]

In his opening pages, the architect reflected a defeatism which evidently afflicted American architects as heavily as it did those in England. Confessing to failure in inventive power, and feeling bound to admit that architects of the past had apparently foreseen all future needs, he said that 'all we can do is to combine, using bits here and there, as our education affords more or less acquaintance with the styles of the past from which we steal our material

[1] Gervase Wheeler: *Homes for the People*, 1855. Pubd. by Charles Scribner, New York. The suggested designs are divided into seven classes: the small villa in a suburb, costing on average $4,000; the small villa in the country, average cost rather less than $3,000; the larger country villa, about $10,000; the country mansion for either North or South, up to $25,000; the *cottage-ornée*, for as little as $2,000; the cheap cottage-home in a suburb for rather less; and the house on a farm for about $4,000.

112

. . . the clumsy piecing together of the coinage of other men's brains, instead of the working out of an idea'. Which means, in other words, that the American, like the English, architects could hope to arrive only at an aggregate and never at a synthesis. An ominous but revealing condition for arriving at this aggregate was laid down by the American. 'Its chief charm', he insisted, 'should be in its consistent freedom from the trammels of architectural style.' No doubt the 20,000 country mansions which Gervase Wheeler could so readily supply were designed for those who, in his words, were the architects of their own fortunes; business-men who, after a lifetime of financial success, sought to close their activities by building themselves houses 'on a scale commensurate with their past transactions'. Such mansions were erected in places like Berkshire County, Mass.; on the banks of the Hudson; on Long Island Sound; in the suburbs of New England towns; and in the States of the South, with a little adaptation. In the generation before Wheeler, the elder Brunel[1] had crossed the Atlantic to build one or two large houses on the Hudson; but by Wheeler's time these were out of fashion and, it was thought, were better pulled down. It is not likely that Brunel indulged in revivalisms, but they certainly were indulged in by architects in America in the 'thirties and 'forties with almost as much fantasy as in England. 'Architectural knick-knackery' is what

[1] Marc Isambard Brunel, 1769–1849, was in New York as a French refugee from 1793 till early in 1799. In addition to practising privately as architect and civil engineer, he held the public appointment of chief engineer of New York.

113

Gervase Wheeler called it. Circular towers, octa-
gonal rooms, battlemented parapets and 'all the
finery of the very worst styles of pseudo middle-age
architecture' were lavished on the American country-
dwelling. Olden-Time, however, seems to have
been reluctantly omitted from American revivals,
probably for lack of the genuine models; a taste for
olden-time can only grow from long and continuous
habitation, whereas the medieval taste, nurtured on
ruins, depends on the remote past and can be up-
rooted and re-planted. 'We cannot', said Wheeler,
'in one generation gain the picturesqueness of the
old homes of a long-resident family, each life of
which added a wing, or a porch, or a room, and so
gave a quaintness and pictorial beauty which a
single effort can hardly reach.'

Gervase Wheeler was too modest. Some of his de-
signs possess an undoubted pictorial charm, especially
as he was always careful to relate the house to the
varied slopes of the ground and to the surrounding
trees and vegetation. Many passages in his books
stress the importance of doing this, whether in the
North or the South. Another matter emphasised in
the description of every one of his designs was the
importance of plumbing. In the 1850's American
builders were not so far ahead of their English
counterparts as they now are, and the water-closets
and baths with hot and cold running water which
Wheeler provided could also have been found in a
few houses this side of the Atlantic, as Richard
Brown's plans showed. The internal ice-closet, how-
ever, seems to be a purely American developement
of the 18th-century ice-house in the grounds;

Wheeler already, in the 1850's, was calling this ice-closet a refrigerator, and he designed also some picturesque out-of-door and above-ground examples.

If he had harsh things to say about contemporary ideas of his native villa architecture, Wheeler was equally harsh about the interior decoration and furnishing of such villas. They did not, he complained, show very much evidence of either tasteful or consistent planning. Such an interior as he disapproved of may be re-assembled from his description of what he saw as the average, large, rather expensive villa, possibly on Long Island Sound. The front parlour would be crimson and rosewood, with a great, straggling pattern in gay colours all over the very expensive carpet; the rear parlour would be blue and rosewood with probably the same carpet; and the carpet would be suitable for neither room. The walls would be bare white, with here and there a staring picture in a gaudy frame, with the cords and tassels even more prominent than the picture itself. There would be lace curtains and a great deal of gilding everywhere, and the furniture would have been chosen with no thought of congruity with either carpets or walls; it would be what Wheeler described as 'routine furniture'. Throughout the principal living-rooms there would be an absence of 'keeping'—to use the word still in vogue on both sides of the Atlantic to imply unity of tone. But, snorted Gervase Wheeler, such violations of the beauty of simplicity and artistic taste were as often as not vindicated by the declaration that the rooms had been 'done by a fashionable upholsterer'. The fashionable upholsterer, the interior decorator of to-

day, has a more remote ancestry than that, however. In England the firm of the Adam brothers was 'doing' houses eighty years or so before Wheeler made his protest in New York; but it was doing so with a difference. Decorator and architect were then one firm, concerned throughout with both the exterior and the interior of the house they were 'doing'.

Wheeler's complaint is fundamentally the same as that made by so many English critics of contemporary architecture; that there was no accepted standard to which everyone, client, architect, builder, furniture-designer and decorator, could, as a matter of course, refer. There was, that is to say, no such standard to be looked for among his contemporaries, either in England or in America. When he admitted that the most that American architects could hope to do was to combine different bits from here and there, his context implies that he meant the combining of styles from the past. The actual illustrations of his designs, however, show that he took a good deal from contemporary English practice. Many of his smaller villas and *cottages ornées* reflect the Picturesque and Rustic tastes advocated by the publishers of many English books of designs of the 'forties. The most influential of these was Loudon's *Cottage Architecture*,[1] and it is still the best-known. So famous, indeed, was it that an eminent Hungarian novelist[2] of the period described the fashionable type of Anglomaniac who builds for

[1] J. C. Loudon: *Encyclopædia of Cottage, Farm and Villa Architecture,* 1832.

[2] Baron Eötvös: *The Village Notary, c.* 1840.

himself in Hungary a house on the approved English lines as laid down by Loudon.

Cottages and villas, however, although they reflected marked currents of taste, were hardly major architecture. They did not provide the main theatre for the War of the Styles. That conflict began early in the century between two sets of rival theorists, each of whom believed at first in ultimate victory and each of whom lapsed at the end into defeatism.[1] An early and characteristic engagement in the War of the Styles took place over the building of the Reform Club,[2] the Building Committee of which met in the summer of 1837 to confer with a panel of architects from among whom the final choice was to be made. The winning design was that of Barry, which was Italian, and in this case the contest seems to have been between two kinds of Classic and two kinds of Italian, with no Gothic competition; it was still an accepted principle that the Gothic was not suitable for public buildings. The chief architects in the classic manner are seen to derive to a large extent from the illustrious Soane; Basevi, the builder of a large part of Belgravia, and of the Fitzwilliam Museum in Cambridge, was his pupil; Smirke, designer of the

[1] A more or less random selection of public buildings erected or designed between 1830 and 1850 includes the following. In the Classical Taste: National Gallery, British Museum, Fitzwilliam Museum at Cambridge, Taylorian at Oxford, St. George's Hall at Liverpool, Town Hall at Birmingham, the Arch and Great Hall at Euston Station, London, and the works of 'Grecian' Thomson at Edinburgh and Glasgow. In the Gothic taste: the Houses of Parliament, the churches of Pugin, much at King's, Trinity and elsewhere at Cambridge, and the London church of St. Dunstan's-in-the-West.

[2] Louis Fagan: *The Reform Club*, 1887.

British Museum, was also a pupil, and Gilbert Scott, as a young man, attended Smirke's lectures. J. B. Papworth, chiefly responsible for the classic elegance of Cheltenham, was not a pupil of Soane, but was, when very young, a protégé of the ageing Sir William Chambers, designer of Somerset House. It is more through the influence of Soane than through that of John Nash that the classic tradition of the 18th century was carried over into the 19th.

The gradually increasing strength of the swing towards Gothic, for buildings other than churches and villas, came simultaneously from two sources: from Augustus Welby Pugin's medievalism based on Christianity, and from the widespread, fashionable medievalism based perhaps on Sir Walter Scott, and having as its symptoms a fondness for Plantagenet pageants and *bals-masqués* and dresses *à la Marie-Stuart*. But hardly had the Gothic won its domestic, as opposed to its earlier ecclesiastical victory, than it was faced in the later 'forties with a new rival from Italy. This, the revived Italian Renaissance taste, made great headway during the 'fifties and 'sixties. Three early examples are Osborne House, Bridgwater House and Dorchester House. Osborne, designed in 1844 by Thomas Cubitt and Prince Albert, is in the style of the Italian Villa rather than the Palazzo, and had an immense influence on the small-large houses of the next decade, as well as on the large-small villa of the outer suburbs and Home Counties. Bridgwater House, designed by Barry for Lord Ellesmere in 1847, is much more in the High Renaissance palazzo style than the same architect's Palladian Reform Club of eight years

118

earlier. Dorchester House, begun in 1848 by Lewis Vulliamy in close co-operation with his patron, R. S. Holford, was even more rich and magnificent in the same taste.

Bridgwater and Dorchester Houses were the last of their noble and aristocratic kind. They marked the end of the classical approach to architecture, for Ruskin had become dominant before Dorchester House was completed in 1863. But they also marked the end of the belief that a house, to be good architecture, must be vast in size. That idea was a growth of the 'thirties, as was pointed out by Ruskin when he described it as 'altogether of modern growth.' [1] The Georgian and pure Regency architects had identified excellence not with size, but with scale. Excellence, they knew, could lie in any size, from palatial to very small, provided that every part of the building was consistent in scale throughout. The Early Victorian architects tended to think that excellence could lie only in what was immediately impressive and of monumental size. Some justification for this view can be found in the very year of Victoria's accession, 1837, with the beginning of work on the greatest building of the 19th century surviving in London: the new Palace of Westminster, or Houses of Parliament.

The rebuilding of the Houses of Parliament constitutes one of the very few points in the 19th century at which the arts of architecture and painting jointly occupied the minds of thinking men for a single common purpose. Many hours of discussion and many pages of print, over a period of many

[1] Ruskin: *Seven Lamps of Architecture.* Lamp VI: Memory.

years, were devoted equally to the building and the decoration of the new Palace of Westminster. Once more it must be said that to judge the results by our own particular standards of to-day would be to lose sight of the main point. That point is, that there was a determination to employ the best talent available in the country in the direction which the best-qualified opinion could agree upon as being most suitable to its purpose. If we cut away the complicated irrelevancies which quickly developed as adhesions round the central matter, we find a question of prime importance to the nation being approached in a spirit of deep earnestness and determination to achieve the right result. Unfortunately, there was no Wren, or Burlington, or George IV to determine what that should be. Although the building of the Palace and its adornment were from almost the beginning seen to be intimately related, there was no one voice to speak with equal authority in both spheres. Consequently, there was much and very lengthy argument; and by far the most acrimonious of the arguments raged over the internal decorations rather than over the architecture of the building itself.

The old Palace of Westminster was destroyed by fire in October 1834, the only parts to survive being Westminster Hall and the remains of the already ruined St. Stephen's Chapel. Benjamin Robert Haydon, who had long been badgering Lord Grey and Lord Melbourne for a commission to decorate the old House of Lords with historical paintings, saw the fire. He wrote in his Journal, on the 16th October, 1834, 'Good God! I am just returned from the terrible burning of the Houses of Parlia-

PLATE 11

CLIFTON SUSPENSION BRIDGE, BRISTOL
Designed by Isambard Brunel, 1831; built 1836–53 and 1861–64

PLATE 12

CONWAY TUBULAR RAILWAY BRIDGE
Robert Stephenson, 1849. *From a contemporary print*

ment. Mary and I went in a cab, and drove over the bridge. From the bridge it was sublime. We alighted, and went into a room of a public-house, which was full. The feeling among the people was extraordinary—jokes and radicalism universal. If Ministers had heard the shrewd sense and intelligence of these drunken remarks! I hurried Mary away. . . . The comfort is, there is now a better prospect of painting a House of Lords.' Haydon, as all readers of his pathetic and sadly moving Journal are aware, had a wonderful talent for identifying national questions with his own theories, and therefore with his own personal problems.

The practical business of carrying on the nation's life naturally made the building of new Houses of Parliament a matter of immediate urgency; it would probably have become so in any case with the passing of the Reform Bill of 1832, and the consequent change in both size and character of the House of Commons. Less than five months after the fire, a Parliamentary Select Committee was appointed to examine and report upon the question of rebuilding. Its deliberations lasted three months, and its Report, issued in June 1835, recommended that the rebuilding should be carried out on the old historic site and that in style it should be either Gothic or Elizabethan; the survival of the 14th-century Westminster Hall was obviously the deciding factor.

That was an important decision. The recognised principle that the Gothic style should be used for purposes wholly or partly ecclesiastical; that the Elizabethan, Jacobean, or Stuart styles should be

used for domestic purposes; and that for public buildings the Classical, Renaissance or Neo-Greek conventions were most suitable, was now, for the most important piece of public architecture of the day, authoritatively overthrown. It is legitimate to explain this as a triumph of English romanticism over Academic theory; it is more plausible to see it as a mark of respect to the lone-surviving Westminster Hall, for nine centuries the radiant point of English statecraft and jurisprudence. Whatever their reasoning may have been, the Select Committee made their decision. That having been made, a Royal Commission was appointed in July 1835, about six weeks after the Select Committee's Report. Cockerell, arguing against the terms of reference, sent in an Italianate–Elizabethan design; Anthony Salvin's design was correctly Tudor; Charles Barry's was Classical dressed Gothic, and won the competition.

The decision in favour of the Gothic, and the selection of Barry's design, caused much embittered controversy, which long flourished in pamphlet warfare. Not for some years did work actually begin on the building, and in the interval Joseph Gwilt had published his *Elements of Architectural Criticism*, with its defence of the neo-classic so long as it was correct neo-classic. Not only did controversy arise over the respective claims of the Gothic and the Classicist styles for such a building; but it arose also over the respective claims of Charles Barry and Augustus Welby Pugin to be the chief begetter of the design as finally executed. This side of the controversy makes unhappy reading, and does not in-

crease the dignity of either party; moreover, it was continued for years by the sons of both Barry and Pugin. It is enough for us that they collaborated towards the great final result in approximately equal shares. Without unduly simplifying a very complex question, it may be said that the mass, silhouette and plan of the building are due to Barry; and that the detail and decoration throughout (except, of course, for the fresco-work) were designed down to the smallest item by Pugin. All this, however, has been discussed point by point by many authorities in recent years.[1] As was to be expected, with an undertaking of that size and public importance, there was an immense amount of both friendly and hostile criticism, equally while the building was still but a project and while it was being erected. We to-day accept the Palace of Westminster as the most important 19th-century Gothic work in England and, with St. Paul's Cathedral, as one of the two dominant architectural features of London. But it was by no means so universally accepted while it was still a novelty. One of the chief grounds of contemporary disapproval was that the new Houses of Parliament were either not purely Gothic or else not purely Classic; they thus came under fire from both sides. Pugin himself condemned Barry's river-front elevation because it was pure Grecian in its symmetry; and that very influential critic, James Fergusson, later damned the whole affair with faint praise in making allowances for its insufficiently Gothic character.

Here a short chronological summary, borrowed in

[1] See especially Trappes-Lomax: *Pugin*, 1932.

part from a modern writer on the 19th century,[1] may not be out of place. The year 1830 saw the building of the Travellers' Club in London by Charles Barry in the Italian-Classical style; the middle-'thirties saw the steady rise in reputation of Decimus Burton, and the appointment of a Select Committee on Arts and Manufactures. The year 1837 saw the death of Soane, and also that of Constable; the beginning of George Basevi's building of the Fitzwilliam Museum at Cambridge; and the beginning of Charles Barry's building of the Reform Club in London and Highclere Castle in Hampshire. The year 1838 saw the enormous advance in applied science represented by the building of the London and Birmingham Railway and by the crossing of the Atlantic by the steamship *Sirius*. In 1839 the sadly short-lived genius Harvey Lonsdale Elmes witnessed the building of his St. George's Hall at Liverpool, the most perfect monument to the Classical in England. In 1840 Decimus Burton built the modern-Grecian Grimston Park, Barry laid out Trafalgar Square and work was begun on his Gothic-Classic compromise at the Palace of Westminster. Throughout the 'forties railway building proceeded fast and spread all over the country, with the famous crash-producing mania for railway speculation reaching its height about the year 1845. In 1847 Philip Charles Hardwick designed the Great Hall at the Euston Terminus, the most important and beautiful late survival of Regency traditions, and a worthy addition to his father's station and great Arch.

[1] G. M. Young: *Victorian England*, 1936.

The new and violent impact of machinery might, if people like George Vivian and Paxton had always had their way, have had a radical effect on mid-19th-century architecture. But neither they nor any others were strong enough to offset the general defeatism in the face of the vast implications of modernity nor to undermine the consequent dependence on revived modes. Even the railway architects [1] failed, on the whole, to grasp the opportunity of contriving a new architectural language suited to a wholly new purpose. In the earliest days of the railway age, Brunel and Stephenson succeeded in fusing the functions of engineer and architect into one, especially in the designing of bridges and tunnel mouths; but even they occasionally translated an engineering work into one of the familiar revival conventions, either Grecian or Castellated. Exceptions are rare, but among them are Stephenson's great tubular railway bridge across the Menai Strait, opened in 1850, and Brunel's roadway suspension bridge, designed in 1831, which now soars across the Avon Gorge at Clifton. Both of these take their place with Paxton's Crystal Palace (in its original form) as the perfect marriage in the modern era of the architect and the engineer. They capture the imagination by their magnitude, their simplicity and their beauty, and in their designs they owe nothing at all to any past age.

The examples of Brunel and Stephenson were

[1] The word 'railroad' was displaced fairly early in England by 'railway', though it has survived in the United States. Ruskin used 'lines of railroad' as late as 1854, when publishing his 1853 Edinburgh Lectures on Architecture.

not widely followed. Most of the railway architects followed the domestic and civic architects, and designed their stations, bridges or tunnel-mouths in one or other of the revived modes. The majority of the early terminal stations were either neo-Classic, like Euston, or modified Palladian, like the original forms of Nine Elms, Broad Street, Leicester or Birmingham. The much later St. Pancras Station [1] was the first application to railway needs of the romantically exciting Gothic in place of the more solid dignity of the Grecian or the Palladian. King's Cross [2] alone deliberately announced its function, and still, though sadly obscured, stands apart, in its unique excellence and independence of the past, from all its fellows, whether they be its contemporaries or successors. In contrast to the great London and provincial terminal stations, the early small country stations were usually designed in a Cottage-Picturesque or Olden-Time mode, as if holding at arms' length the snorting iron monster they were destined to serve. Fortunately, a large number of them still survive all over the country; they may not be eloquent of the new railway age, but the bland inappropriateness of combining the form of the *cottage-ornée* with the requirements of modern science makes an appeal which it is impossible to resist. To a far greater extent than railway stations, however, tunnel-mouths were from the beginning seen to provide an opportunity for the engineer-architect. Occasionally they proclaimed

[1] Designed by Sir Gilbert Scott, 1865.
[2] Designed 1851 by Lewis Cubitt, a brother of Thomas and William Cubitt.

themselves for what they were, in classical simplicity. More often the novel and gigantic labour of piercing through a hill, the very thought of trains roaring through the dark earth to emerge safely into the light, called for something more romantic to emphasise the heroic achievement. The Gothic ruin and the castellated fortress were made, over and over again, to serve this purpose. The tubular bridge at Conway,[1] serving as an introduction to the great Castle, shows how successful this marriage of the past with the present could sometimes be. Railway-engineering was an adventurous and romantic modern marvel, and had to be seen as such.

There were, however, occasional complaints about railway stations looking not like railway stations, but like almost anything else. Some complaints of this nature came from influential quarters. *Punch*,[2] for instance, in 1848 said that there were far too many varieties and they were all inappropriate, and in support illustrated a Jacobean lodge, a Swiss châlet, a Turkish pavilion, a Grecian temple and an Italian villa. More formidable than *Punch* was Ruskin. In the *Seven Lamps*[3] he stated that 'one of the strange and evil tendencies of the present day is to the *decoration* of the railroad station'. In Ruskin's opinion, there could be no more impertinent and flagrant folly than ornamental railroad stations. Would anyone, he asked, be willing to pay an increased fare on the South-Western because the

[1] Designed by Robert Stephenson, opened 1850 at the same time as his Britannia tubular bridge over the Menai Strait.
[2] *Punch*, Vol. 14, 1848, p. 219.
[3] *The Seven Lamps of Architecture*. Lamp IV: Beauty.

columns of the terminus were covered with patterns from Nineveh? Or on the North-Western because the roof of Crewe station had Early-English spandrels? Since travellers by railroad were people in a hurry, they were therefore, for the time being, miserable, and in no frame of mind for the contemplation of beauty. Ruskin at that early period hated the railways, and could not see that they were even useful; but if they had to be, let nothing be spent on them but what made for safety and speed. It was not a widely-shared view. One concession, it must be admitted, was made by Ruskin, which must have been warmly approved by Vivian, Brunel and Paxton, if any of them ever read it. 'Railroad architecture', he wrote in the passage already quoted, 'has or would have dignity of its own if it were only left to its work.'

ART AND THE STATE

EARLY in 1840 the new Palace of Westminster was so far advanced that the question of its internal decoration began to occupy a few minds. It had already, it seems, begun to do so about eighteen months earlier when the *Quarterly* uttered a word of warning[1] about what was assumed, rightly, as it happened, to be the official intention. 'Government', said the *Quarterly*, 'may cover the walls of the new Houses of Parliament with subjects from our national history. Louis-Philippe is giving this sort of encouragement to art at Versailles. The result when measured by the yard or mile may be magnificent, but we doubt its success when measured by another standard.' This reference to the Versailles of Louis-Philippe recalls the gallery of Victories of the French Navy painted by Baron Gudin, which, some thirty-five years later in the 1870's, was dismantled. Since the decoration, internally, of the Palace of Westminster came to occupy so large a part of the public attention during the 1840's, it would be as well to recount the course of events.

In February 1841 the President of the Board of Trade, Henry Labouchere, doubtless with an eye on the future decoration of the Houses of Parliament, asked for a grant for some experiments in the technique of fresco-painting. This request seems to have

[1] *Quarterly Review*, vol. 62, 1838.

started the ball rolling. The Prime Minister, Sir Robert Peel, appointed a Royal Commission 'to take into consideration the Promotion of the Fine Arts of this Country, in connexion with the Re-building of the Houses of Parliament'. The man whom Peel appointed as Chairman of this Com-mission was, to the astonishment of most people, Prince Albert; he was then aged twenty-two and had been in England, as the Queen's husband, for less than two years.

There can be little doubt, as Lady Eastlake said,[1] that Peel had already realised the remarkable charac-ter and abilities of the Prince, and had been hoping for an opportunity to make use of this hitherto waste power in a direction that would not provoke political controversy. Here was Peel's chance, and he took it; the young Prince's abilities were thus directed on to official yet non-political territory, which offered that 'neutral ground in public matters on which a royal individual could safely tread'.[2] Prince Albert, it may be said, startled everyone concerned, by showing at once that he did not regard the Chairman's duties as merely nominal. He further startled everybody who did not already know him well (and few did), by showing an extraordinary knowledge of conditions governing the practice of the arts, and by his under-standing of the artist's mind.

The Royal Commission at once appointed a Select Committee on the Fine Arts, which issued its

[1] *Quarterly Review*, January 1862: Obituary Notice of the Prince Consort, written by Lady Eastlake anonymously.
[2] Ibid.

first Report as early as June 1841.[1] This Committee included Sir Benjamin Hawes, Henry Labouchere, Henry Gally Knight, Sir Thomas Wyse, William Ewart, Sir Robert Peel himself, Sir Robert Inglis, Henry Thomas Hope of Deepdene, Philip Pusey, Colonel Rawdon, Monckton Milnes (afterwards first Lord Houghton), Lord Brabazon and Lord Francis Egerton (afterwards first Earl of Ellesmere). Some of these, doubtless, were passengers, but on the whole this selection shows a fair balance between men who were experienced amateurs of the arts and men who were more concerned with the arts as educational and sociological factors. This Select Committee, in its first Report, expressed unanimously the opinion that this important national undertaking should be the means of encouraging not only High Art, but all the subordinate branches as well. A more immediately practical decision was that the Houses should be decorated with several series of large paintings, either Historical or Allegorical in subject and either oil or fresco in technique. To help them to their decisions on these points, they summoned and examined a number of eminent men who carried high authority in matters of taste; these included the architect himself, Charles Barry; William Dyce, the Superintendent of the School of Design; Sir Martin Archer Shee, President of the Royal Academy; Bellenden Ker, the great advocate for the popular diffusion of art and literature and one of the founders of the Arundel Society; George Vivian;

[1] P. S. King: *Catalogue of Parliamentary Papers*, vol. 1, p. 204, no. 2843: 'Report of the Committee on the Promotion of the Fine Arts. . . . Evidence, Appendix and Index. June 1841.'

131

and Charles Eastlake. These, together with the members of the Select Committee, formed an impressively powerful debating body, which was a quite sufficient guarantee that the matters would be discussed with intelligence and a proper sense of responsibility.

After prolonged debate by the Select Committee and the eminent witnesses, it was decided that the paintings for both Houses should depict History rather than Allegory, and that they should be executed in fresco rather than oil. History meant illustration of Britain's achievements in 'the nobler activities of mankind' (which, needless to say, included war and conquest). True to their epoch, the Committee preferred the factual and direct to the allusive and oblique, and it is not surprising that there was no strong support for Allegory. For one thing, there was always the danger that Allegory, unless most rigidly controlled, would tend to savour of a pagan impiety; it could hardly be said that either the robust baroque goddesses of Sir James Thornhill or the drooping classical nymphs of Angelica Kauffmann would have been a suitable guise for the industrial Britannia of 1840. For another thing, history was partly a series of moral lessons for posterity to mark and digest, and partly a series of material benefits which had accumulated to the advantage of the present. Not only was such history a glorious background to the solid splendour of Britain's position in the world, but the graphic illustration of certain aspects of it, easily apprehended by everybody, would express the ideology underlying the Crown, the Constitution and the Empire. So History, unquestionably, it must be.

Nevertheless, both George Vivian and Bellenden Ker urged that neither History nor Allegory be adopted, on the realistic ground that to embark on such schemes in the present state of the arts in England might be rather hazardous; urging a non-committal course of safety, they recommended a purely decorative scheme of arabesques and friezes, and were heavily defeated.

The decision to employ fresco is a reflection of the wide influence which German art was then exercising in this country. King Otto at Munich and Cornelius at Düsseldorf were accepted as the standards of reference, even by Eastlake when it came to a question of technique. One of the witnesses before the Select Committee, Thomas Wyse, said that he had actually discussed the matter with Cornelius himself as early as 1839, and that the Master of Düsseldorf had described this as an admirable opportunity for founding a School of fresco-painting in England. Another witness vehemently urged that Cornelius be brought over to carry out the whole scheme. It is remarkable that throughout the Select Committee's Report no suggestion was made that the paintings should be in the same style as the architecture of the Houses—that is, in a Revived Medieval style. From the beginning it seems to have been accepted that they should follow the modern German version of Raphaelesque Italian. Eastlake had grave doubts about the wisdom of this, but the Prince, not unnaturally, shared the majority's Germanic view, and Eastlake was apparently reluctant to give him contrary advice.[1]

[1] William Bell Scott: *Autobiographical Notes*, 1892.

133

The last of the hurdles on the first lap which faced the Select Committee was the question whether the artists to do the work should be appointed by direct commission or be selected in open competition.. Archer Shee boldly spoke out for the former course, but the Committee played for safety and decided on the easier course of competition. Early in 1842 a competition was announced for designs selected, either from British History or else from the works of Spenser, Shakespeare or Milton—the full extent of the official literary Pantheon. A very large number of Cartoons must have been sent in, and about 140 were selected for awards, whether or no they were eventually to be used. An exhibition of these was opened in July 1843, and excited enormous public interest, being visited, it seems, by twenty to thirty thousand people a day for two months.[1] Many of the humbler visitors insisted on bringing their infants with them, and Eastlake describes these as being collected in droves by the police and being packed up in the vestibule of Westminster Hall to await collection by their parents. The Queen, of course, visited the exhibition, and was shown round by the Prince. It was his first triumph in the field that later he made so peculiarly his own—the arts in service to the public.

Among the competitors whose cartoons were rejected were William Bell Scott and B. R. Haydon. Both had the generosity of spirit to admire the successful designs and to record their admiration.[2] Poor paranoiac Haydon, however, soon abandoned

[1] Lady Eastlake: *Memoir of Sir Charles Eastlake.*
[2] William Bell Scott, op. cit.

134

his mood of generosity. His disappointment must have been infinitely more acute than Bell Scott's, for he had everything at stake, as he always had with every new enterprise. On 1st June, 1843, he had written in his *Journal* [1]: 'Oh, God, I thank Thee that this day I have safely placed my cartoons in Westminster Hall. Prosper them!' Three weeks later Eastlake had to break to him the news that they were not among those selected for reward. For a month Haydon bore up bravely and generously, but before long he fancied hostility on the part of the Royal Commission. In the words of John Wilson Croker,[2] he expected the Deity to avenge his quarrel with the Royal Commissioners, but seemed in doubt whether his Heavenly Champion or the Government would have the best of it. Croker quoted Haydon's almost incredible remark in the *Journal*: 'I have trust in God, and we shall see who is most powerful—He or the Royal Commission. We shall see!'

The successful artists whose designs were carried out in various parts of the Houses of Parliament were William Dyce, C. W. Cope, E. M. Ward, J. C. Horsley, Daniel Maclise, John Tenniel and G. F. Watts. Although Parliament had finally approved the scheme for decoration by 1847, it was not until three years later that the Treasury decided to vote any money for the purpose; but then it voted £4,000 a year, which was not ungenerous.[3] *Punch,*

[1] Edited by Tom Taylor, 1853, 3 vols.

[2] *Quarterly Review*, 1853. Review of the above; anonymous, but by J. W. Croker.

[3] There were many delays in the execution of the work, due to disputes between the Commissioners, Barry and Pugin and to the

of course, had a skit on Historical High Art in general, and the Westminster designs in particular, which hammered away at the dull and unintelligent eclecticism that passed for High Art and at the cloak-and-sword dramatics that passed for History.[1] It attacked also Prince Albert, but no doubt the Prince was already beginning to immunise himself against *Punch's* weekly injections of venom; he had many more years of them yet ahead of him.

One of the principal ideas behind the appointment of the Royal Commission was, as we have seen, the ambition of improving public taste by raising the standard of design and technique. By the beginning of the 'fifties most people were agreed that the decorations at Westminster would actually improve public taste. The formidable John Wilson Croker, however, was sceptical; and Croker commanded no small authority. By 1853[2] he was beginning to wonder how far the work would serve its purpose of improvement. 'When the first novelty is over,' asked Croker, 'will these works appear deserving of the eternity for which they are destined?' Nor did he think that the employment of several different artists working in an unfamiliar medium would be at all a successful project. Finally, Croker suspected that the next generation might reverse the current judgement; a true enough suspicion, since that is what next generations always have done throughout

difficulty of painting in fresco on walls that were still unfinished. Dyce's work, in the Queen's Robing Room, never was completed; one panel still remains blank.

[1] *Punch*, 1847, vol. XII, p. 19.
[2] *Quarterly Review*, 1853.

history. They might, he suspected, decide that bare walls would have done less discredit to the national taste than the things with which Haydon's theory of High Art would cover them. Haydon's theory it certainly was, but it was not to be put into practice by Haydon's hand.

Throughout the early stages of this affair a very important part was played by Sir Charles Eastlake. Mr. Eastlake, as he then was, in fact performed a triple role; he was at once the professional artist, the expert authority and the public servant. He had been among those originally invited by Peel to serve on the Royal Commission, but had declined, since, as a painter and a possible competitor, he could not be disinterested. As a painter, and an already distinguished Royal Academician, he was asked to give evidence before the Select Committee when the suitability or otherwise of fresco-painting was being discussed; but he found himself giving that evidence as an expert authority on Art History. Finally, and as a result of that evidence, Eastlake was appointed in November 1841 Secretary of the Royal Commission; it was against his will, but the Prince had insisted. From that moment Eastlake ceased to be a painter and became an authority.

The experiment in the Palace of Westminster is one of the extremely rare examples in England of State patronage of painting. This is not the place to discuss whether we now find the results admirable or otherwise; our own standards are not so fixed or established that we can safely judge an experiment of a hundred years ago with any assurance of certainty,

and such judgements must remain for some time expressions of purely individual taste. For better or worse, however, the result of Sir Robert Peel's Royal Commission of 1841 was that the State (personified by the Prince and the Select Committee) found itself patron and sole controller of a particular form of art devoted to a specific public purpose. No commercial considerations were involved. The object was, as was made perfectly clear, to secure the best available talent for the decoration of a great public building; and by that means to elevate, if possible, public taste. The elevation of public taste was nearly an obsession during the 1840's. The optimistic side of the Early-Victorian character believed that such a thing was possible; the materialistic side saw commercial advantage in it; and the nostalgic Olden-Time side of it saw a chance of getting back on to a footing with the past, and of producing a style of architecture and a standard of craftsmanship comparable with the best of earlier ages.

Certainly a large body of influential opinion believed that principles of good taste in the applied arts could be taught through schools and institutions, and that such teaching should be State-supported. Such advocates were careful not to urge taste for taste's sake, but stressed, very sensibly, the commercial advantages of the improvements in design which, they hoped, would result. This theory of State-aid was quite new in England, though it had for long been the accepted practice in other countries, as, for examples, in the porcelain and tapestry factories of France and the German Principalities. Since the

time when the Royal tapestry factory at Mortlake
had been subsidised by Charles I, no such enterprise
had existed in England. Some attempt had been
made to fill the gap by a private body, the Society of
Arts. This had been founded in 1754 'for the
Encouragement of the Arts, Manufactures and
Commerce of the Country, by bestowing rewards
... and generally to assist in the advancement,
development and practical application of every
department of science'. Just on ninety years after its
foundation, Prince Albert saw in the Society of Arts
a useful instrument for carrying out some of his own
ideas, and became its President in 1843. The Prince
and the Society (by then the Royal Society of Arts)
were together responsible for originating the Great
Exhibition of 1851.

It may be observed here, in passing, that the
architecture and applied arts of 18th-century England
do not appear to have suffered very gravely from the
total absence of official Royal or State patronage.
The supreme excellence to which they attained was
due to either direct or invisible authority of a
succession of individuals. It was fairly obvious to
most people in the 1830's and 1840's, on the other
hand, that though many individuals claimed to
exercise high authority, no one actually did. It was
not, however, obvious to Haydon. He remained
convinced that, at any rate in High Art, one indivi-
dual could exercise dominant authority—himself;
but even he must have State aid for his authority to
bear full fruit. And Haydon, further, was a strong
advocate of State aid for design in the applied arts.
In 1834 Haydon had an interview with Lord Mel-

bourne, then Prime Minister, and gave an account of it in his Journal[1] which is so revealing of Melbourne and Haydon that part of it must be quoted.

'Called on Lord Melbourne and, after a little while, was admitted. He looked round with his arch face and said "What now?" ... "Now, my Lord," said I, "I am going to be discreet for the rest of my life, and take you as an example." I got up and was eagerly talking away when he said "Sit down." Down I sat, and continued, "Do you admit the necessity of State support?" "I do not," said he, "there is private patronage enough to do all that is requisite." "That I deny," I replied ... he then went to the glass and began to comb his hair.' Haydon went on to urge that High Art had flourished wherever it had been supported by State patronage, and Melbourne continued to deprecate State interference, until Haydon produced an argument which might have convinced Peel a dozen years later but which probably left the very eighteenth-century Melbourne unconvinced. ' "High Art," said Haydon to the Prime Minister, who may still have been combing his hair, "does not end with itself. It presupposes great knowledge, which influences manufactures, as in France. Why is she superior in manufactures at Lyons? Because by State support she educates youth to design." '

Lord Melbourne was the principal recipient of Haydon's message so far as High Art was con-

[1] B. R. Haydon: *Journal*, 19th October, 1834. Haydon's great attention to conversation and his genius for recording it inspire confidence that he has accurately reported the words of Melbourne and himself. Melbourne was Prime Minister from June to November 1834.

cerned. But, as the last sentences of the above-quoted passage indicate, Haydon also had a message about industrial art; the principal recipient of this was William Ewart.[1] Ewart formed a Committee in June 1836 to consider the connection between arts and manufactures, and thus made one of the first serious attempts to relate informed and experienced taste on the one hand with popular commercial requirements on the other. The committee examined manufacturers and also artists, connoisseurs and art-dealers. Haydon himself was examined, about eight months after the conversation with Lord Melbourne, and was considerably strengthened in his belief in his own mission; but if he were strengthened in that, he was equally strengthened in his conviction of hostility on the part of the Royal Academy and the Trustees of the National Gallery. There certainly was hostility, for which Haydon's own unfortunate manner over more than thirty years was at least partly to blame. Yet many of Haydon's recommendations, made to Ewart's committee and on other occasions, were ultimately adopted, not, however, before his despairing, self-inflicted death.

After his examination by Ewart's committee on 28th June, 1836, Haydon wrote in his Journal, '. . .I must believe myself destined for a great purpose. I feel it, I ever felt it, I know it.' However little of that ambition may have come true, one result at least of

[1] William Ewart, 1798–1869, of Liverpool. One of the great reformer Members of Parliament. Among many other causes, he advocated the opening of museums and galleries to the working-classes, free from prevailing restrictions. The terms of reference of his 1836 Committee included, in addition to Industry and Design, enquiries into the R.A. and the National Gallery.

the Ewart Committee's report was the establishment
of the Government School of Design, which was
opened at Somerset House in 1837. Haydon's
vehement advocacy of State patronage must have
had a good deal to do with this. From that point
onwards, opinion, and to some extent events, may
be seen as tending steadily, though not without
obstruction, towards the triumph of the Great
Exhibition.

A minor but typical symptom of the tendency in
the late 'thirties is seen in a paper by George Jack-
son read at the Mechanics' Institute at Manchester
in October 1837 on 'A School of Design for the
Useful Arts'. This was a plea for improvement, with,
throughout, a double emphasis on artistic and moral
improvement—the second being expected to follow
as a matter of course from the first. The author
pleaded for elementary instruction in drawing and
designing for the young, in order to elevate the
standard of textiles and manufactured objects; and
he also pleaded for the instruction, amusement and
general education of the working-classes in order to
improve their minds and thus, as what seemed a
natural consequence, to improve their morals. George
Jackson's pleas and contentions are representative of
a good deal of argument made public either by
papers read at meetings or by published pamphlets.
First, he urged the establishment of a permanent
exhibition of 'the works, not of the Ancients, but of
the present day; not of the things of luxury alone,
but of everyone's necessity. . . . The access to this
emporium of useful arts should be free, and its time
of access from early morn till late at night; sit

utility in spreading knowledge, and its great good in checking vice, would depend on this.' Then, secondly, Jackson developed that point with: 'The great cause of much dissipation and crime is the want of some such emporium as this, in which spare time might be passed to profit and amusement.' And finally he delivered a rebuke to Manchester which really was an oblique and heavily-disguised compliment to that already self-conscious city: 'The present state of the arts of design I consider to be a blot on the fair fame of our country, and particularly so to Manchester where, if a different course were adopted, she would increase her wealth—add to her reputation—become the dictator of taste—and confer a benefit on mankind at large.'

The hopes of the obscure George Jackson, as expressed in this forgotten paper, have not all been fulfilled. Some of them never could be. But in one respect at least he is typical of mid-19th-century Liberal thought: that by raising the æsthetic standard of the people, preferably by State or public enterprise, you would automatically raise the ethical standard. This was an article of faith held by philanthropists, reformers, educationists and social workers in a very impressive degree of conviction; it must be distinguished sharply from the other widely held conviction that an improved æsthetic standard would earn improved commercial dividends. The problem common to both schools of thought was how to elevate the æsthetic standards of the people. The Government Schools of Design seemed to promise an answer. Everyone appears to have agreed on that and, in the words of William Bell Scott many

143

years later,[1] 'various men were ready to advise and prescribe, Mr. Haydon among others, whose lectures had done much good but who never could work in union with anyone'. William Bell Scott was not among those who chose to complicate the issue with ethical or moral considerations. With evident agreement, he ascribed the Government's action in founding the School of Design to its fear 'that our want of taste would countervail the advantages of our machinery and the excellence of our materials'.

The Government School of Design began in a small way and, when it actually came to the point, met with but a small response. A Council was formed, presided over by Poulett Thomson, the President of the Board of Trade, and consisting of the nearly inevitable Henry Bellenden Ker, Alderman Sir William Copeland (the porcelain manufacturer, and Lord Mayor of London) and four artists: Eastlake, Callcott, Chantrey and Cockerell. It does not appear to have been a very effectual committee. It first met in December 1836, and for more than eighteen months was quite unable to advise on what a Government School of Design should actually do. The only unanimous conclusion it came to was a not unsound one—that while the School's function was to educate in art, it was absolutely necessary that it should avoid rearing artists. This decision caused a storm, a contributing factor being confusion between a school of design and an *école de dessein*. Those who had hoped that the Government School was going to teach such things as drawing, perspective, colour and modelling to promising art students were fur-

[1] Retrospective article in the *Fortnightly Review*, October 1870.

iously disappointed. But, as W. B. Scott himself pointed out,[1] such was the ignorant hatred of art indulged in by many Englishmen of the day, that the opposite decision would have been at least as furiously assailed. As it was, the Board of Trade provided a printed table of rules for its School, one of which said that no one intending to follow any of the Fine Arts professionally was admissible as a student; and another that drawing the human figure was forbidden.[2] This, however, is to look ahead a little bit.

The original committee that met at the end of 1836, after many months of nearly fruitless deliberation, decided that William Dyce must be called in to help. This distinguished painter was at that time directing an enquiry for the Scottish Board of Trustees for Manufactures, Scotland then also holding the view that a Government School of Design was the infallible means to the improvement of industry. Dyce was seized by the London committee and sent off by the Board of Trade to examine the State schools in Prussia, Bavaria and France. In his report made on his return, Dyce defined his own purpose as having been 'to examine what kind of influence is exerted by schools of art; or whether they, by themselves alone, confer the great and palpable benefits in manufactures which it has of late been so much the fashion in this country to ascribe to them'. Here indeed was a rather disconcerting note of scepticism sounded by a distinguished authority. Worse followed. 'It is evident', continued Dyce, 'that we

[1] William Bell Scott: *Autobiographical Notes.*
[2] Ibid.

must cease to look upon the mere establishment of schools of design as an infallible *nostrum*, and regard them as only one among many agents in promoting the cause of manufacture.'

This was a rebuke to the easy-going optimists, but nevertheless his report brought Dyce the appointment, in July 1838, of Director of the Government School of Design at Somerset House. Five years later, in 1843, he resigned. He was, after all, a professional painter, and he could no longer bear to devote the whole of his energies to tedious and sadly unrewarding administrative duties; the competition for the Westminster Palace frescoes provided a much better application of his great artistic gifts. It was after Dyce's resignation and under the directorship of Charles Heath Wilson, with Bellenden Ker as chairman, that the sharp definition was made between industrial art and fine art, and that the School of Design formulated the Board of Trade rules quoted above. The storm caused by these rules brought with it resignations of teachers and secession by the leading students. A lull ensued at Somerset House, which was only brought to an end in 1851, by the Great Exhibition. Sir Henry Cole went so far as to say[1] that in his opinion the School of Design and its offspring in the provinces were until then useless and a waste of money. Cole, with half-a-century's experience of administration, and as the real founder of the Victoria and Albert Museum, did not speak without authority. Sir Henry Cole, it may be noted, differed from the school of thought represented by Haydon and Bellenden Ker, in believing that

[1] Sir Henry Cole: *Fifty Years of Public Work*, 1884.

voluntary enterprise in art instruction should be fostered throughout the country, and that Treasury assistance should encourage but never supersede it. The advocates of State support, however, had their way. In 1840, while Dyce was still at Somerset House, Government grants were made to establish schools of design in certain provincial cities, such as Manchester, Birmingham, Glasgow, Paisley and Leeds. Within a very few years it began to be evident that something was wrong. Some people even came round to the view that the State could not provide the answer to everything; that, for example, it could not elevate taste where taste was wholly absent.

Let us remind ourselves once again that it is not a question of whether the products of the 1840's seem to us to be in good taste or bad. To the men of the 1840's the question was whether British products were in better taste than those of France, Bavaria, Prussia or anywhere else. The standards were those of the educated and discriminating men who alone are entitled, in any period, to pronounce in public their views on such a subject. It must be admitted that the view of many of the men thus qualified to answer that question was that British products were in far worse taste than those of their chief continental competitors. The mills and factories of Britain were humming day and night, and goods were pouring out. This was regarded as admirable by those who held the view that the more goods you can produce the more you will sell and will go on selling. It was regarded as less admirable by those (and they were both many and influential) who believed that trade

147

depended on the excellence more than on the total bulk of goods produced. They were able, as it happens, to bring forward the powerful argument that, despite the Government Schools of Design, enterprising manufacturers still, five years after their establishment, had to call in foreign designers out of sheer necessity.

The *Quarterly Review* published a long article on the subject of Design in Industry in 1844.[1] This article emphasised the point that it was in design rather than in productivity that the average workman was at fault when compared with, for example, the French. This, said the *Quarterly*, was because we had so long neglected the cultivation of taste in the artisan, whereas the French, by contrast, designed upon long-settled principles. It was from this 'notorious deficiency in the higher requisites' that British manufacturers had the greatest difficulty in making headway against their continental rivals, whose goods were so much more attractive. In criticism of the Government Schools, the *Quarterly* quoted from an obscure source which, nevertheless, expressed the situation simply and clearly. The source was a paper read by a Mr. Crabbe to the Decorative Art Society, presumably in or shortly before 1844: 'Our whole system', said Mr. Crabbe, 'has now to be changed . . . we have only to compare the productions of France and Germany with our own and we shall find that their staples are all con-

[1] Anonymous, but by the Rev. Henry Wellesley. He was a regular contributor to the *Quarterly* on matters connected with the arts, and his articles, read as a whole, are both impressive and important.

148

nected with *taste* and that our staples are those of quantity.'

Punch, in 1845,[1] for once abandoning the facetious and contumacious note of its early issues, spoke with deep and well-reasoned earnestness on the same subject. It had been, thought *Punch*, a hopeful day for England when the Minister had announced the resolution to found a British School of Design; Manchester, Sheffield and Norwich rejoiced; 'even Spitalfields lifted up her wan face and thought how henceforth she would meet and beat the patterns of the French'. But the hopes of *Punch* had not been fulfilled, nor, it maintained, had those of anyone else, including Pugin. Pugin himself was quoted as having said, 'I do not use too strong language when I say that the School on its present system is worse than useless, for it diffuses bad and paltry taste.' Then *Punch* launched itself into the recurrent, and permanently valid, attack on the stupidity of officialdom when dealing with men of original talent. 'At the present time,' it said, 'Mr. Pugin has the direction of the greatest amount of decorative work[2] that may be required by Government for half a century. And who executes this work? He was compelled to take steamer and cross the seas. And now he returns with workmen from Louvain, Bruges, Ghent.' The 'removal' of William Dyce from the directorship of the Government School was bitterly attacked by *Punch*; though Dyce, with all his great ability, must have been a trying man to deal with, as the Royal Commission on the Fine Arts discovered. As to his

[1] *Punch*, vol. IX, 1845.
[2] At the Palace of Westminster.

successor, Charles Heath Wilson, *Punch* merely observed, 'It is said that Mr. Wilson is a decorative gardener. It is a pity for the success of the School of Design that he was ever transplanted from Edinburgh.'

It will be remarked that much of the argument exemplified by the articles in the *Quarterly* and *Punch* is based on the premise that you can teach good taste to a people in whom it is neither a natural gift, nor a racial characteristic, nor an inherited and still active tradition. This belief in the extended powers of education was not widely held before the emergence of 19th-century Liberal democracy. Ruskin, however, had another answer to the problem. 'All our schools of design', he wrote,[1] 'and committees of taste, all our academies and lectures, all the sacrifices which we are beginning to make . . . will be as useless as efforts and emotions in a dream, unless we are content to submit architecture and all art, like other things, to English law.' If this means anything, it means that Ruskin was advocating a Ministry of Fine and Applied Arts, with legislation to follow, and penalties for the infringement of Acts of Parliament in matters of taste.

Despite attacks and ridicule, and despite muddles and false starts, despite even the loss of Dyce's services, the Government Schools of Design did not expire. They lived, barely animate, until the stupendous project of the Great Exhibition came both to save and transfigure them.

There is another early Government excursion into

[1] Ruskin: *Seven Lamps of Architecture*, 1849; the Seventh Lamp.

the field of applied art which deserves mention, and that is the celebrated and unfortunate Mulready Envelope. By an Act of August, 1839, penny postage had been introduced.[1] This very beneficent revolution meant that the cost of sending a letter was now paid by the sender instead of by the recipient. Postage stamps, to be stuck on the envelope by the sender, were required by the Post Office, and their design was a subject of much discussion. In the end, William Wyon, chief engraver to the Mint, and a very great medallist in the classical tradition, was commissioned to design the adhesive stamp bearing the Queen's head. At the same time, the Post Office decided to put into use a stamped envelope as well— that is to say, an envelope bearing an embossed stamp instead of an adhesive one. Henry Cole, at that time a senior keeper in the Record Office, was charged to obtain a design for this. He consulted Sir Martin Archer Shee, President of the Royal Academy, and also Charles Eastlake, of course; he also consulted the sculptor Sir Richard Westmacott, the architect C. R. Cockerell and the painter William Hilton. As the result of these consultations, the painter Mulready was commissioned officially to design an envelope. He produced one described by Cole as 'highly poetic', which was much admired by the Royal Academicians, officially approved and issued, and instantly and loudly ridiculed by the public. The envelope was intended primarily for use in business houses, so its poetic quality seems re-

[1] Through the single-handed efforts of Sir Rowland Hill, in the face of continued obstruction and opposition by successive Governments and by the higher officials of the Post Office.

dundant. The function was perhaps not very care-
fully considered by the designer, for more than half
the surface area was taken up by the ornamental
design. In the centre was Britannia, with a
recumbent lion; to right and left were scenes from
life in the Indies, the Far East and the Americas; in
the lower corners were wives and children eagerly
receiving letters from their loved ones without hav-
ing to pay for them themselves; and along the top
flew four angels, hurrying to the four corners of the
world. Somewhere there was room for the sender to
write the name and address of the recipient, but
there was not very much. The Mulready Envelope
was not a success, and quickly sank into oblivion.
On the other hand, Wyon's wonderful first stamps of
Queen Victoria have not yet been surpassed in
philatelic design.

Sir Henry Cole felt very keenly the fiasco of his
Mulready Envelope. About seven years later he
again ventured into commercial art, but in private
rather than officially. This was with a Christmas
card for 1846. William Bell Scott had been before
him with the idea, but in that instance the idea had
been still-born. He had designed, in 1837, a large
Christmas card of foolscap size, with the Virgin in
Glory at the top, verses of a carol running down each
side, and a medieval boar's head dinner-party at the
bottom. No publisher, it seems, would venture on
producing this odd assembly of allusions for Bell
Scott. In any case, it was thought to be too papis-
tical. Carols, moreover, were apparently becoming
vulgar. Cole had better luck with the Christmas
card which was designed for him in 1846 by J. C.

Horsley, R.A., and published by Summerley of Bond Street. This was one of the first Christmas cards ever published and was the beginning of that connection between commerce and the major Christian festivals which has so clearly reflected the tastes of successive generations.

THE PRE-RAPHAELITE BROTHER-HOOD

In an earlier chapter the state of painting in England and also in Germany during the 'thirties and 'forties was discussed, and was seen as foreshadowing the rise and gradual acceptance of the Pre-Raphaelites. The movement to which they gave their name was one of the most important and interesting in the whole history of 19th-century art, but it was not, as is often claimed for it, a revolution. It endeavoured to establish certain doctrines which, in a diluted form, continued active for two generations; but it did not permanently supplant the accepted standards against which it revolted. These, though perhaps dethroned for a short while, were so deep-rooted in Victorian taste that they persisted until well into the present century. As the background to the Pre-Raphaelites, an essential part of the story is the art of their contemporaries. The tendency until recently has been to present the Pre-Raphaelites as actors in a serio-comic drama, with no prologue, but with, perhaps, an epilogue, extending to the 'nineties. Certainly the individuals and their models who made the movement contrived, in their lives, to provide enough drama for a score of first-class biographies and narrative accounts. In the story of mid-19th-century taste in art as a whole, however, the Pre-Raphaelites ought really to be viewed with either the same focus as that applied by us to their contem-

154

poraries or else the same as that applied by their contemporaries to them. Although the contemporaries of the Pre-Raphaelites have already been discussed earlier, it would be well, even at the risk of some repetition, to say a little more. It may also be repeated that the German Cornelius, who by his youthful influence affected the Pre-Raphaelites, had also, as a self-proclaimed Master, an influence on the Grand Historic School in England, as exemplified at Westminster. Thus one link joins two very different lines of development.

To revert to the historical school as represented at the end of the 18th century by Benjamin West and in the next generation by Haydon, the German Passavant may again be quoted.[1] The historical department of painting, he observed, thinking in terms of what was being done and preached in Germany, was far too little encouraged in England. For the attainment of the higher branches of art, in Passavant's opinion, 'there should exist a self-contemplative thoughtfulness, such as can penetrate into the depths of our spiritual being; in a word, a people imbued with a deeply poetic feeling'. This, if it means anything, means that such qualities when possessed by a people will produce artists who can compare favourably with Peter Cornelius. Judged by this criterion, the English fell down badly. 'Enough has been said', concluded Passavant, 'to prove that there exist no grounds for anticipating their advancement in the higher walk of art, or even for admitting that the feeling for it is possessed by them.' Passavant was not a very perceptive person,

[1] Passavant: *Tour in England*, 1832; trans. Elizabeth Eastlake.

but no amount of perception could have told an observer in the early 'thirties that within twenty years a handful of painters could have made their mark through precisely those qualities of thoughtfulness, spirituality and poetry; and that they would have moved in the opposite direction from Passavant's 'higher' or 'historic' department of painting.

Although Constable had died when Rossetti, Millais and Holman Hunt were still boys in 1837,[1] Turner lived on until 1851, an eminent but solitary giant. Probably Turner entered less into their consciousness than other Royal Academicians more typical of their age, but his stock was beginning slowly to rise, in the estimation of experienced observers, after the slump that had overtaken it soon after 1820. Since both Turner and the Pre-Raphaelites found the same champion, in Ruskin, this matter of Turner-appreciation is not irrelevant.

William Bell Scott[2] provides a revealing little glimpse of Turner at a dinner-party in Edinburgh in 1831. It is quite clear from the context that Turner was considered a great man, even by the latter-day Athenians of Edinburgh. Great man he might be, but, if that dinner-party were typical, Edinburgh fashionable intellectuals held an unfavourable opinion of him. Bell Scott recorded that the guests included Turner himself, Francis Grant and Daniel MacNee[3]; the great joke of the

[1] Dante Gabriel Rossetti, 1828–82; John Everett Millais, 1829–96; William Holman Hunt, 1827–1910.

[2] William Bell Scott: *Autobiographical Notes.*

[3] Francis Grant, 1803–78; afterwards Sir Francis, and President of the Royal Academy. Daniel MacNee, 1806–82; afterwards Sir Daniel, and President of the Royal Scottish Academy.

evening and the prevailing topic of conversation was Turner's Cockney accent and conspicuous lack of culture. The Master, it is to be feared, fell far below the standards of gentility which the New Town has for so long upheld.

Lady Eastlake, a more sensitive but less impersonal observer than Bell Scott, vividly recorded [1] the rise of Turner in her own estimation. Most of what Lady Eastlake said about her contemporaries is worth listening to. In March, 1844, when she was still Miss Rigby, Lockhart (the editor of the *Quarterly*) and his wife dined with her and her mother in Edinburgh. Also present was 'Turner the artist, a queer little being, very knowing about all the castles he has drawn; a cynical kind of body, who seems to love his art for no other reason than because it is his own'. But she was impressed, and a couple of days later she admitted, looking at some of his water-colours, that if Turner is sometimes beyond our comprehension, that is perhaps our fault. 'He can never be vulgar,' she wrote, 'if vulgar means common, for his faults are as rare as his beauties.' A year later, in February 1845, she offered unstinted praise, in such expressions as: 'Absolutely unfair to place Turner in competition with others', 'a bit of reality among ranks full of imitation'; 'he does what he will, the others what they can'; 'objects fused in light, becoming visible from amidst the furnace of his glory'. Miss Rigby's future husband, Charles Eastlake, had already in 1829 arrived at much the same opinion, though he expressed it more moderately. In a letter

[1] *Journals and Correspondence* of Lady Eastlake, ed. Charles Eastlake Smith.

of that year, from Rome, he mentioned being joined by 'Mr. Turner,[1] the landscape painter'. In a later letter of the same year he said: 'I am disposed to think that the excellences which belong to Painting are more understood in England by a few men than anywhere else. Of these, it is my opinion that Turner is the first, without going to the length of admiring all his extravagances, though his very exaggerations have opened my eyes to his real merits.' That was high praise from the cautiously critical young Eastlake, to whom Venice meant Titian rather than Turner's Lagoons and Grand Canal.

Punch, so far as late Turner was concerned, found it altogether too much of a bad thing. Writing of the Academy exhibition of 1845, it said of Turner's 'Whalers' that it 'embodies one of those singular effects which are only met with in lobster salads or in this artist's pictures. Whether he calls his picture Whalers, or Venice, or Morning, or Noon, or Night, it is all the same.' This was written, unfortunately for the critic, just before Ruskin's *Modern Painters* made Turner, in the late evening of his life, a popular success among a public at least as numerous as that which read *Punch*.

Dr. Waagen, Passavant's fellow-countryman, has already been quoted in an earlier chapter for his remarks on art in England in and before 1838. In his later compilation of 1854,[2] Waagen wrote of Turner that in his last period he appears to have aimed at a mere indication rather than a representation of his thoughts. This Waagen found hard to forgive, and

[1] Quoted by Lady Eastlake in her Memoir, op. cit.
[2] Waagen: *Treasures of Art in England*, 1854.

he was himself unable to share the rapture, as he put it, of the many Englishmen who preferred Turner's later to his early period. That Turner's later and most atmospheric pictures aroused within his life-time an admiration limited in extent, but profound, is evident from other sources than Waagen. But Waagen was not among the admirers. He adhered, as he said, to the sober conviction 'that a work of art executed in this material world of ours must have a complete and natural body as well as a beautiful soul'. In asking for naturalism complete in every de-tail, Waagen was at one with the majority. Beauty of soul, or spiritual beauty, however, was a very different matter, and one which Waagen did not follow up; had he done so he must have followed Ruskin as advocate for the Pre-Raphaelites. Only by them, and only for a short while, were naturalis-tic and spiritual intensity combined.

To us, a century after the Pre-Raphaelites made their first impact on the public, Turner is immeasur-ably the greatest of the painters then living. But to their contemporaries, except a very few, he was not the most important. Wilkie, dead in 1841, lived in memory as the greatest of modern painters. Maclise, according to the experienced observation of William Bell Scott, was generally regarded as the ablest and most inventive draughtsman of England. When Eastlake was musing in Venice in 1829 on English painters, he clearly thought that there were a few who understood their art better than those of any other country. Whom, one wonders, had Eastlake in mind, apart from Turner? Constable, one hopes, though he does not say so. Wilkie? James Ward?

He would have been right had he had them in mind; possibly he had. Fifteen or twenty years later he might have, but not necessarily would have, included Sir Augustus Callcott, then widely regarded as the greatest landscape-painter of the British School; Landseer, of whom Lady Eastlake rather intemperately wrote that in honouring him 'future generations will rival but can never surpass us'; Etty, Frith, Augustus Egg, all well established in critical as well as popular favour.

The Pre-Raphaelite Movement was initiated in 1848 in deliberate revolt against, first, the slackness and general laziness in technical matters of contemporary painting; and, secondly, its triviality and banality. Even if the Maclises and Leslies and Landseers had been as good painters as Wilkie or Lawrence had been, the second charge would have remained. It would have been echoed, moreover, by many who were neither painters nor experienced critics, but in whom successive Academy exhibitions aroused feelings of irritation, derision or boredom, akin to those aroused by a small and constantly repeated repertory of anecdotes.

Charles Dickens, for one, felt this banality very strongly, though he would have been sadly upset had he realised that he was sharing an attitude of mind with the young Pre-Raphaelite iconoclasts. In a letter to the Baroness Burdett-Coutts,[1] dated from Rome 18th March, 1845, he described the professional artists' models hanging about on the steps of the Trinità de' Monti. 'I could not conceive', he

[1] *Letters of Charles Dickens to the Baroness Burdett-Coutts*, ed. C. C. Osborne, 1931.

wrote, 'how their faces were familiar to me, how they seemed to have bored me for many years.' Then he remembered that he had met them all, year in, year out, on the walls of the Royal Academy. There they all were, the Venerable Patriarch model, the Pastoral, the Assassin and the Haughty models, the women and children Family models. 'It is a good illustration of student life as it is,' thought Dickens, 'that young men should go on copying these people elaborately time after time, and find nothing fresh or suggestive in the actual world about them.'

Punch also had a good deal to say [1] about the lack of originality shown by the Academicians, and combined it with jokes about the equally trite clichés in picture criticism, particularly as written in the *Art-Union*. To quote the jokes in full would be as boring as *Punch* found the original topics to be. It is enough that they hammer away at the prevalence of the same historical subjects, of the same literary illustrations and of the same pompous portraits of unimportant people. The more eminent artists are guyed under thinly disguised names, such as Maclish, R.A.; Mulrowdy, R.A.; Ledslie, R.A.; or Picklegill, R.A. *Punch's* happiest suggestion, in 1845, is that in future Academy exhibitions the largest room be devoted exclusively to portraits, while the next largest be set apart for Vicars of Wakefield. As for historical subjects, the Westminster Hall Cartoons in 1847 exasperated *Punch* once more. Of Pickersgill's 'Burial of King Harold', it said, 'King Harold is buried at last; and we hope that British

[1] E.g., 1841, vol. 1; 1844, vol. 6; 1845, vol. 8; 1847, vol. 13; 1853, vol. 24.

artists will leave off finding his body any more, which they have been doing in every exhibition these fifty years.' And as for the eminent Landseer, almost sacrosanct, *Punch* contrived to give a combined joint kick both to him and to royalty. When criticising a picture by Landseer, said *Punch*, you are bound to unqualified commendation; 'if the subject be Prince Albert's Hat or the Queen's Macaw, some ingenious compliment to royal patrons is expected'. Ruskin himself made the same bitter complaint. 'Look around at our exhibitions,'[1] he exclaimed, 'look at the myriads of men who are making their bread by drawing dances of naked women from academy models, or idealities of chivalry fitted out with Wardour Street armour, or eternal scenes from Gil Blas, Don Quixote and the Vicar of Wakefield.'

In 1848, Dante Gabriel Rossetti was aged twenty. He and his immediate circle of friends were deeply discontented with these conventional trivialities that were seeming to dominate art in England. With the young Millais, one year his junior, he had for some time felt that a new current was needed to flood the stream of art, but had no idea how to set such a current flowing. To us it seems surprising that the inspired genius of Blake and the hardly less profound imagination of Samuel Palmer, ready to their hand, were neglected. Probably they seemed too dangerously neo-classical. The inspiration came, almost accidentally and very much at second-hand, from the Italian 15th century. As many writers have recorded, Rossetti, Millais and Holman Hunt (a year older than Rossetti) came by chance one day

[1] Ruskin: *Pre-Raphaelitism*, 1851.

in 1848 on a volume of rather bad engravings after Benozzo Gozzoli;[1] and at once decided on their course: to revive some form of medievalism, to make some return to before the days of the Renaissance or at any rate before the days of, say, Raphael.

Forty years earlier, as we have seen, a group of young German artist-rebels in Rome had come to much the same kind of decision. As the enthusiasm of Rossetti and his friends was aroused by the Gozzoli engravings, so that of Cornelius and Overbeck and their friends had been aroused by the famous Boisserée collection of early German and Italian masters, which Ludwig I in due course acquired for Munich. Although the English Pre-Raphaelites and the German Pre-Raphaelites, or Nazarenes, sprang from quite independent origins, the former can hardly have been unaware of the latter. The most likely link is to be found in Ford Madox Brown. He was seven years older than Rossetti, but was a close friend, and although he was never a member of the Pre-Raphaelite brotherhood, he was much in sympathy with them at first. In 1845, during a journey abroad, he had become familiar with the work of the Nazarenes; and in 1848 Rossetti became his pupil, he himself having been a pupil of Wappers of Antwerp. None of the other members of either the inner or the outer circles of the Pre-Raphaelites had yet travelled out of England. A link there undoubtedly was between the Pre-Raphaelites and the Nazarenes, or *Préraphaelites*, of thirty or forty years earlier. Not only

[1] *Engravings of the Benozzo Gozzoli Frescoes in the Campo Santo at Pisa*, by Carlo Lasinio, 1810.

did they share a name, but they also shared the con-
viction of being a group separated from the rest of
the painting world. The English group, to be sure,
did not go so far as the Nazarenes. Although they
were to themselves a Brotherhood, they were never
a Community; although they repudiated all art
since the Renaissance, they by no means repudiated
the world they lived in. Apart, however, from the
common name and the common feeling of brother-
hood, there is the link of Medievalism. But even
there the Pre-Raphaelites had been anticipated.

Medievalism, as a conscious and deliberate evoca-
tion of an age, had appeared in English painting
before the end of the 18th century. The most
notable instances are the subject-pictures of Fuseli
and Stothard,[1] who flourished more than a generation
before any of the Pre-Raphaelites were born.
Stothard, with his "Canterbury Pilgrims," is a true
precursor of Madox Brown with his "Chaucer at the
Court of Edward III". The Pre-Raphaelites are
nearer in descent to Stothard than they are to Corne-
lius. While the Nazarenes and the men of Düssel-
dorf thought in vaguely medievalist terms but
worked in a borrowed neo-classic idiom, and avoided
the passions of the world, the young men of Chelsea
illumined their medievalism by passion. Their doc-
trine was one of protest, and they did not protest
against the world by resigning from it, but by defy-
ing it. What they protested against was the kind of
art that Lady Eastlake, in 1846, when still Elizabeth
Rigby, called 'laborious idleness'. But when she

[1] Henry Fuseli, R.A., 1741–1825; Thomas Stothard, R.A.,
1755–1834.

used that expression, Miss Rigby was not speaking of Maclise or Leslie or Mulready. She was describing the performances of the Düsseldorf descendants of the Nazarenes. And when she said that there was no stronger proof of the absence of any right feeling for art in the present public, it was of the German public she was speaking. The Pre-Raphaelites had no difficulty in transferring Miss Rigby's attack to British painters and public, and in allying their own discontent with hers.

The Pre-Raphaelite Brotherhood, strictly as such, lasted but a very few years; the movement to which it gave rise lasted a generation. Dante Gabriel Rossetti, the founder of the Brotherhood and the *enfant terrible* of the movement, felt that for a new current in art three things were necessary: a coherent and disciplined group of artists; a doctrine; and a journal in which to proclaim the doctrine. The group was formed, in the late summer of 1848, round Rossetti, Millais and Holman Hunt. The other members were Rossetti's brother William Michael; Thomas Woolner, sculptor, Australian-goldfield digger and rather a remarkable collector and connoisseur; James Collinson; and Frederick George Stephens. Seven brethren in all. The doctrine, quite simply, was that Academism and Scholism date from Raphael; that there must be no more Schools or formulas; and that each artist must read on his own account in the book of Nature, and copy her naïvely, like the painters before Raphael.[1] The journal was *The Germ*, in which the brethren, or

[1] Cf. the English section of Michel's *Histoire de l'Art*, edition 1928, contributed by Comte Paul Biver.

some of them, showed themselves poets as well as propagandists. *The Germ* ran for four numbers only, all published in the first half of 1850. William Bell Scott called those four numbers the culmination of the Brotherhood, which, as a closely-knit group, began to dissolve soon afterwards. Woolner left for the Australian diggings in 1852, and Holman Hunt for Palestine and the Near East in 1854. By that time Millais was already en route for the Royal Academy. *The Germ*, however, despite its short life, did at least one of the things it was expected to do. It brought adherents. Charles Collins and Walter Deverell, Arthur Hughes, that exquisite painter, and Ford Madox Brown, who in 1848 had refused to join the Brotherhood, all became members of the widening and loosening circle. Before the end of the 'fifties, William Morris and Edward Burne-Jones had joined them. Bell Scott recorded, as the last sign of united action among those formerly so closely bound together, a project started by Rossetti, Holman Hunt and Millais in 1854 to found a Sketching Club. This was to be called *The Folio*, and eighteen members were named. Their names form a very mixed and interesting list. Apart from the three mentioned, the only ones of the original P.R.B., there were Madox Brown, Charles Collins, Arthur Hughes, Bell Scott himself, that brilliant amateur and remarkable woman Louisa, Marchioness of Waterford, and, so unexpected in such a list, the *Punch* stalwarts Richard Doyle and John Leech. 'This scheme', remarked Bell Scott,[1] 'was never

[1] William Bell Scott: *Autobiographical Notes.* A very important source for Pre-Raphaelite research.

166

carried out. . . . The difference in quality would have been too obvious.'

It seems clear that the Brotherhood on its formation did not expect any very great success. W. M. Rossetti told Bell Scott in Newcastle in the late summer of 1848 that the P.R.B. was 'only a sort of club some of Gabriel's and Hunt's friends have planned out, and I am to be secretary. It's only friendly, we're making a start on a new line.' When within a year or two the P.R.B. became so celebrated, probably nobody was more surprised than they were themselves. At the very outset they met with formidable hostility. The Academy exhibitions of 1849 and 1850 contained their first gestures of defiance, including Millais' 'Isabella', 'Ferdinand and Ariel' and 'The Carpenter's Shop'. At once, in June 1850, the guns of the *Athenæum* thundered.[1] 'This school of English youths', it pronounced, 'has, it may be granted, ambition . . . their ambition is an unhealthy thirst which seeks notoriety by means of mere conceit. Abruptness, singularity, uncouthness are the counters by which they play for fame. Their trick is to defy the principles of beauty and the recognised axioms of taste.' There follows an attack on Millais' 'Carpenter's Shop', a picture which caused the *Athenæum* to recoil 'in horror and disgust'. 'Great talents', it said, 'have here been perverted to the use of an eccentricity both lamentable and revolting.' A fortnight later came Dickens's now famous attack on the same picture in *Household Words*.[2]

[1] *The Athenæum*, 1st June, 1850; 'A Letter from an R.A.'
[2] *Household Words*, 15th June, 1850; Charles Dickens on the Royal Academy Exhibition.

This passage has been too often quoted to be quoted in full here, but the closing lines may be recalled: 'This, in the nineteenth century . . . is what Pre-Raphaelite Art can do to render reverence and homage to the faith in which we live and die. . . . We should be certain of the Plague, among other advantages, if this Brotherhood were properly encouraged.' Dickens led his readers into battle against the Brotherhood as if it were a crusade against a band of infidels. He knew his readers; he knew what battle-cry would, in 1850, evoke the fiercest enthusiasm. The *Athenæum*, on the other hand, with one foot still in the first decade of the century, called up the axioms of taste and the principles of beauty. Such phrases, recalling Uvedale Price or Archibald Alison, would appeal to those who still looked for authority in matters of taste. To most such, it might be thought, the Royal Academy stood for authority. Yet the Royal Academy had accepted and hung the very pictures which were now being so violently attacked. The courage of the Hanging Committees of 1849 and 1850, which accepted the earliest Pre-Raphaelite pictures, is not always given its due.[1]

The iconography of the Scriptures was a dangerous thing for an artist to tamper with in 1850. With both the Evangelical and Oxford Movements at their height, and suspicions about everyone else's motives being almost passionately entertained by both sides, it was a brave man who painted a Scriptural scene in

[1] These were: 1849, C. W. Cope, William Dyce, Richard Cooke, Sir Richard Westmacott and J. P. Deering. 1850, W. F. Witherington, Daniel Maclise, Solomon Hart and Richard Westmacott, jnr.

an untraditional manner. Rossetti's 'Girlhood of Mary Virgin' of 1849, for instance, was attacked on the one hand as being a brazen display of Mariolatry, and on the other hand, by those with a tendency towards Oxford, as being insufficiently Mariolatrous. Millais' 'Carpenter's Shop' of the following year was not attacked for its choice of subject, which was a perfectly permissible if rather unusual one, but because the *mise en scène* was unconventional, and did not at once recall the long-familiar and Raphaelesque aspect of the Holy Family. Since dogmatic theology was liable to be brought into any argument on any subject, the Pre-Raphaelites were certain to be in trouble before long on that score, even if they could have avoided trouble on the score of axiomatic taste. The religious temper of 1849 was one of extremes. Extreme Evangelicalism and extreme Ritualism were both in the air; in the air of the domestic parlour, the London drawing-room, the club, the university common-room. There were, of course, far more people who discussed and condemned either extreme than there were those who practised them. The Ritualists of Oxford were a minority in religious practice, but a conspicuous one; like all missionaries, and like the one righteous man in Israel, they seem deliberately to have invited the arrows of opposition. So equally did the Evangelicals, who not long since had shouted Hallelujah with Edward Irving. But unfortunately for the Ritualists, many of their adherents forgot their authoritative origin, denied their Laud and went over to Rome.

The Pre-Raphaelites in their first year or two

played, innocently enough, into the hands of their
hostile critics. Dislike of the earliest Pre-Raphaelite
pictures was very general, but there can be little
doubt that this was really only because they seemed
ugly and unconventional. To express this feeling
in critical form was difficult, because the leading
Academicians were at that very moment widely
accused of being too conventional. There remained
the invocation of fashionable prejudice: Mariolatry,
hagiolatry and Romanism. Each of them was ready
to hand, both as a hateful dogma and as a damning
stigma. These young men, by repudiating Raphael,
had embraced Medievalism; and Medievalism meant
Romanism. That remarkable synthesis was in fact
based on topical politics, for it must be remembered
that in 1850 Pius IX revived the Catholic Hierarchy
in England, and thereby revived all the politico-
religious controversies of twenty years earlier. It is a
synthesis which has as its prime authority Ruskin
himself, writing in defence of the Pre-Raphaelites in
1851.[1] Already the issue had been complicated by
the dragging in of theological in the place of spiritual
values, and Ruskin was not in the mood, at that time,
to allow Protestant theology to take second place.
'If', he wrote, 'their sympathies with the early
artists lead them into medievalism or Romanism they
will of course come to nothing. But I believe there
is no danger of this, at least for the strongest among
them. There may be some weak ones whom the
Tractarian heresies may touch; but if so, they will
drop off like decayed branches from a strong stem.'
In fact, one of the original members of the Brother-

[1] Ruskin: *Pre-Raphaelitism*, 1851.

hood did so behave, and helped, unfortunately, to cast the suspicion of heresy on the whole group; the example of the Nazarenes was not yet quite forgotten. The decayed branch which thus dropped off was James Collinson, whose best-known picture was his 'Saint Elizabeth of Hungary'.[1] Of him, William Bell Scott wrote [2] that he was seriously moved by the momentary religious tone then in vogue, which, in his own words, meant 'the feckless dilettantism of the converts who were then dropping out of their places in Oxford and Cambridge into Mariolatry and Jesuitism'. The rest of Collinson's unhappy story may also be told in Bell Scott's own words, which are here, for him, unusually stark. 'In fact,' he continued, 'this James Collinson actually did become Romanist, wanted to be a priest, painted no more and entered a seminary where they set him to clean boots . . . they did not want him as a priest, so he left, and turned to painting again and disappeared.'

It is perhaps worth noting incidentally that Ruskin and Bell Scott, temperamentally so different, met more than once on common ground when discussing the Pre-Raphaelites. In each such case they made the same point, but approached it at a different angle: the former exhorting, the latter stating fact. This is seen in the passages just quoted about Romanism; it is also seen in another aspect of Pre-Raphaelitism which was hit upon by both—the scientific. Immediately before the passage just quoted,

[1] St. Elizabeth of Hungary, 1207–31. Daughter of Andrew II of Hungary. Converted her husband to Christianity by performing a miracle in his presence. She was canonised four years after her death.
 [2] William Bell Scott: *Autobiographical Notes.*

Ruskin said, 'If they adhere to their principles and paint nature as it is around them, with the help of modern science, with the earnestness of the men of the 13th and 14th centuries, they will, as I said, found a new and noble school in England.' To invoke the 13th and 14th centuries was almost useless, since very few people, and certainly not the young men in question, knew anything at all of that period. To invoke science, on the other hand, was very much to the point, since science here meant, or could mean, the new and marvellously revealing discovery of photography. Bell Scott used the same material when discussing Pre-Raphaelitism, but he used it as fact, and not as a postulate. 'The seed of the flower of Pre-Raphaelitism was photography,' he wrote. 'History, genre, medievalism or any poetry were allowable as subject, but the execution was to be like the binocular representations of leaves that the stereoscope was then beginning to show.' Maybe that was partly true. Probably the new discovery was in fact responsible for the 'stereoscopic eye' of the Pre-Raphaelites. But, even so, that would only have accounted for the execution of their pictures, and not for their conception. It would not have accounted for their spiritual and emotional intensity, for the high seriousness of their endeavour, for their romantic sadness or for their esoteric symbolism. It would not, by itself, have accounted for any of the qualities which separated them from their contemporaries and drew upon their heads so much rage and derision.

The Pre-Raphaelites must be viewed as a part of that last phase of the traditionally labelled Romantic

172

Movement, the phase that under the same text-book label includes equally the Oxford Ritualists and Tennyson. Both the Pusey aspect and the Newman aspect of Tractarianism would have to be very carefully considered in any prolonged study of the hostility which the Pre-Raphaelites aroused in their early years. To put Tennyson into the same envelope might be more dangerous. Tennyson was a poet and a prophet; Rossetti was a painter and a poet. To compare their poetry in the effort to deduce similarity would be as useless as, say, to compare Rossetti with Matthew Arnold; except in one respect. If Tennyson had been also a painter, the background of his pictures round about 1850 would have been extremely Pre-Raphaelite. A not unfair comparison could be drawn between the Choric Song in *The Lotus-Eaters* and the background of an early Millais; and when they both interpreted severally the romantic weariness of the *Mariana* story, Tennyson produced a perfect Millais, and Millais a perfect Tennyson. The exercise in comparison could be stretched to include Matthew Arnold also. Many lines of his *Tristram and Iseult* of 1852 are purely Pre-Raphaelite in the intensity with which physical sights and sounds are described, and the story itself is Pre-Raphaelite enough in its remoteness in time, in the romance of its conflict and in the sadness of its conclusion. But there, in the background, comparison must end; the rest will not stand it. Where Tennyson would extract a philosophy of optimism and of belief in the future of mankind, and where Arnold re-created great tragedy, a Pre-Raphaelite would not have reached beyond pathos.

That was one of their limitations which invited hostile criticism. Had the readiness of their emotions and the intensity of their descriptive powers been matched by a capacity for tragedy instead of only for pathos, the Pre-Raphaelites could not have been attacked. Admittedly, they would not have been much liked, either. But, though disliked by the generality, their earliest performances would probably have been treated with the respect that was only accorded to their pictures of 1852 and later.

The year 1852 may in fact be taken as the date when the Brotherhood was promoted from notoriety into fame; the very year in which Woolner left for the Australian gold-fields and the fraternity began to dissolve. Until well into that year they continued to be the victims of jokes about their medievalism and to be accused of bad draughtsmanship, crude colouring and morbidity; the charge of irreverence, or even of blasphemy, seems to have been soon dropped when it was realised that these young men were at least sincerely devout, if occasionally a bit Mariolatrous. The derision which their medievalism aroused is peculiar, since the medievalist architects never had to share it. Even Pugin, an avowed papist and a violent extremist, was treated with greater respect than were the much less medievalist Rossetti, Millais or Hunt. To quote *Punch* once more, in 1850[1] it had a description of a Pre-Raphaelite 'Holy Family' purporting to be written by 'Our Surgical Adviser', who detailed all the diseases and malformations which he maintained he could see in the picture, and proved that this and, by implica-

[1] *Punch*, vol. 18, 1850.

tion, all Pre-Raphaelite pictures were in fact composed out of the phenomena of morbid anatomy. By the early part of 1852 *Punch's* fun had become a little more gentle.[1] This time it was a letter from a lady headed 'Cimabue Cottage, Camden Town', and saying 'My husband used to see things like other people, but lately he has become a Pre-Raphaelite. . . .'

Punch was already a little behind the times. In that same year 1852, as Bell Scott said, the new movement was making much noise in the world and all the leaders were becoming celebrated. He also quoted a letter written to him by Rossetti, dated not very explicitly 'Tuesday, 1852', saying, 'Millais has been at Oxford as witness in a trial regarding some estate or some contested will. The judge, on hearing his name, asked if he was the painter of that exquisite picture in the Academy. This looks like fame. . . .'[2] It was indeed; Millais became an A.R.A. only one year later, in 1853. By 1853 *Punch* had caught up with the change in feeling, and published an article[3] on the Pre-Raphaelites that was both serious and sympathetic. Having noted how Art, in proportion as it became a tradition and affair of schools and Academies, sank down and down towards a dead level of pretty, graceful no-meaning, it observed that Art must adapt itself to the conditions of the time and the life it has to reflect. 'These conditions', it continued, 'my young friends the Pre-

[1] *Punch*, vol. 22, 1852.

[2] William Bell Scott: *Autobiographical Notes*. Millais' Academy picture was either 'The Huguenot' or 'Ophelia', both of which were exhibited in 1852.

[3] *Punch*, vol. 24, 1853.

Raffaelites (sic) appear to be conscious of and to submit to. . . . Their first-fruits are already before the world, and already it has felt that the undertaking is new, startling and cheerfully courageous: that, further than might be expected from such beardless champions, it has already succeeded.' Those whom a year earlier it had derided with Cimabue Cottage, *Punch* now hailed as 'these young Luthers of the worn-out Art faith'. Also in 1853, Ruskin, when addressing an Edinburgh audience, could introduce the name and principles of Pre-Raphaelitism into a lecture about something else,[1] knowing that his hearers would both accept the designation and respect the School.

In passing, it may be observed that the designation 'Pre-Raphaelite', even by 1852, had not passed completely into general circulation as applying to the Brotherhood and its adherents. Two or three years before the Brotherhood was formed, the term had enjoyed a revived currency during the Westminster Palace competition. It was remembered at the time that Cornelius, consulted as an oracle, had, a generation earlier, been derisively dubbed *Préraphaélite*. There must have been many who could not yet free themselves from that association of terms. There were still others who, beginning seriously to explore the early Italian schools, used the term quite literally for the painters before Raphael. Lady Eastlake did, as late as 1852. Writing from Dresden in that year, she said:[2] 'I feel that the early Italian pictures in the Berlin Gallery have almost spoilt my eye for

[1] Ruskin: *Lectures on Architecture*, delivered at Edinburgh, 1853.
[2] Lady Eastlake, *Journal and Correspondence*.

the late masters. . . . I had no idea that the Pre-Raphaelites could have given me such intense pleasure.' Nevertheless, outside the circle of the Eastlakes and the *Quarterly Reviewers*, and probably the Prince himself, most people in England would by then accept the term as applying to the P.R.B. rather than to Fra Angelico. Some of the *Quarterly Reviewers*, however, such as Layard, continued to hedge about the exact significance of the term for several years. In 1857, Layard wrote: 'It is in the class of painters of "tableaux de genre" that we must place the Pre-Raphaelites, as they are called. These young painters occupy at this moment so important a position in English art that we cannot pass them over without a few observations.' The observations are what by then had become commonplaces of criticism—praise for their casting away of academic conventions and condemnation for their alleged bad drawing. In the following year, however, Layard appears to apply the term to the early Italian painters. Writing of Italian Art he said,[1] 'Those who cannot enter into the earnest feeling which inspired the works of the 14th century will detect and dwell upon errors of detail apparent to the least practised eye. Few, therefore, are able to feel true sympathy for what are somewhat contemptuously called "Pre-Raphaelite pictures".'

It was observed at the beginning of this chapter that the Brotherhood was formed to establish certain doctrines as a protest against the established practice and beliefs then prevailing. By 1853 Ruskin, and probably Ruskin alone, was able to view their work

[1] *Quarterly Review*, vol. 104, 1858.

in some kind of perspective; and, moreover, to relate it to Turner.[1] Having described their aims and recounted their earliest vicissitudes, which included being hissed by their fellow-students in the life-school, he said, 'Pre-Raphaelitism has but one principle, that of absolute uncompromising truth in all that it does, obtained from nature and from nature only. . . . Every Pre-Raphaelite figure is a true portrait of some living person.' Ruskin, however, denied the quality of sublimity in their vision or in their work, the sublimity which he believed could only be expressed by the adoption of a new and daring convention. At the same time, he readily admitted that that was not what the Pre-Raphaelites were for. Turner had done it before them, delighting, as Ruskin said, to begin at the very point where Pre-Raphaelitism becomes powerless.

This, though acute criticism in 1853, is not the whole truth. Had it been, the Pre-Raphaelite revolt would have been a successful revolution. If absolute fidelity to outward appearance, minute accuracy in detail, and a single-focused sharpness of vision had been all, then there would be little difference between Millais' 'Ophelia' of 1852 and his 'North-West Passage' of 1874. But in fact a world separates them; the world of imaginative poetry, to which the 'Ophelia' belongs and the 'North-West Passage' does not. To their imaginative intensity the Pre-Raphaelites added a profound feeling for parable and symbol which was capable of transmuting what had become familiar, or even

[1] Ruskin: *Lecture on Pre-Raphaelitism*, delivered at Edinburgh, 1853.

commonplace, back into the precious metal that it had once been. By that feeling Holman Hunt's 'Scapegoat' was elevated from a platitude to something approaching tragedy; and Millais' 'Ophelia' became, in Ruskin's words, 'the loveliest English landscape, haunted by sorrow'.

MID-CENTURY: THE EASTLAKES AND OTHERS

THE formation and the short triumph of the Pre-Raphaelite Brotherhood mark the middle of the century. That point is also marked by the very different but resounding triumph of the Great Exhibition. It is fitting, therefore, to pause at this point and, in taking stock, look backwards and forwards, and particularly to inspect at closer quarters some of the men and women we have met and shall meet again. It is fitting also at this point to call in various miscellaneous pieces of evidence which together help to show how baffling was the character of mid-19th-century taste. So complex is that character, and so various are the individuals who helped in forming it, that almost any piece of evidence that seems to point in some direction or another can be used to prove almost any case.

Of the persons who must appear and reappear in any survey of mid-19th-century taste, some, like Prince Albert, Ruskin, and the individual Pre-Raphaelites, are in the class of those who are written about continually and at regular intervals.[1] Others, like Anna Jameson, Charles and Elizabeth Eastlake, Layard or Palgrave, are known to a few, by whom they are considerably respected, but yet await their

[1] Nevertheless, it is still possible for distinguished historians to write lives of the Prince which ignore his services to Art.

introduction to a wider public. Pugin and Paxton, existing merely as ghostly names [1] for about three generations after their deaths, have been brought back to life only within the last two decades. A few, like Waagen, Passavant or William Bell Scott, are now little more than the names of valuable reference books described, quite rightly, as mines of information. The explorer in the territory covered by such a survey will, in the course of his reading, occasionally come across a name which would mean nothing at all to him but for the spotlight thrown on to it by the context in such a way as to illumine a path in art or scholarship at the time the passage was written. Though apparently unimportant now, such passages may be found useful by some future, industrious historian; just as pieces of string are saved because, although they are too short to be of any immediate use to anybody, they may, if carefully knotted together, serve to tie up a considerable parcel.

Who, for an example, was the Rev. Thomas Fosbrooke, F.S.A., who died in 1842, in his seventy-third year? He was evidently of some note in his day, since he had the distinction of an obituary-notice in *The Annual Register*, which described him as the author of a great variety of antiquarian and topographical works, including an *Encyclopædia of Antiquities and Elements of Archæology* and a *Tourist's Grammar*. Fosbrooke is a person whom a thorough historian either of antiquarianism or of the art of viewing in the first half of the 19th century

[1] Paxton's name, it must be admitted, is actively kept alive by a public-house in Knightsbridge, nearly opposite the scene of his Great Exhibition triumph.

181

ought to consult. Alas, *The Annual Register* con-
cluded its notice of him, 'We regret to say that he
left his family very insufficiently provided for.' Here
so evidently is the type of serious, devoted scholar,
lacking patronage, preferment or private means,
which begins to appear repeatedly towards the end of
the 18th century and becomes commonplace during
the first half of the 19th. Most of these antiquarian
parsons were, in their own field, very far from being
comparable with White of Selborne or William
Gilpin in their respective fields of natural history or
landscape-viewing; yet to the accumulated results of
their researches, made at a time of rapid increase of
knowledge, present-day scholars find it prudent to
pay respect.

Who, for another example in a different vein,
was Mlle. Félicie de Fauveau? She makes a brief
appearance in the pages of Lord Lindsay[1] as the
recipient of a tribute couched in terms which throw
a revealing light on European society in the 'forties.
Mademoiselle de Fauveau, of Florence, was of the
company with which Lord Lindsay travelled in
Italy in 1840. She aroused Lindsay's sympathy and
compassion because, being a gentlewoman by birth,
she was so unfortunate as to be compelled by circum-
stances to take up sculpture for her living. Her
'Francesca da Rimini', her 'St. George and the
Dragon', her busts of 'H.R.H. the Duc de Bor-
deaux' and 'H.R.H. the Grand Duchess Olga' were
particularly mentioned by Lindsay. He concluded
his remarks by observing, 'It is to be regretted when

[1] Lord Lindsay: Advertisement, i.e. preface, to his *Sketches of
the History of Christian Art.*

the noble in birth as well as spirit are compelled . . .
to depend on genius for their bread, but human
nature is exalted by it and Art is a gainer.' Had
Mademoiselle de Fauveau been a professional artist
of perhaps humbler birth, it is possible that Lindsay
would still have said that she had genius. But the
spectacle of a lady in reduced circumstances turning
her talent to account made the use of the words
'genius' and 'nobility' almost inevitable. Moreover,
in thus drawing attention to the lady, Lindsay was
defending her as well as paying her a tribute. It was
not considered desirable that ladies of gentle birth
should possess creative talent, and it was actively
undesirable that they should parade such talent.
If, in addition to being artists in so unfeminine a
medium as sculpture, they were compelled to earn
their own living, they had to face a different but
even more formidable social obstacle. The case
of Louisa, Marchioness of Waterford,[1] is not in-
appropriate here. Admittedly, she was a painter
rather than a sculptor, and only a water-colourist at
that. Notwithstanding the demands of her position,
she devoted most of her time to her art, and im-
pressed her generation as being among the artists
who counted. Despite the declaration of G. F.
Watts that she was as great as any of the Venetian
masters, Louisa, Lady Waterford, really was a dis-
tinguished artist with a deep personal feeling. Yet
her reputation depended, was even founded upon,
her amateur status. As a professional, she would

[1] Daughter of 2nd Lord Stuart de Rothesay; married 3rd Mar-
quess of Waterford 1842 and died 1891. Her portrait by Sir Francis
Grant is in the National Portrait Gallery.

have been regarded as a traitor to her caste, and would not have been taken seriously.

The mid-19th-century lady may have been discouraged by social taboos from professional activity in the arts, but in literature, and even in such unlikely fields as political economy, there was no such inhibition; on the contrary, the age produced a number of remarkable women who either in their writings or in their actions exercised a high authority in the moral, intellectual or spiritual lives of their contemporaries. Nightingale and Burdett-Coutts are the inevitably cited examples, below the Queen herself. Mrs. Opie, Mrs. Grote and Lady Eastlake; Agnes Strickland and Sarah Austin; Maria Edgeworth, Harriet Martineau and Anna Jameson—these are but a few among a surprisingly large number of women of that day who still live useful posthumous lives as authorities in their own spheres. These eminent women, except Mrs. Jameson, would have no relevance here, were it not that Elizabeth Eastlake knew most of them. She visited them, met them at dinners and parties, and we may assume that those who listened respectfully to Mrs. Grote on French politics; to Mrs. Opie on reform; and to Miss Strickland on the Plantagenets or Louis-Philippe, listened with equal respect to Lady Eastlake on Orcagna, Fra Angelico, Cornelius or Sir Edwin Landseer. Her *Journal and Correspondence*, already quoted here so often, occasionally provided an admirable snapshot of some of these formidable ladies. In March 1844, for example, the then Mrs. Eastlake wrote, 'Called on Miss Strickland—the perfection of blues: she seems to think the

PLATE 13

Birmingham Museum and Art Gallery.

THE BLIND GIRL
Painting by Sir G. E. Millais, 1856

PLATE 14

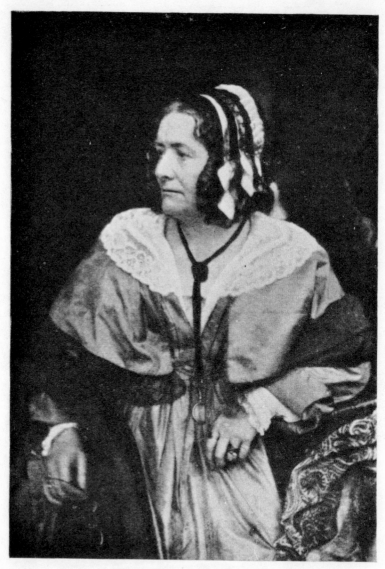

MRS. JAMESON
Photograph by David Octavius Hill, c. 1845

most fortunate thing in life is to get a name; never-theless very interesting. She showed me letters from Guizot etc., and evidently thought herself the his-torian of the age.' So there is poor Agnes Strick-land, the industrious and ambitious bluestocking, unable to make up her mind whether to be a great historian or an influential journalist. Three days later, Elizabeth Eastlake called on Maria Edgeworth, then aged seventy-seven. 'To Miss Edgeworth's,' she wrote; 'the dear old lady sitting working, and I had the privilege of threading her needle. She talked most amusingly; said Mrs. Siddons was aw-fully dull, except when she got upon her own pro-fession.' Although this hardly reincarnates the sar-donic young authoress of *Castle Rackrent*, it is equally far from the authoress of *The Parent's Assis-tant*. Ten years later, in June 1854, Elizabeth East-lake recorded her first meeting with the magni-ficently individual Mrs. Grote. 'Dined at the Mur-chisons,' she wrote; 'Mrs. Grote made my acquaint-ance and begged me to come and see her, which is a compliment, as she eschews all stupid women and declares she seldom meets with a sensible one. She is herself the cleverest woman in London, but of mas-culine and not feminine character.' That is a very fair portrait of a dominant and brilliant woman who, though a bluestocking, habitually wore red ones, and displayed them with as little reticence as she showed in her conversation. Perhaps Mrs. Eastlake was terri-fied of Mrs. Grote, but from Anna Jameson she evidently can have felt no fear of intellectual rivalry. She described her as 'a woman of very determined mind, who has worked beyond her

strength. . . . She is full of art. . . .' Perhaps that is
not, extracted from its context, quite just to Mrs.
Jameson, yet 'full of art' she was, provided that it
was Christian art. She was rather a compiler than a
thinker, perhaps; but she was a woman of wide ex-
perience and immense industry in her field, whose
labours still bear fruit.

Mrs. Eastlake may not have regarded Mrs.
Jameson as an intellectual rival, but there can be
little doubt that she was one of Mrs. Jameson's
disciples. Anna Jameson, born in 1794, was four-
teen years older than Elizabeth Eastlake and eigh-
teen years older than Lord Lindsay. When still
young she was expressing her thoughts and senti-
ments entirely in a late-18th-century manner, as
may be seen in her once-famous *Diary of an
Ennuyée* of the 1820's; and, again in the late 18th-
century manner, her first travels abroad were through
France, Italy and the Low Countries. Up to that
point there was little to distinguish Anna Jameson
from any other of the active, sensitive and intelligent
women of her generation, but in 1833 she stepped
as a pioneer into a new world not yet familiar
in England: the world of contemporary German
thought. Although that was a world that very soon
did become familiar in this country, Mrs. Jameson
was among its first interpreters. The key was given
her by a rapidly-formed friendship with Ottilie
von Goethe, which naturally bred other distin-
guished friendships and placed her at once *en
rapport* with German artistic and philosophic ideas.
Her interpretation of these was given in her *Visits
and Sketches* of 1834, a book which is both delight-

ful to read and historically important. This was beyond doubt one of Elizabeth Eastlake's main early sources of inspiration, and must have impelled her to her own first studies of German art published in the *Quarterly*. The influence of Anna upon Elizabeth is not evident from the biographical details of either of them, and must have been more literary than personal. Yet there was evidently a long, if not a close, connection between them during many years, for it was Lady Eastlake who was chosen in 1860 to complete Mrs. Jameson's last work left unfinished at her death.

When Anna Jameson died in 1860, worn out by overwork and under-payment, a new era of art-history and criticism had already begun with Morelli, Crowe and Cavalcaselle. She is therefore a most important link between old and modern criticism. Many of the other eminent women just mentioned provide in themselves similar links, but Elizabeth Eastlake is not one of these. Eminent she unquestionably was, but she had nothing of the 18th century in her. If Anna Jameson serves partly as a linkand partly as a pioneer interpreter, Elizabeth Eastlake seldom reminds us of an earlier generation and, though of the *avant-garde*, was not a pioneer. She did not originate, but nevertheless she influenced the thought of her generation and, both in her own right and through her husband, she is for us very much to the point in any discussion of the arts in mid-19th-century England. She and Charles Eastlake must be regarded as a partnership, and must be accorded the European status which they achieved in their joint lifetime. They, and the circles of their

associates in London or Edinburgh, in Manchester or Liverpool, and Ruskin himself, were the fruits of the new culture. It was a culture which had existed vigorously in the 18th century in the hands of a dictatorial and highly qualified few, concentrated in London. Although echoes of it were to be heard in Dublin and Edinburgh, and even in Cambridge and in Oxford, and although Derby, Lichfield and Birmingham were active centres of high-thinking during the second half of the 18th century, nevertheless, culture, meaning a vigorous and inquisitive intellectual life, was the prerogative of London till about the turn of the century. After 1800 or thereabouts, however, the provinces could claim equality with the capital as nurseries of high culture. The newly-enriched and empowered provincial middle-class may have made some unfortunate mistakes, but, on the other hand, it produced a remarkably large proportion of the men and women who formed the taste and opinions of their generation.

Since this chapter is avowedly discursive, an encounter between letters and art, and between the 18th and 19th centuries, in 1854, can be described without too much irrelevance. In that year William Bell Scott[1] went out of his way to visit Paris when going to Germany. He did this on behalf of a friend, in order, as he said, to deliver to the sculptor David d'Angers[2] the pen of Mrs. Opie, left him in her will as a remembrance. Amelia Opie had died the previous year at the age of eighty-four, in the sunset glow of a fame that had spread over England

[1] William Bell Scott: *Autobiographical Notes.*
[2] David d'Angers, 1788–1856.

and France. David d'Angers, still enjoying a similar fame in a different form of activity, was then aged sixty-six. The pen thus bequeathed by an august writer to an equally august artist was, it appears, a quill ornamented with beads by the hand of the aged lady herself. 'We found', wrote Bell Scott, 'the amiable old sculptor in his immense studio surrounded by busts innumerable of the illustrious men and women of the age.' One can but hope that his amiability survived the test of being given a quill pen ornamented with beads.

The same rich source provides several other glimpses of letters in contact with art. Among these is a fascinating, if horrifying, one of Carlyle; horrifying, that is, when related to the reputation which Carlyle enjoyed as a Thinker. In 1850, Bell Scott spent an evening in Cheyne Row with him and Woolner, the sculptor and Pre-Raphaelite Brother. Carlyle's voice, manner and accent, said Scott, were 'those of a man proud of his humble and provincial antecedents. . . . His voice was like the rattling of pebbles and boulders driven against each other in a spate. "Ah," said he, "you're an artist (pronounced airtist)—ah well, I can make nothing of artists, nor their work either. Empty as are other folks' kettles, artists' kettles are emptier and good for nothing but tying to the tails of mad dogs. So little do I care to venture on these speculations, that I have never been at an exhibition all the many years I have lived in London."' Anyone in search of ammunition with which to attack Carlyle the Sage need look no farther than this unfortunate exposure. Bell Scott also on another occasion about the same

year linked Woolner and Carlyle together as sharing
socialist, or rather radical, views; and, rather un-
expectedly, brought Tennyson in as well. Woolner
had been asked to Wallington, in Northumberland,
by Lady Trevelyan to execute a commission for
some sculpture. The visit was arranged through Bell
Scott, who said that when he called to make the
proposal he found Woolner 'in a disposition to
revenge himself on the world at large for his want of
success'. The sculptor swore, continued Scott, 'that
he would not go near any people with handles to
their names; they were all "devastators of the day,
maggots in the wounds of us poor devils who have to
fight the battle of life "; Carlyle thought so, and also
Tennyson'. Perhaps the future Lord Tennyson did
really think so, at the age of forty; Bell Scott's
authority is generally sound.

Lady Eastlake is as good as Bell Scott at providing
personal glimpses of people whose individuality,
apart from their work, had long since been other-
wise forgotten and lost. Waagen and Passavant, for
instance, are made almost to appear in person for
us, both separately and together. Waagen's first ex-
perience of London[1] must have been something of a
strain on an elderly scholar straight from the narrow
provincial commonplaces of Berlin. He owed this first
visit, in 1845, to his close connection with Edward
Solly,[2] the collector, who 'greeted Mr. Waagen[3]

[1] *Quarterly Review*, vol. 62, 1838.

[2] And also to his friendships with Sir Charles Eastlake and John
Murray, the publisher.

[3] Waagen's own somewhat different description was 'Italian pic-
tures of the time of Raphael'. Lady Eastlake must have forgotten that
the Solly Raphael was already in Berlin and had been there since 1821.

on his first arrival with a good dinner and a genuine Raphael over the sideboard'. 'Was ever professor,' it might indeed be asked, 'emerging from his first trip in a Hamburg steamboat, domiciliated under more favourable auspices? Lectured at by Faraday the same evening—received by Baron Bülow next morning—galleries and collections opened to him by the influence of the Duke of Cambridge—the sights and sounds of London in May brought before him into sudden contrast with the garrison dullness of Berlin.'

Passavant, a younger and less eminent lion than Waagen, first appeared in the Eastlake circle of London in 1850. In May of that year he stayed with the Eastlakes and, according to their nephew,[1] his social conduct was pretty astonishing. On the first day he locked his bedroom door on coming down to dinner and gravely handed the key to the butler, Tucker. His table manners were even more puzzling, and Charles Eastlake tried in vain to work out the logic of his method of feeding himself. The butler Tucker, one imagines, already badly shaken by the episode of the bedroom key, must have undergone an almost insupportable ordeal. So, probably, did Anna Jameson; she was placed next to Passavant at the first dinner-party given by the Eastlakes after his arrival, on the grounds, no doubt, that, as she was already acquainted with him, she would know what to expect. At the second dinner-party, since there were ten men to six ladies, Passavant was not provided with a lady next to him; 'he knew no differ-

[1] Charles Eastlake Smith, editor of Lady Eastlake's *Journals and Correspondence*.

ence,' said Lady Eastlake. The most memorable moment, for everyone concerned in it, during this visit in the May of 1850, must have been the meeting of Passavant and Waagen, who was then again in London. Lady Eastlake's account of this is short and terse, but could not have been more complete were it ten times as long. 'Dr. Waagen has arrived,' she said: 'a plain old man, but with far more in him than Passavant. T. M. was terribly tried, as she alone was present when they kissed each other.' Whoever T. M. was, it can only be hoped that she remained composed until she could get out of the room. Waagen seems to have been, socially, an improvement on Passavant. He was, in Lady Eastlake's opinion, an intelligent, clever and witty old gentleman, full of mimicry and drollery, and better bred than most Germans. He was at any rate sufficiently presentable for the Eastlakes to take him, during a later visit in 1854, to a party at Lansdowne House; also to a dinner-party at Miss Rushout's, where there were 'no end of interesting and noble relatives of hers'. Probably more congenial to Dr. Waagen, however, was dining with John Forster [1] in his chambers in Lincoln's Inn, when Daniel Maclise and the Eastlakes were present. Lady Eastlake said it was 'a sociable and amusing dinner, and quite a new world for Waagen'. Incidentally, it appears that Waagen spoke English very imperfectly, but was 'inventive and original' in his use of the language, while Passavant's English was almost unintelligible, though he insisted on speaking it all the time.

[1] John Forster, 1812–76. Historian; friend and biographer of Dickens.

It is not inappropriate at this point to glance in a biographical way at Charles Eastlake himself.[1] He was, after all, the most important figure in the international art-collecting world of his day. Born at Plymouth in 1793, he was educated first at that same Grammar School at Plympton which Reynolds had attended seventy years earlier. His later education was at Charterhouse, during which period, about 1808, he first met Haydon, his fellow-townsman and seven years his senior. Filled with the ambition to be a painter, he left Charterhouse early, and actually endured lodging with Haydon for a few years from 1809. During 1814–15 Eastlake was in Paris, until Napoleon's sudden return from Elba and the resumption of the war. Paris was the goal of every artist and connoisseur that year, and it is important to remember what an immensely valuable opportunity that year provided, with the Louvre full of Napoleon's looted pictures from Italy and elsewhere. In fact, for seeing masterpieces of art concentrated in one place, Paris in 1814–15 provided the greatest opportunity until the series of winter exhibitions in London during the 1930's, though the latter were due to international friendliness and co-operation, while the former was rather markedly not. After 1815, Eastlake travelled in Greece and Italy, and was taken up by eminent people such as Jeremiah Harman, the banker and collector who had been concerned in the sale of the Orleans Collection, and who was one of his earliest patrons, and Lord and Lady Ruthven,

[1] See Lady Eastlake's *Memoir* of her husband prefixed to her edition, 1870, of his *Contributions to the Literature of the Fine Arts.*

with whom he travelled about the Mediterranean, to Greece, Malta and Sicily. Of far greater importance, however, in forming the background to Eastlake's later, mature life was his experience of Rome in the years 1819–20. The Papal capital at that time provided, in addition to its own great Roman society of princes, cardinals and scholars, a continuously fluid society of English talent and fashion. Among those with whom Eastlake then made acquaintance that lasted for years and became intimacy, were the statesman Earl Spencer; the great Sir Humphry Davy and his gifted wife; the two Miss Berrys, sharp-tongued survivors of the court of Horace Walpole; Tom Moore and Samuel Rogers; and, among the artists, John Jackson, Sir Thomas Lawrence, Sir Francis Chantrey and Turner himself. That is a pretty dazzling galaxy of talent to find in a foreign capital during one winter. Eastlake quickly became a star in that galaxy, and his fame both as a painter and a deeply intelligent young man quickly spread at home.

Until about 1840, Eastlake's growing fame was mainly based on his work as a painter. After that date, his reputation was increasingly that of the recognised expert in all matters connected with art-scholarship. During the 'forties, for instance, he was invited to accept in turn the Curatorship of the pictures at Greenwich, the Directorship of a proposed English Academy at Rome and the Superintendence of the Government Schools of Design. Moreover, everyone who wanted either to sell or buy a picture consulted him, whether they had a claim on his time or not. The man who had most to do with

the beginning of Eastlake's career in the official art-world was Sir Robert Peel. It was through his influence that Eastlake was appointed Secretary to the National Gallery in 1843, a post which he held, and in which he exercised considerable influence, till 1847. In 1850 he was elected President of the Royal Academy, partly no doubt on his accepted, though by then rather past, reputation as a painter, and partly on his already unique position in the official art-world. But no doubt the high social eminence enjoyed, and very much enjoyed, by both Charles and Elizabeth Eastlake, had a great deal to do with it. The provincial cultures of Plymouth and Edinburgh united in them to help form the culture of London and to become part of the culture of Europe. Eastlake, it is reported, was profoundly reluctant to become P.R.A., but the Queen, Prince Albert and Peel had all insisted that he should accept the office if the Council of the Royal Academy offered it to him. With that formidable pressure threatening them, it looks as if the Council had little choice.

Eastlake is not remembered as President of the Royal Academy. He is, and always will be, remembered as one of the greatest Directors the National Gallery, or any other Gallery in the world, has ever had. He was appointed to that office in 1855, while continuing to be P.R.A., and held it till his death ten years later. He died at Pisa in December 1865. It is enough to say here that, courageously using un-rivalled opportunities, he transformed the National Gallery from an awkward, adolescent institution in-to a collection of the very first importance, if judged by quality rather than quantity. Of Eastlake's two

great supporters, the Prince lived to see him magnificently fulfil his mission; Peel did not, for he died in 1850. Peel's sudden and accidental death removed one of the two dominant figures in English public life, and the other, Wellington, departed eighteen months later. But the riding accident in Constitution Hill in June 1850, which deprived the nation of its greatest Prime Minister between Pitt and Gladstone, also removed a very great and enlightened collector and a sympathetic ally who would have smoothed away many of Eastlake's difficulties with the Treasury. Peel felt both affection and admiration for Eastlake; he also felt in some degree responsible for him. Lady Eastlake has an account [1] of the first meeting of the Royal Fine Arts Commission in March 1842, with her husband beginning his new duties as Secretary. Sir Robert Peel watched anxiously to see how his protégé would acquit himself in the presence of that very remarkable assemblage—an assemblage which included the Prince as Chairman.[2] Peel, as it turned out, need have felt no anxiety, and it is probable that after the first meeting he felt none. It must, as a result of this, have been Peel who engineered Eastlake's appointment as Secretary of the National Gallery a year later.

The *Journals and Correspondence* of Lady Eastlake, already much quoted, bring both the Eastlakes before us throughout the twenty years between their first meeting and his death in 1865. Although he himself was a great man, and she a remarkable

[1] Lady Eastlake: *Memoir* of her husband, op. cit.
[2] See Chapter VI, above.

woman in her own right, they managed to achieve a twin fame as a partnership, unlike the Grotes, who remained two separate distinct personalities connected by marriage. The celebrated Miss Rigby of Edinburgh and Charles Eastlake seem to have met for the first time at a dinner-party given by the John Murrays in Albemarle Street in May 1846. Among the guests were Turner and Landseer, Kinglake (*Eöthen*), two fashionable portrait-painters John Simpson and James Swinton, and Charles Eastlake himself: notable lions. The lionesses were Mrs. Jameson and Elizabeth Rigby. Eastlake took Miss Rigby in to dinner and was 'most refined and amiable'. Three years later, in 1849, they were married. The Eastlakes quickly occupied an important position in both the social and art worlds; or rather, in the world of intellectual fashion and official art. In June 1850 Elizabeth wrote to her mother from London, 'I had a large party here yesterday afternoon to meet Madame Rossi and hear her sing. About 60 came, including the Dowager Lady Essex, the Malmesbury's, Lady Hopetoun, Lord Lovelace, Lady Chantrey and Lady Davy. I was proud to introduce Madame Rossi to Lady Essex, and they met with mutual interest: they are a well-matched pair.' They were indeed. The Countess of Essex was the once-famous singer Catherine Stephens; the Countess Rossi was none less than the great Henriette Sontag, a soprano unmatched by any other singer of her time, not even by Malibran. Sontag had been forced out of retirement by financial disasters, and the Eastlakes were already sufficiently influential to be of great help to her.

197

In November 1850 Elizabeth wrote with quiet triumph, again to her mother, 'My dear husband returned to me last night as President of the Royal Academy.' Her account of the proceedings which led up to his election is rather astonishing in its revelations, chiefly of personal relationships; of the official relationship between the Queen and the Royal Academy, and the personal one between the Queen and Sir Edwin Landseer. In this case, as in so many others between 1840 and 1860, the term 'the Queen' may be taken as meaning 'the Prince'. The Queen's *wishes* that Eastlake be elected were conveyed in a letter from the Prince's Private Secretary to Landseer, who was himself, it must be remembered, an eligible candidate. The letter stated that the Queen and Prince earnestly hoped that the Academy would elect Mr. Eastlake as 'by far the best person to fill the office', and went on to say that it was of the utmost importance to elect a president 'who should not only practically illustrate the rules of Art, but also be a gentleman of erudition, refined mind and sound theory'. That they could address such a letter, in such circumstances, to Landseer shows what an extraordinarily high opinion they had of Landseer's character and integrity, quite apart from their taste for his pictures. The Prince was seldom wrong in his estimate of a man's character.

Lady Eastlake was probably one of the best hostesses that any President of the Royal Academy has ever had, but after 1855 it is fairly evident that she regarded herself primarily as the wife and partner of the Director of the National Gallery. Her letters, written from Dresden, Milan, Florence or

198

Rome in the middle 'fifties, throw a sharp, oblique light on both Eastlake's reputation as a connoisseur and on his methods of acquisition. In 1854 she said that her husband 'is a fountain-head of knowledge, and seldom quits a collection of any kind without having cleared up some doubtful masters for the owners. I find his worth is unfailingly recognised . . . the way in which he smashes a false name is sometimes very amusing.' There, for better or worse, is foreshadowed the modern expert, exercising his immense authority over the learned journals and the sale-rooms and the dealers' galleries of Europe and America. The results of his directorship of the National Gallery entitle Eastlake to be regarded as pre-eminently the re-founder of the collection. He set about it with courage, but also with the greatest circumspection. He was in his day the outstanding expert at the tricky game of attribution, and but few of his judgements have since been set aside. To that he added an unfailing talent for getting on the scent of important pictures, and patience, prudence and caution in following it up.

Two of Lady Eastlake's letters to her mother are very much to the point here, both written in 1855. The first was from Milan: 'My dear husband is, between ourselves, in treaty for some prizes, and has more prospect of getting what is really grand and fine than we could have expected. . . . Last year he made acquaintances which now serve his purpose. Most of the owners are needy and in debt. . . glad to have good prices for things which in their opinion any modern daub will replace.' The second was written from Florence, with a sharp freshness of ex-

199

pression that suggests rather a New York lady of the
period than an Edinburgh one: 'We see a good deal
of a certain class of men, namely picture-dealers—
not educated, but sharp and cute. Poor devils!
They are the only class who know anything of art,
and they have a native drollery which sends us into
fits. Some are fine-hearted creatures, honest and
would be generous if they could; but the majority
are sly and intriguing, and require such a cautious
character as my husband to be their match.' From
then till his death ten years later Eastlake's life be-
longs to the history of the National Gallery. It is
worth noting that throughout that period, and for
long before it, one of the Eastlakes' closest friends
was Layard. Eastlake appears to have valued his
judgement very highly, and after her husband's
death Lady Eastlake was largely guided by Layard's
advice in the publication of his notes and manu-
scripts.

Attempts to find a path through the tangled growth
of mid-19th-century taste are constantly frustrated
by the absence of any authoritative guides. We find
ourselves, unfortunately, a long way removed from
the clarity of mind and sureness about standards
that make travel through the 18th century so much
more comfortable. There are still no maps to mid-
19th-century æsthetic thought. When critics of the
day praise or adversely criticise a work of art of the
past, we have no clue to their standards of compara-
tive criticism. An intelligent person, for instance,
like Lady Eastlake can compare Raphael with
Wilkie. In 1846, she wrote[1] of the Raphael Car-

[1] Lady Eastlake: *Journal and Correspondence.*

200

PLATE 15

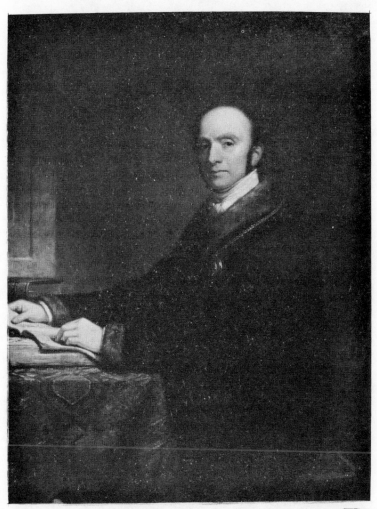

SIR CHARLES EASTLAKE, P.R.A.
Painting by Daniel Huntington, 1851

PLATE 16

A CORNER OF THE GREAT EXHIBITION, 1851

toons, which were then at Hampton Court, 'Grandeur, simplicity, generality, particularity! As powerful as Michael Angelo, had his power stood alone; as activing as Rubens, had his action taken precedence; as individual in character as Wilkie, had that been his sole object.' Lord Ronald Gower, less intelligent perhaps than Lady Eastlake but equally experienced, can cite Titian and Velasquez in the same context as Delaroche and Gudin. Describing the pictures at Stafford House in his boyhood,[1] he mentioned 'Zurburan, Murillo, Velasquez, Parmigiano, Titian, Paul Veronese and Correggio; historical subjects by Paul Delaroche, sea-scenes by Gudin.' And he added 'two portrait-groups by two great artists, one by Lawrence, the other by Landseer'. Delaroche, incidentally, was honoured by Disraeli in his novel *Coningsby*, in which Lady Monmouth's boudoir in Monmouth House was hung with amber satin 'painted by Delaroche with such subjects as might be expected from his brilliant and picturesque pencil'.[2]

Architectural criticism, as we have seen, could be as confusing as the criticism of pictures. Ruskin, brandishing his pen in the battle of the styles, does not help the explorer when he says:[3] 'The choice of Classical or Gothic may be questionable when it concerns some single and considerable public building; but I cannot conceive it questionable for an instant when it regards modern uses in general: I cannot conceive any architect insane enough to project

[1] Lord Ronald Gower: *Reminiscences*.
[2] Published 1845. This is a late survival, very Disraelian, of the earlier usage of 'pencil' meaning 'brush'.
[3] Ruskin: *The Seven Lamps of Architecture*, 1849; Lamp VII.

the vulgarisation of Greek architecture.' Vulgarisation, of course, meant adaptation to popular everyday needs. Every one of Ruskin's readers in 1849 must have been perfectly aware that architects were still designing houses and villas in the Grecian taste as well as in the Gothic; and that it was only a few years since Grecian had been regarded as quite correct for churches and dissenting chapels as well. On two points at any rate the majority of critics found themselves in agreement. One was detestation of 18th-century architecture, or what we to-day call Georgian; the other was belief in their own good taste, even if they did not quite know in what direction to apply it. Lady Eastlake combined both these points when she wrote:[1] 'The last century, ugly and uninteresting as it may look to our present more fastidious eyes, was essentially a time of recovery. Great affectation and odious taste there was to be sure.' They, in the eyes of us, their posterity, misunderstood the taste of the 18th century. It is quite certain that we, in the eyes of our own posterity, shall be shown-up as misunderstanding the taste of the mid-19th century, even though posterity may not go quite so far as to describe it as 'fastidious'.

With 18th-century tastes so much out of favour, it is almost startling to find an occasion of elegant caprice in, of all unexpected places, the Buckingham Palace of the Queen and Prince Albert. This was the decoration of a little garden-pavilion in the grounds of the palace, undertaken on the initiative of the Queen and Prince early in 1844. The pavilion or summer-house was a picturesque affair erected on

[1] Reviewing Waagen's *Treasures of Art in Great Britain*, 1854.

a mound formed during the excavation of the lake. Grüner[1] described it as 'picturesque and fantastic, without any regular style of architecture'. It consisted of three rooms and a kitchen, the principal room being an octagon. This was decorated in fresco with subjects from *Comus*, and the two small rooms on either side were decorated respectively in the Pompeian taste and with subjects from Walter Scott. *Comus* was selected because 'nothing could be more beautifully adapted to the shades of a trim garden devoted to the recreation of our Lady Sovereign, than the chaste, polished, yet picturesque elegance of the poem'. Scott and Pompeii were chosen for the contrast and comparison of the romantic with the classical. Unfortunately, the scheme for the *Comus* octagon did not work out as well as it would have done had there been one directing mind in charge of the whole scheme. As it was, the eight eminent Royal Academicians[2] employed on the job displayed collectively that lack of imaginative invention of which so many critics complained at Academy exhibitions and elsewhere. Out of the eight lunettes, three repeated one subject and two another; it seems that not even the Prince could overcome the artists' insistence each on his own arbitrary choice. Nevertheless, and although the result was not altogether satisfactory, the conception of an elaborately decorated garden-pavilion suggests rather George II's Queen Caroline or

[1] L. Grüner: *The Decoration of the Garden-Pavilion in the Grounds of Buckingham Palace.* Pubd. John Murray, 1846, by Command of the Queen.

[2] Stanfield, Uwins, Leslie, Ross, Eastlake, Maclise, Landseer and Etty.

Frederick Prince of Wales than Queen Victoria and Prince Albert; it suggests the 1740's rather than the 1840's. And the decision to have it frescoe'd by the most eminent artists of the day suggests the will of a Renaissance prince, however little that comparison would have pleased the Prince concerned; but Raphael adorning the walls of the Villa Farnesina, and Guido Reni painting his 'Aurora' on the ceiling of a Rospigliosi summer-house, cannot have escaped the knowledge of Prince Albert.

The 19th century, however, spoke clearly in the *Quarterly Review* about this garden-pavilion.[1] It had no time for 18th-century speculations about courtly or royal elegance, recreation or good taste. Even the Queen's little summer-house was to be regarded as an educational experiment. Alluding to 'the little Casino in the garden of Buckingham Palace', the *Quarterly* said, 'We look forward with much interest to the result of the experiment, as showing what *can* be done and thus defining the true starting-point of an English school of fresco-painting.' Since this was written three years after the Select Committee on the Fine Arts had been appointed and had decided to pursue just that object, it looks as if the Rev. Henry Wellesley was sharing with a good many other people at that moment the view that the fresco-decorations in the Palace of Westminster would turn out to be little more than imported Cornelius-Munich. He was wrong, as it happens, in that view. He was equally wrong if he thought that the Queen's garden-pavilion would

[1] Rev. H. Wellesley, *Quarterly Review*, 1844, on Fresco-painting.

inspire a new tradition in English art. If a great national undertaking like the Houses of Parliament failed to do so, it could hardly be achieved by a little pavilion in the private garden of the Palace. It must have gone sadly against the grain for Mr. Wellesley and the serious-minded subscribers to the *Quarterly* to have to recognise the possibility that the Queen and the Prince might be commissioning this work for their own amusement and pleasure, rather than for the edification of the people.

The Garden Pavilion no longer exists;[1] Comus has fled from Buckingham Palace as finally as he has from Ludlow Castle. Hardly had the Prince seen the charming toy completed when his mind began to be occupied with an undertaking so immense that in the end it became of world importance and remains his greatest single achievement for the country: the Great Exhibition. Mid-century, if it be taken literally as the year 1850, is both tragically and triumphantly significant; both for the calamity of Peel's sudden, tragic death, and for the organising of the Exhibition. The two are by no means unconnected, for the first nearly wrecked the second, apart from almost breaking the Prince's heart. The silencing of Peel's voice meant for the Prince the

[1] The following information has been graciously conveyed to me by H.M. Queen Mary. The Garden Pavilion was removed in August 1928. It was by then in a very bad state and, in the opinion of both Her Majesty and of H.R.H. the Princess Royal, was damaged and derelict beyond repair. Shortage of staff during the 1914–18 War meant that much routine work of preservation had to be abandoned, and the Pavilion with its paintings became ruined by damp and practically fell to pieces. Its final disappearance, though regretted, was inevitable.

loss of his one great support in the House of Commons on this issue, and left him to fight opposition alone, from outside the House. Before the end of 1850 he was advancing securely and triumphantly to success.

THE GREAT EXHIBITION

'THE Earth is the Lord's and all that therein is: the compass of the world and they that dwell therein.' The organisers of the Great Exhibition of 1851 paid their unquestioningly, and unquestionably, sincere and humble tribute to God when they inscribed that at the head of the title-page of their Official Descriptive Catalogue; and no less sincere is the last paragraph of the Preface: 'It is probable that, with the return of the Exhibitors and of the articles to the numerous localities abroad whence they were derived, copies of this Catalogue will be sent and taken also, and that these pages will be read in many lands long after the Exhibition shall have become matter of history. May they be found on examination to contain nothing which is not in harmony with the spirit of the motto on the title-page; and, while descriptive of the successful labours of man, may it not have been forgotten that the glory and praise are due to God alone.'

The Great Exhibition has become, indeed, a matter of history. So much so that it has become also the object of emulation in many countries ever since. Its correct description is The Great Exhibition of the Works of Industry of all Nations. This was by no means the first large-scale exhibition of industry and industrial art. France had organised the first ever to be held, in 1798, under the government of the

Directory; and had organised successive ones in
1801, 1802, 1806 and systematically from 1819
onwards. For thirty years before 1850, the great
industrial centres of England had rivalled Lille and
Lyons with exhibitions of machinery and manu-
factures, of which the most strikingly successful was
that at Birmingham in 1849. In 1829 the Royal
Dublin Society founded a triennial exhibition of art,
science and manufacture, limited, until 1850, to
Irish productions. The British exhibitions were all
private and local, without any form of State aid or
even State encouragement. The French exhibitions,
on the other hand, enjoyed Government support;
they were successful, those of 1844 and 1849 par-
ticularly so. The essential difference between all
these and the Great Exhibition was that the latter
was international, while the others were but national
or local. Great Britain, confidently assuming the
authority of recognised leadership, challenged the
rest of the world to compete with her. She was
already in a very strong position, but she still had
much to gain. She also had the prestige and pros-
perity of the next two or three generations to lose.
That she gained much and lost nothing was due, so
far as it was due to any one man, to the Prince; in a
wider sense it was due to the enthusiasm of public
subscribers and the courage of guarantors. In hardly
any respect was it due to Government. Having
appointed a Royal Commission of management, and
provided a central site, Government took no further
responsibility; which, in the words of the Com-
mission, threw 'the whole burden of the Exhibi-
tion upon voluntary contributions'. This was at the

request of the organisers. Put another way, it means that, since Government was not helping financially, it was impossible to determine the scale and extent of the exhibition until subscriptions and guarantees had begun rolling in. It says a good deal for the magnificent confidence that prevailed among the leaders of industrial and commercial England in the late 'forties, that they should be willing to subscribe handsomely to a project which, until they had so subscribed, must necessarily remain undefined.

That the project was conceived in the mind of the Prince has never been disputed. The conception took place, in fact, on 29th June, 1849. In seeking for the remoter origins of the idea, one finds no lack of authorities, but certainly the most reliable are the Introduction to the Catalogue[1] and Sir Henry Cole.[2] Cole was a member of the small and efficient Executive Committee of five which, under the personal direction of the Prince, was entirely responsible for carrying the Exhibition into effect; his statements of the course of events must therefore be respected, though they were written down many years later.

The Society of Arts played[3] a large and honourable part in the early stages of the story. Cole regarded the actual genesis of the Great Exhibition as being in a competition organised by the Society in 1845 for a tea-service and beer-jugs for common use; a humble enough origin for so splendid an offspring. It happened, however, that this competi-

[1] Published in three heavy volumes, lavishly illustrated, just before the close of the Exhibition.
[2] Sir Henry Cole: *Fifty Years of Public Work*, 1892.
[3] See Chapter VI, above.

tion was distinguished by the illustrious firms of Minton, Spode, and Wedgwood all competing. This gave rise to the Society's idea of annual exhibitions of British Art Manufactures,[1] which, after an uncertain start, were successful in 1847 and 1848, and developed into a project for a much larger exhibition of British Industry to be held in 1851. Prince Albert was President of the Society of Arts at that time, having succeeded the Queen's uncle, the Duke of Sussex, in 1845. Under him, the Council of the Society prepared and published a report on the French exposition of 1849, and from that moment the Prince took over personally. By June 1849 he had made up his mind that the 1851 Exhibition should be international, not national. This decision he announced on June 30th at a meeting at the Palace and developed further at a meeting at the Mansion House in October, when it was resolved that 'the cost of the Exhibition should be provided by voluntary subscriptions and not by the general taxation of the country'.

Difficulties were both unforeseen and apparently endless. Despite the wide and generous public support, there was a noisy minority in opposition to the scheme itself, to each suggestion for a site and to each design for the building. It was Henry Cole's conviction that no one but the Prince, with his great wisdom and prudence and the advantages of his rank, could have conquered the numerous difficulties of all kinds and overcome the incalculable and unforeseen prejudices which the Exhibition excited

[1] The terminology of the time was not very happy; but it is perhaps no happier to-day.

in a nation so conservative as the English. Lady Eastlake gave an entertaining and rather acid hint of these tribulations in her admirable obituary-article on the Prince, alas only eleven years later.[1] 'The feelings which succeeded the announced plan, the prejudices and discouragements it endured, are,' she wrote, 'fresh in the minds of our readers. The most formidable difficulties were opposed by Government itself, startled out of all its proprieties by a scheme its philosophy had never dreamt of.' That is probably less than fair to Sir Robert Peel, the Prime Minister, but there certainly was a considerable degree of Parliamentary opposition. The famous Mansion House dinner was rightly seen by Lady Eastlake as the chief factor in winning public opinion to the plan. It was the presence of 180 provincial Mayors that did it. To begin with, they were all delighted at being invited to the Mansion House; and, secondly, 'they were all flattered in being nominally associated in a scheme for the failure of which none thought they should be held responsible. It was well they came, for the Prince had girded himself up to do battle for Peace and Industry with weapons none could oppose.' 'The getting together of 180 Mayors', added Lady Eastlake, 'was, however, no pledge of concurrence or even of comprehension of his views.'

The controversy about the site for the Great Exhibition was particularly violent. The Prince, with Eastlake and the rest of the Commissioners, wanted one on the south side of Hyde Park, between Rotten Row and the Kensington Road. *The Times*,

[1] *Quarterly Review*, January 1862.

on the other hand, with strong support, advocated a site at Battersea; and there were other suggestions. Peel was strongly in favour of the Hyde Park site, and his support was the Prince's great comfort. Two days before the debate on the subject in the House in June 1850 Peel was thrown from his horse on Constitution Hill; and on the day of the debate, early in the morning, he died. Peel himself had said 'they must remain firm about Hyde Park or give up the Commission'. The Prince said [1] : 'Peel was to have taken the lead in our defence, but now there is no one'. Both Parliament and the Press, especially *The Times*, furiously attacked the Hyde Park project.

Since we, a century after the event, know how spectacularly beautiful and successful the Exhibition was, it is easy to blame them for lack of imagination. But not quite fair; such a show might, if badly handled, have turned the Park into a wilderness and Kensington and Knightsbridge into slums. The Prince, deprived of Peel's support, was near despair. He wrote to his faithful Baron Stockmar, in June 1850,[2] 'The Exhibition is now attacked furiously by *The Times*, and the House of Commons is going to drive us out of the park . . . if we are driven out of the park the work is done for.' And to his mother-in-law, the Duchess of Kent, he wrote in the same month [3], '. . . the whole public, led on by *The Times*, has all at once made a set against me and the Exhibition, on the ground of interference with Hyde Park. . . .'

The Hyde Park site, however, was carried.

[1-3] Letters quoted by Sir Henry Cole, op. cit.

Immediately controversy about the building brought a fresh threat of frustration. In January 1850, long before either the site or the extent of the Exhibition had been settled, a Building Committee was appointed. It was distinguished and authoritative, yet all it achieved was to arouse yet more hostility. The members of this Committee were the Duke of Buccleuch and Lord Francis Egerton (by then Earl of Ellesmere), the two great architects Charles Robert Cockerell and Sir Charles Barry, the even greater engineers Robert Stephenson and Isambard Brunel and, as Chairman, the magnificently enterprising engineer and contractor Sir William Cubitt. In the difficult circumstances, calling for quick and courageous decisions, the Committee was either too big or too individualist to be workable. Probably any one of its members could have produced a good result if he had had sole responsibility, but as a whole they, in Cole's words, 'nearly wrecked the Exhibition by dispute and delay, and after five months produced an impracticable plan'. This plan, after no fewer than 245 designs had been received, considered and rejected, was the fruit of the Committee's own deliberations, and meant a solid brick structure, containing nineteen million bricks, with a dome two hundred feet in diameter. This plan met with universal disapproval. The public rightly considered that nineteen million bricks threatened an ominously, and indeed definitely, permanent intrusion on their Park, and would not have it. So after five months the Committee was back where it started. Then Joseph Paxton came on the scene with a design for a building of iron and glass; this was the Crystal

Palace. Some authorities say that this design was received coldly by the Building Committee, but whether or not that be so, the Committee set aside its own nineteen million abortive bricks and accepted the gardener's gigantic greenhouse. Paxton, as the Duke of Devonshire's highly privileged superintendent of gardens, had erected at Chatsworth a vast greenhouse for tropical plants which served, in the event, as a dress-rehearsal for the first great revolutionary building of our day.

So much time had already been wasted that there were grave doubts as to whether the building could be ready in time. The Duke of Wellington, in whom the entire nation now trusted for everything, allayed such doubts; with his talent for recognising genius as soon as he met it, the Duke said, 'It will be ready, I know it will—Paxton has said it will.' It was, of course; but, moreover, building operations had actually begun a month before the deed of contract was signed in October 1850, and the public-spirited contractors, Fox, Henderson and Company, had incurred a liability of £50,000 without any guarantee. It is impossible to avoid pointing the contrast between their and Paxton's courageous enterprise and the timidity shown by the top-heavy Commission and Committees. The Prince himself, heavily handicapped by official makeweights hung round him, urged and watched every forward step. Throughout the process of building he was constantly on the spot, consulting, but never interfering with Paxton and the departmental foremen; all this, it need hardly be added, in addition to his heavy duties as the Queen's permanent political adviser

214

and as a generally overworked Royalty. Queen Victoria herself, in the twelve weeks before the opening, between the end of January and 1st May, 1851, paid eight visits while the building was being completed and the exhibits were being assembled. Anyone who has had experience of an international exhibition in the weeks preceding its opening will realise the conditions the Queen had to face. It is worth noting here that during the course of the Great Exhibition, between her official opening of it on 1st May and the final evacuation of the empty building on 11th November, the Queen paid no fewer than thirty-four visits, of which fifteen were in the first month.

Of all the opponents to the Exhibition, from its inception, the most impassioned was the famous Colonel Sibthorp, Member of Parliament for Lincoln, an eccentric and rather magnificently ultra-Tory die-hard. Colonel Sibthorp's chief ground of opposition was probably his dislike of foreigners, embodied in the Prince. In a speech in the House early in 1851 he prayed that hail or lightning might descend from heaven to destroy the project. Other opponents [1] contented themselves with prophesying that such an influx of foreigners and multitudinous crowds would only result in damage to private and public property, outbreaks of plague and cholera, destruction of morals, encouragement of revolution and the proclamation of the Red Republic. More ominous still was a pamphlet by the Astronomer Royal, Sir George Airy, proving that Paxton's Crystal Palace was theoretically bound

[1] Cf. Sir Theodore Martin's *Life of the Prince Consort*.

to fall down, even before being completed. On the other hand, William Brockedon[1] gave Lady Eastlake the most convincing scientific reasons why it should stand up.

An attitude characteristic of many people at the time—opposition converted by experience into admiration—is shown by Mrs. George Villiers.[2] She had lived most of her life in Kent House, Knightsbridge, almost opposite the site of the Exhibition, and the close proximity inspired violent disapproval in her and in most of the neighbouring residents. Extracts from her family correspondence in 1850–51 show Mrs. Villiers in the moods successively of condemnation, derision, toleration and praise. They also show a markedly anti-Court attitude. 'Hyde Park', she wrote, 'will be spoilt, children will not be able to walk there, the trees will be cut down and all sorts of horrors will take place. If Prince Albert wants to indulge fancies, let him and Courtiers pay for them, or the Grandees of the land. But to send the begging-bowl round to poor clerks, and to be told the Queen will be displeased if people don't subscribe—I think it is too bad.' Mrs. Villiers had rather angrily given a shilling to the public subscription fund. Later on, when the Crystal Palace was nearing completion, she began to find it difficult to disguise her growing interest in it. Her children were taken 'to see the opposite Monstrosity' by a friend, who said that its only beauty was from its

[1] William Brockedon, F.R.S., 1787–1854; painter, author of travel-books and mechanical inventor.
[2] 1775–1856. Mother of the 4th Earl of Clarendon. Correspondence edited by Marjorie Villiers, *Quarterly Review*, July 1944.

unparalleled vastness. 'A great many Builders and Architects', she wrote, 'are very doubtful of its security, but that may be *jalousie de métier*. The size is so vast that Theresa says the great old elms look like little Christmas Trees inside.' As the opening day approached, Mrs. Villiers indulged in ridicule of the Queen as well as of the Exhibition: 'The programme for the foolish thing is settled. "Gracious Missus" goes in state and will sit on a throne. She is to declare the Exhibition of the World's Fair open. At Bartlemy Fair the Beadles used to give out that the Fair was open, so the idea is not new.' After that devastating remark, she refused to attend the opening, but stayed at home and wrote letters, in one of which she said: 'I am sitting at home while they are gone to the nonsensical pageant. To keep my mind off the terrible calamities that may be happening, I write to you of other things.' And then, a fortnight later, Mrs. Villiers was converted. 'What do you think!' she exclaimed. 'I've been to the Exhibition, I have indeed. . . . I was allowed to use my eyes as much as I pleased, but not my legs. Tomorrow Lord Granville [1] will allow me a wheeling chair. It must be ultra-splendid when one sees the whole.' Since Mrs. Villiers was then aged seventy-six, she must have been grateful for the privilege. Probably she was envied by everyone who saw her.

A more illustrious convert from hostility, or at the best indifference, to enthusiasm was Thomas Love

[1] 2nd Earl Granville, 1815–91. One of the Commissioners invited by the Municipality of Paris in August 1851 to celebrate the success of the Exhibition. It is said that his exquisite French, with a slight *ancien régime* Court accent, was a valuable asset in Paris.

Peacock. For many weeks he abstained from going to the Exhibition, but, having once gone, he went afterwards every day till it closed. Charles Dickens, on the other hand, was never an enthusiast for it. He described himself as 'quite used up by the Exhibition'. There was too much to see, too much to take in; he only went twice.[1]

None of the calamities prophesied by Colonel Sibthorp or Mrs. Villiers occurred. There was no revolution, no cholera. The Duke of Wellington had feared riots, and talked much about being prepared and keeping roads open to facilitate the passage of soldiers, but the Prince refused to believe in such a possibility. The Duke's instinct, so unfailingly sure when dealing with individuals, was often surprisingly at fault in gauging public opinion, while the Prince seldom went wrong in that respect, foreigner though he was. Though there were no calamities, there were one or two incidental problems that called for tactful solution. One of these occurred while the exhibits were being assembled, in March 1851. It was observed with dismay that Pugin had ostentatiously exhibited a crucifix.[2] Pugin, for all his extremism, was regarded with considerable respect, and the position might have become difficult. Fortunately, he readily agreed to lower the position of that then so controversial emblem. The British and Foreign Bible Society, according to Sir Henry Cole, also caused trouble and anxiety by insisting on exhibition space after the closing date for applications, and then exhibiting a case of Bibles, 'not as specimens of printing, but as a display of their

[1] Sir Henry Cole, op. cit. [2] Ibid.

218

religious enthusiasm'. Cole himself was gravely exercised by a problem of a more personal nature. Should he attend the opening in a Court suit? Cobden, true to his unaccommodating principles, had refused to wear one, but the more realistic Mulready advised Cole to wear the usual prescribed get-up, 'as the occasion', he said, 'was not worthy of eccentricity'.

Figures and statistics may or may not mean anything to anybody; it depends on who uses them and for what purpose, since, as often as not, the same set of figures can be used to prove whatever anybody wants them to prove. The Great Exhibition provided magnificent opportunities for the statisticians. Let the reader make what he will of the figures. For instance, in the six months of its existence the Exhibition had more than six million visitors, and brought in not far short of half a million pounds in admission fees and from the sale of catalogues and refreshments; it showed a clear profit of about £185,000, which was vested in the Commissioners to be ploughed back into the soil from which the gigantic idea had grown: the improvement of design in industry. Paxton's revolutionary building of iron and glass was popularly believed to be 1,851 feet long, which perhaps it was. It was also said that if one person devoted three minutes to looking at each object exhibited, it would take him thirty-six years to do it. The area of space devoted to the products of the United Kingdom was about 210,000 superficial feet; to those of foreign countries about the same; and to those of the British Colonies about 50,000—of which India occupied three-fifths. France

had by far the largest area among foreign countries, with 50,000 or more superficial feet; the United States were next with 40,000. There was much competition to get the contract for catering, and finally Messrs. Schweppes secured it with their offer of £5,500 for the privilege. There are thousands of other pieces of more or less useless information to be got from a variety of sources.

The great three-volume Descriptive Catalogue of the Exhibition provides enough material for even more books than will doubtless be written on the subject. One passage, however, although it is irrelevant to this particular book, may be quoted for its historical significance. The section devoted to the United States [1] lays emphasis on the absence there of those vast accumulations of wealth to be met with in many European countries and which favour the expenditure of large sums on articles of luxury. No comment is needed here, other than that of the Muse Clio herself. One other passage may be quoted, as evidence that, with all their courageous optimism, the organisers were not by any means certain that the Great Exhibition, or any other exhibition, was infallibly going to do what was expected of it; namely, the improvement in quality and design of manufactured articles. France had for many years led the way in exhibitions of national and local industries, and in the section devoted to that country [2] it was found interesting to regard her contribution as an example 'of the effect of exhibitions of industrial

[1] *Official Descriptive and Illustrated Catalogue of the Great Exhibition*, 1851, 3 vols., vol. III, p. 1431.
[2] Ibid., vol. III, p. 1168.

products upon the nature and quality of the articles produced'. French articles of luxury and 'objects of minute art' showed a high state of refinement and perfection, but they formed an observable contrast with the quality of ordinary articles in common demand. The Catalogue (without much conviction, however) thought that the character of the more ordinary objects was perhaps better than it had been formerly. 'That improvement', said the Catalogue, 'in the manufacture of these commoner articles of life, which is now rapidly extending in France, may be in part attributable to the powerful encouragement to the production of this class of objects constantly offered at the National Expositions at Paris.' Possibly; it could only be hoped that British manufactures would show a more positive improvement in quality and design than those of France had done.

The principles on which the Prince and his fellow-Commissioners formed the Exhibition were based on the four classifications, of Raw Materials and Produce; Machinery; Manufactures; and Fine Arts. Only the last two departments are relevant here, though the whole catalogue excites wonder and admiration: wonder at the degree of inventive ingenuity and admiration at the degree of technical efficiency achieved by 1850.

The limitations imposed on the department of Fine Arts were so severe as to exclude all the Fine Arts except that of Sculpture. Oil-paintings, watercolours, frescoes, drawings, engravings were all excluded; sculpture and the barely defined Plastic Arts were alone admitted 'if they exhibit such a

degree of taste and skill as to come under the denomination of *Fine Art*' and if they were the work of living artists or of artists deceased within three years before 1st January, 1850. This was very reasonably explained in the Introduction to the Fine Arts section,[1] which said firmly, 'The Exhibition having relations far more extensive with the industrial occupations and products of mankind than with the Fine Arts, the limits of the present Class have been defined with considerable strictness.' It was first and foremost an industrial exhibition; at the same time, it was recognised that some form of Art, Fine or Applied, was essential, if only as an embellishment. The definition of what was admissible meant, in its effect, those departments of art which are connected with mechanical processes, and those mechanical processes which are applicable to the arts. Colour-prints and chromo-lithographs were admissible. Paintings as works of art were not, but if they demonstrated an improvement in manufactured colours they were admissible. Mosaics, enamels, ivory-carving, wood-carving, medals were also allowed. So, moreover, was sculpture. Marble statuary came well within the definition of mechanical processes applied to the arts. For many generations past, carving had ceased to be the work of the sculptor, and had been carried out by skilled workmen using mechanical appliances.

A point does appear to have been stretched in the section of the United States of America, where a model of a large modern building was admitted. It

[1] *Official Descriptive and Illustrated Catalogue of the Great Exhibition*, 1851, 3 vols., vol. II, p. 818.

was, however, no ordinary building. It was the Floating Church for Seamen at Philadelphia. 'This neat edifice', said the Official Catalogue, 'now floats on the waters of the Delaware.' The church floated on the twin hulls of two New York clipper-ships, and had a tower surmounted by a spire; its style was Gothic throughout, the exterior was painted to resemble brown stone, the interior had a groined roof and its furnishings included a bishop's chair—this last suggests that it was used for Confirmation-services as well as for the usual daily offices. The architect and builder of this uncommon church was Clement L. Dennington, of New York.

It is safe to guess that the class dearest to the Prince's own heart was that of Manufactures, for that was the only one of the four which provided full scope for the contention at which he, and the Society of Arts before him, had been hammering away—that improvement in quality would be a better investment than increase in quantity. Yet the Introduction to the Ceramic section [1] almost let him down. 'In other countries', it said, 'the finer descriptions of ceramic productions are produced of a greatly superior character to ours; but in no other country but Great Britain is the common earthenware, for the ordinary purposes of life, produced either in such quantities or of such a quality and degree of economy in price.' May be the latter point was a true one; foreign buyers, fortunately, seemed to think so.

It soon became clear that Great Britain, better

[1] *Official Descriptive and Illustrated Catalogue of the Great Exhibition*, 1851, 3 vols., vol. II, p. 709.

than other countries, could produce very large quantities of widely-useful goods, of solid and lasting quality and at reasonably cheap prices. Also that she could produce expensive articles of furniture and upholstery of equally solid quality which, in the words of the Catalogue, 'bespeak a high degree of national prosperity, and . . . indicate not less distinctly the wealth and domestic refinement of those for whose use the greater majority of the articles exhibited (i.e. in that particular Class) are unquestionably intended'.

Reliability and value for money, yes. The Great Exhibition demonstrated that those qualities at least, for many years to come, could be relied upon in any object, cheap or costly, manufactured in Great Britain. Improvement in design was another matter. By what standard can 'improvement' be judged? Who can measure it? To-day in the middle of the 20th century, of that minute proportion of the population which thinks about design at all, the greater part holds that mid-Victorian taste was deplorable, Regency taste was good, the whole of the 18th century except its Gothic side exquisite, and everything earlier, even the bastard renaissance of the Jacobean, beyond criticism. In the condemnation of mid-Victorian taste it is often asserted that the rot set in with the Great Exhibition. To assert that is to assert that the taste of 1855 was 'worse' than that of 1845, yet in the early and middle 'forties the view was often expressed that British design in manufacture was deplorably behind that of France; hence, as we have seen, the establishment of the Schools of Design. Those Schools, with all their

high intention, seem to have achieved little enough. The Exhibition, at least in the eyes of certain foreigners, achieved a great deal. The French, for instance, who cannot be expected to have hoped for British success, expressed the opinion about 1862 that during the ten years since the Great Exhibition British design had shown such an improvement as to have become perhaps competitively dangerous.

There is no absolute canon of taste, no standard by which we can assess progress or the reverse. There is only the variable standard of fashion. As an example, a gold or silver ewer wrought by Benvenuto Cellini is generally held in high admiration; a similar type of object in the same metal, exhibited in 1851 by Garrard and Co. of the Haymarket, is held in horror. In both is the same tortured use of the metal, the same delight in ingenuity for its own sake, the same ignoring of suitability, the same exhibitionist display of skilfulness. A 16th-century German goblet is to-day fought for by collectors, while one in exactly the same spirit, exhibited in 1851 by George Angel of the Haymarket, is thought fit only for melting down. An elaborately rococo mirror, carved with shells, birds and foliage, shown by Samuel Clark of Dean Street, is derided by the same people who are captivated by an even more elaborate piece of rococo from Chippendale's workshop. Or an over-mantel in Jacobean-Renaissance manner by Holland of Mount Street is held to be in bad taste, while a genuine object of that period is widely held to be a desirable possession. In all these cases it cannot be the *taste* of the mid-Victorian design to which critics object, since that taste is a repetition of one

which the same critics admire. Where such design can, however, be legitimately assailed very often is for the *spirit* in which a particular taste is expressed. The spirit of an original style, exuberance or reticence, elegance or plainness, or just perfection of good manners, will almost always be absent from a revival of that style. When the designers of 1850 evolve an object that is original and not based on the past, as for example an easy-chair by Jennens and Betteridge, to-day's critic is hampered, probably unconsciously, by the prejudice that always surrounds the taste of a century ago. The mid-Victorians hated Chippendale, the Regency disliked Kent, the Georgians hated the Stuart and the Augustans found the Jacobean inexpressibly barbarous. The majority today considers the early- and mid-Victorian ugly. Ugly, however, is a highly subjective expression. Not until the usual cyclical prejudice has worn itself out will the period come to be regarded objectively, and its merits and demerits seriously assessed. It will then be found that the taste of 1850 reflects many of the qualities that we associate with the general thought and feeling of the period in England.

Assertion of material opulence; awareness of being the richest nation in the world; heavy reliance on the winning-powers of mechanical progress both in sustaining and in increasing that leadership; and the pessimistic doubt that such a belief would lead only to the Mechanical Fallacy[1]—these can all be detected by careful study of the Great Exhibition Catalogue. The opulence proclaims itself in the illustrations and

[1] To borrow an expression used by Geoffrey Scott in his *Architecture of Humanism*, 1914.

descriptions, while the awareness of leadership is implied in the introductions to almost every British section. The doubt is obliquely yet clearly expressed in the nostalgia for the past shown in section after section of the Catalogue. Nostalgia is perhaps not the right word, since its primary meaning is an anguished longing to return home; not just to go somewhere else, but to go home. Home means one place, one place only, above all others. The men of 1850 who looked back to the past had no home and were only too well aware of the lack of one; they searched everywhere—in Italy and Germany, in the Gothic centuries of England and in the Olden Time. Home might be in any of those, only they could not feel that it lay with them, now, in their own time.

In knowledge, the men of 1850 in England were masters of the world, and they had no doubts about it. In feeling, in æsthetic sensibility, they did not seem to be masters of anyone, let alone themselves. Judging as we only can to-day, from our own point of view, the Great Exhibition demonstrates two points above all others. First, as a whole, Britain's magnificent achievements on the pragmatic side, as having a positive and practical effect on man's material life. Secondly, in the parts concerned, the fallaciousness of that Mechanical Fallacy that to Know was better than to Feel; that the mission of modern leadership lay more in improved mechanisation than in a search for an æsthetic principle. That fallacy, of which many people in 1850, including the Prince and of course Ruskin, were well aware, gave rise a generation later to a fallacy of equal

magnitude: the fallacy of William Morris, that the search for æsthetic principle could only be successful if mechanical progress were ignored. Morris could not stem the torrent released by the Exhibition, and in trying to do so he condemned his own mission to failure. Had he addressed himself more to manufacturers and less to craftsmen, he could have crowned the Exhibition with a posthumous success more lasting than any it actually achieved, by inspiring the production of mass-produced objects sensitive in design, economical in cost and sound in construction.

As it was, the only object connected with the Exhibition that possessed all those qualities and is regarded beyond all controversy as a success, was the building that housed it—Paxton's Crystal Palace. The superb mechanics of its structure command the admiration of engineers; the production and the prefabrication of all its thousands of parts are the envy of contractors;[1] the completed whole was, and will always be, cited as an architectural triumph so overwhelming as to entitle the Palace to a place among the great epoch-inaugurating buildings of history. With the exception of the large greenhouse at Chatsworth, it had no predecessor in all man's experience; its descendants all over the world are beyond counting.

We can only see the Crystal Palace in photographs in drawings and prints, and through the eyes of witnesses. We cannot, unhappily for ourselves, see

[1] The whole extraordinary story of the construction of the building is set out factually and without emphasis in the *Catalogue*, vol. I, pp. 49–81.

it as its inspirer the Prince and its creator Paxton saw it, growing with incredible speed through a carefully ordered forest of scaffolding into a miracle of glass and slender iron columns, glittering in the sun in the fresh green setting of Hyde Park in May. One of the most humbling experiences one can have is to try to imagine the thoughts and the emotions of the Prince and Joseph Paxton on 1st May, 1851.

The Great Exhibition, when it came to an end in October 1851, was considered beyond question to have been a success. Its immediate object, the stimulation of British manufacture, was undoubtedly achieved. Whether its ultimate object, the improvement of design in industry, was likely to be achieved, no one was in a position to say. One could only hope. The Prince himself, who might well have rested content with that colossal achievement, was not content. He believed that the stimulus to industry provided by his Great Exhibition must be followed up by the stimulus of a more specialised exhibition devoted to what he conceived as the complementary object—education of the public in art and in the appreciation of art. Out of that belief grew the celebrated Art Treasures Exhibition held in Manchester in 1857; that it should have been held in Manchester shows how clearly the Prince linked the improvement of industrial design with æsthetic experience. That, however, was still six years in the future.

By the end of October 1851, the Crystal Palace was empty and had become a problem. Paxton himself proposed that it be turned into a perman-ent Winter-park under glass, with climbing plants

229

trained up the columns and along the girders to give shade in summer, and with a collection of live birds from all temperate climates.[1] *Punch* was all for it; not only would it be extremely beautiful, but it would be a permanent source of instruction in botany and ornithology. The Commissioners thought otherwise, and decided to sell the building. *Punch* was incredulous and indignant; it refused to believe that the Royal Commission could be capable 'of anything so foolish as the wanton destruction of the only National Building that an Englishman is not ashamed of owning'.[2] However, the Palace was sold to a Company and re-erected, with certain alterations in both design and structure, at Sydenham. As a permanent exhibition and pleasure-garden combined, it rapidly became even more of a wonder than it had been in Hyde Park, and Paxton's reputation was increased even further. Dickens, indeed, was so facetious as to recommend that Paxton be authorised to take down Mont Blanc and re-erect it at Sydenham.[3]

With Lady Eastlake's comments on the re-erected Crystal Palace we come at once to one of the cardinal principles of the mid-century; that public amusement should be combined with education. Pleasure with instruction was what the masses

[1] Paxton even estimated the cost of such a project. 'Labour, fuel, water, feeding and attendance to birds, gravel for walks and general superintendence = £8,000. Constant painting, renewals and repairs = £4,000. Total, £12,000 p.a.' Of this total, at least £9,000 p.a. would be produced by the interest on the invested profits of the Great Exhibition.

[2] *Punch*, vol. 22, 1852.

[3] Letter from Charles Dickens to the Baroness Burdett-Coutts, from Milan, 25th October, 1853.

needed. All too clearly, in the 19th century they were in desperate need of both. Lady Eastlake had no doubt that the new Crystal Palace made some contribution to these needs. 'It is now', she wrote in 1854,[1] 'a paradise of flowers and works of art. . . . If many make it only an amusement, it will be an innocent one; but, judging from myself, it must be an improvement and raise the whole standard of education.' She developed this point further, and more critically, a year later;[2] but the same point was already emphasised by the Crystal Palace Company itself, in the preface to one of its Guide-books. 'The Palace', it said, 'is an institution intended to last for ages and to widen the scope and brighten the path of education throughout the land.' Lady Eastlake's expression of the same ambition was to hope that the new Palace would combine intelligent amusement with harmless enjoyment and, in addition, would arouse a sense of gratitude in the visitors. She did not know, as well as we of a later generation know, how little gratitude is felt by people who are given a great deal for almost nothing.

The chief point made by Lady Eastlake, through the authoritative and very widely read pages of the *Quarterly*, was that in the past instruction had been too dull and had made no appeal to the imagination; it had been utilitarian. Education was taken very seriously in the 'forties and 'fifties, by educationists. Lady Eastlake was a very intensively educated woman, and she came, moreover, from Edinburgh. She was not an Utilitarian, nor a Liberal, nor a Re-

[1] Lady Eastlake: *Journals and Correspondence*.
[2] *Quarterly Review*, vol. 96, 1855.

former; and she was not an educationist, in the then accepted sense of that term. 'The well-meaning teachers of the lower orders', she wrote, 'for the last quarter of a century have erred in their estimate of the average human mind. Mechanics' Institutes, lectures, swarms of new publications, have failed in their mission.' They failed to appeal to the imagination. That appeal, in her view, was at last being made at the Crystal Palace, which appeared to have as its distinctive purpose 'the encouragement of that fairest ornament of a land—fine taste'. The Prince must have fully agreed, when he read this, with both the definition and the desirability of that purpose. Colonel Sibthorp probably agreed with neither. Lady Eastlake, it should be added, was aware that the new Crystal Palace was the heir of its predecessor in more senses than one. Commercial benefits would come as well as instruction and amusement. In the stoves, ovens and umbrella stands at the exhibitors' stalls, in this practical encouragement to manufacturers and financial advantage to the Crystal Palace Company, Lady Eastlake found, to quote her own words, 'the beauty of fitness'—a quality more often discerned by the early Victorians than we to-day generally suppose.

PLATE 17

CLOCKS IN THE CLASSICAL AND GOTHIC STYLES

SARCOPHAGUS IN COMBINED CLASSICAL AND GOTHIC STYLES
From Catalogue of the Great Exhibition, 1851

PLATE 18

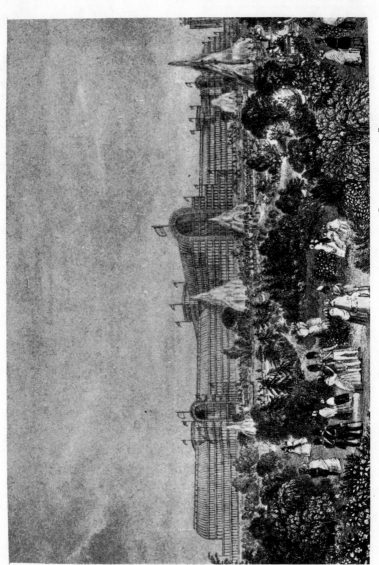

THE CRYSTAL PALACE AS RE-ERECTED AT SYDENHAM, 1854

From a contemporary print

THE 1850's: THE NEW CONNOISSEUR-SHIP

THE transition from the first to the second half of the century, marked by the Great Exhibition, did not in itself turn the current of informed taste in a new direction. Collectors' fancy in the 'fifties followed and developed the tendencies which had begun to appear during the late 'thirties and the 'forties, which marked the final breaking away from the correct taste prevailing at the beginning of the century, still being followed by some of the older generation who clung to Reynolds's *Discourses* as their guide. Were there space for it here, a detailed comparison between the pictures assembled at Paris in 1803 by Napoleon's Commissioners and those shown at the Manchester Fine Arts Exhibition in 1857 would be very illuminating. In 1803 the vogue was still for the Eclectic Masters: for the Carracci, Guido, Albano, Guercino and Domenichino. Half a century later, a number of collectors were already beginning to compete for works bearing the names of Giotto or Orcagna, of any Sienese or Florentine 15th-century Master and even, occasionally, of the Flemish contemporaries. The Manchester Exhibition was to show how strongly the tide, which had already begun to turn, was now flowing in the direction of the early Schools.

This epoch-marking exhibition sprang from the

same root as did the Crystal Palace Exhibition of six
years earlier: zeal for educational usefulness. For
the first the Prince was solely, for the second he was
largely, responsible. Unlike most educationists be-
fore or since, he did not confuse education with in-
struction.[1] Education of the people was for him an
object of which instruction was but a part, and, while
he believed firmly in the intrinsic importance of
factual knowledge, he also believed that such know-
ledge could only be fully fruitful if fertilised by the
imagination. The preliminary stages leading to the
Manchester Exhibition make that clear enough. They
also make clear the extraordinary position of author-
ity which the Prince came to enjoy after, and as a
result of, 1851. The Manchester project was origin-
ally, it seems, for a general exhibition on the lines
already becoming familiar. In the end, thanks to
the Prince's advice, it grew into something of much
more lasting importance: the first large exhibition
for the public of works of art from private collec-
tions in England, including the inherited collection
of the Queen and the personal collection of the Prince.
The organisation was largely entrusted to Waagen,
who probably had a greater factual knowledge of the
private collections of this country than any other one
man, however limited his critical gifts may have been.
His *Treasures of Art in Great Britain* had been
published in 1854, and possibly helped in inspiring
the idea of this exhibition.

In the summer of 1856 a deputation from Man-
chester waited upon the Prince to explain their
objects and to ask his advice. Although Manchester

[1] Except, perhaps, in the upbringing of his eldest son.

men, they were prepared to take advice from Prince Albert, if from no one else outside Lancashire. The Prince's views were set out after the meeting in a letter from him to Lord Ellesmere.[1] After describing the discussions with the deputation, H.R.H. went on to state the principles which he thought should govern the organisers. As he pointed out, Manchester would be at a disadvantage if it contemplated a general exhibition, since it had already been preceded by the Great Exhibition of 1851 and by those at Dublin and Paris in 1853 and 1855. They should therefore avoid a mere repetition, and produce something distinctive by having only an Art Treasures Exhibition.[2] The Prince's characteristic line of thought is expressed very clearly. 'In my opinion,' he wrote to Lord Ellesmere, 'the solution will be found in the *usefulness* of the undertaking . . . in the *educational direction* which may be given to the whole scheme.' It was not enough simply to gratify public curiosity, nor even to provide intellectual entertainment for the connoisseurs. The Exhibition

[1] Published in the *Manchester Guardian*, 8th July, 1856. Lord Francis Egerton, created Earl of Ellesmere in 1846, has been encountered in previous chapters. He appears here as Lord Lieutenant of Lancashire. He did not live to see the project carried out, dying in February 1857.

[2] The Manchester Exhibition, as finally arranged at Old Trafford, included sections for Paintings by Ancient Masters, Modern Pictures by Foreign Masters, the English School, the British Portrait Gallery, Drawings by the Old Masters, Engravings and Etchings, Ornamental Art, Oriental Art and, as a section to itself, the Contribution of the Marquess of Hertford (from what is now the Wallace Collection). The three-volume Catalogue and a Guide were compiled by Waagen, and a series of articles on each section, originally printed in the *Manchester Guardian*, were reprinted as Handbooks.

must serve to instruct the uneducated in art-history. The Prince was not far wrong when he told Lord Ellesmere that no country invested a larger amount of capital in works of art than England or did less for art education. It was quite clearly the Prince's belief that what he called art education (that is, both instruction in art-history and also the opportunity of experiencing works of art) was an important factor in general education; and it was also his belief that such instruction and such experience would ultimately produce a more critical taste in the general public, and thus would raise the standard of design in manufacture. That is probably why he identified himself so closely with such an exhibition in such a centre as Manchester. The Prince's beliefs were not shared by many other people either in his lifetime or for many years after. One had only to point to the Government Schools of Design and shrug one's shoulders.

The Manchester Exhibition gave a new impetus to the science, in the Eastlake sense, of connoisseurship; and it also pointed a new direction in which persons of taste might profitably move. It revealed on an important scale for the first time the possibilities of the early Italian and Northern Masters—thanks principally to the loans from the Prince's collection. As one of the critical notices in the *Manchester Guardian* pointed out,[1] the taste for early Italian art was not a recent developement in this country only; it was a novelty even in Italy. At the

[1] Reprinted in *A Handbook to the Paintings by Ancient Masters in the Art Treasures Exhibition*, published by Bradbury and Evans, 1857.

236

beginning of the century Italian connoisseurs still regarded Perugino as the ultimate point to which investigation might be carried. A first important step had been taken early in the century by Lasinio, the *conservatore* of the Campo Santo at Pisa, in saving the Giotto frescoes from wanton destruction. Subsequent steps had been taken by Lasinio's English disciple William Young Ottley, who made careful drawings of frescoes at Pisa, Florence and Assisi, and, towards diffusing the new taste, by Seroux d'Agincourt in Paris and William Roscoe in Liverpool. But the new taste was slow in spreading, for there was almost no knowledge by which it could be supported. Before 1850 there was no English translation of Vasari,[1] although he had for many years been translated into most other European languages. When Waagen in the early 'fifties compiled his survey of English private collections, he found them still rich in works of the 'Grand Style'. Indeed, no private collector, even so late as that, would have considered himself correct without them. Yet their day in England was over. Lady Eastlake, trained to critical observation, yet capable of enthusiasm, could write from Florence in 1855 that the Carracci and all their tribe no longer interested the English of the present day, and that for her part she was fairly bitten with all the true Pre-Raphaelites;[2] there were, she added, already a chosen few in England who adored them. The fashion had begun very slowly to change even before the Manchester Exhibition, and, as that Exhibition showed, a

[1] Mrs. Foster's version was published in Bohn's edition, 1857.
[2] Meaning painters earlier than Raphael.

taste for the Pre-Renaissance masters was far from rare among collectors at the end of the 'fifties. As many as one-third of the catalogue attributions were to names between Cimabue and Raphael, while two-thirds were to names later than Michael Angelo, the masters of the Academic conventions.

A few contemporary observers, like Layard, attributed this change of fashion to a revival of feeling for 'the pure, simple and devotional charac-ter of the early Italian masters'; some modern observers have said much the same, supporting them-selves on the supposed influence of the Pre-Raphae-lite Brotherhood. The argument, however, is not based on a true premise. The taste for the Early Masters was the sophisticated predilection of a few connoisseurs, like the Rev. W. Holwell Carr, William Young Ottley, Davenport Bromley, the Prince, Thomas Gambier Parry and Samuel Rogers.[1] The taste for the late eclectics, on the other hand, had been in the previous generation the average educated taste of the day, filtered down from the sophisticates of the late 18th century. Nevertheless Raphael con-tinued, and was to continue for many years to come, to be the ultimate authority by which excellence was judged. Subject to the agreed supremacy of Raphael, the notable developement of connoisseurs' taste in the 'fifties was in the direction of the 15th century, of the Quattrocentists, and especially of the later ones, like Mantegna, Cima, the Bellinis and a hitherto unknown master whose planet now began to move into the ascendant: Botticelli. Layard

[1] The taste appears in America in the 'fifties with the notable collection formed by J. J. Jarves, bought from him in 1871 by Yale University.

in 1857[1] wrote of 'Sandro Botticelli, who holds so important a position in the transition period of the 15th century', and said that he was beginning to be very popular amongst collectors in this country. Three years earlier, Lady Eastlake had written that 'Sandro Botticelli is worthy to stand in the Florentine genealogy between Giotto and Michaelangelo'. That a critic of Elizabeth Eastlake's experience could say that, with no reference to Masaccio, suggests the enthusiasm natural to a new discovery, but it was not a bad estimate, all the same. Botticelli was a newly-realised Master, and the critics were still uncertain where to place him. The art-critic of the *Manchester Guardian* at the time of the exhibition made a more perceptive estimate when he compared Botticelli with the equally unfamiliar Lucas Cranach. It was a brilliant comparison of two still unexplored personalities; the Gothic German and the Renaissance Florentine linked by their nude and pagan Venus. When Layard discussed[2] the 15th-century Florentine and Umbrian masters he placed Piero della Francesca first in order of genius and omitted all reference to Botticelli, though even Filippino Lippi was given a place.

The promotion of Botticelli, after centuries of neglect, to an immense popularity towards the end of the 19th century would have confirmed Layard in his realistic view of Taste. In some quarters it was being advocated that the National Gallery should be primarily a collection of the most admired Masters; Layard urged that it should rather be fully repre-

[1] A. H. Layard: *Quarterly Review*, vol. 102, 1857.
[2] A. H. Layard: ibid., vol. 104, 1858.

tative of all Schools. 'Who are the best Masters?' he enquired in 1859. 'What School is most deserving of study and imitation? What works should be selected to improve or form the public taste? Within the last 25 years how great has been the change in the estimation of pictures!' Twenty-five years earlier taste had flowed strongly, still following the precepts of Reynolds sixty years before that, in the direction of the Bolognese and the Eclectic Masters, and collections formed during the two or three decades after Waterloo still abounded in pictures hopefully attributed to Guercino, Domenichino, the Carracci and Guido Reni.[1] 'But', exclaimed Layard, 'a violent reaction has now [since 1850] taken place, leading taste and artists to an opposite extreme, equally vicious and hurtful. German archaism, English Pre-Raphaelitism and the extravagant price now paid for the vilest daubs of what is called early or Gothic art, are symptoms of it.'

Layard's taste in pictures, as expressed in his *Quarterly* articles, was influential. It was evident that he much disliked the early Northern Masters, but that he was prepared to put up with the quite early Italians: Giotto, Ambrogio Lorenzetti, Simone Memmi and, particularly, Orcagna. His handsome tributes to Piero della Francesca and Benozzo Gozzoli savoured rather of obligation than of personal feeling; but his dislike of 16th- and 17th-century Academism was obviously genuine. 'Theatrical groups of muscular apostles and anatomic

[1] The dates of acquisition of nearly all the examples of these Masters in the National Gallery confirm this. See Catalogue of the National Gallery, *passim*.

240

saints,' he snorted. Perhaps what Layard really liked best were the Venetians, though his choice of descriptive adjectives might not be our choice to-day. In an article of 1859, discussing National Gallery masterpieces, he described the Sebastiano del Piombo 'Raising of Lazarus' as 'probably the most precious in money value we possess';[1] Titian's 'Bacchus and Ariadne', on the other hand, was given no stronger adjective than 'excellent'.

It is on the subject of contemporary connoisseur-ship, however, that Layard is most revealing and most entertaining. Very evidently, he did not be-long to the Charles Eastlake school of thought, for which he had some contempt; but then he did not have to bear the responsibility of being Director of the National Gallery. He was a romantic rather than a scholar in his approach to pictures, and had an intense repugnance for the German type of scholar-ship of which Waagen was an example and with which, unfairly and wrongly, he identified Eastlake. To Layard, that modern type of criticism seemed merely captious, throwing a cold damp upon all sentiment and imagination, disputing the authen-ticity of every great picture, however much hallowed by tradition, and leaving 'scarce one fragment of art in Italy unassailed'. There was undoubtedly a Waagen side to Eastlake the scholar, but it was balanced by the romantic side of Eastlake the painter. It was that balance between the two which made Eastlake so much more intelligent a man and

[1] This picture is No. 1 in the National Gallery Catalogue. From the Orleans and Angerstein Collections. Bought with Angerstein's other pictures on the foundation of the National Gallery, 1824.

so much more sensitive a connoisseur than Waagen could ever have hoped to become, or than Ruskin ever was.

A fair interpretation of connoisseurship as Eastlake understood it is provided by his wife.[1] Though the phrasing is hers, the message is his. They were concerned, it must be remembered, to establish for their generation a standard of serious criticism in a field where none existed. Connoisseurship, Lady Eastlake insisted, being clearly influenced by the views that her husband had expressed twenty years earlier, is neither just a knack nor an instinct with which some individuals are born; it requires 'unwearied diligence, sound sense and true humility'. It also, she maintained, required essentially the same education as that of the student in the exact sciences. Here and in her next contention she went beyond the limits of the Eastlake personal creed, but did so with the deliberate overstatement of a case that is common to all who have tried to instil a new spirit into the criticism of any subject at any time throughout the history of thought. 'Works of Art', Lady Eastlake rather unhappily said, 'must be treated as organic remains, subservient to some prevailing law, which it is the critic's task to find out and classify by a life of observation and comparison.' 'But', she added, as an essential condition, 'there must be enthusiasm, pure and engrossing.' Connoisseurship, as the Eastlakes saw it, was of no avail without a deep love of art; together, those two qualities might become the most valuable corrective to materialism.

[1] Lady Eastlake reviewing Waagen's *Treasures of Art in Great Britain; Quarterly Review*, vol. 94, 1854.

The Eastlakes were among the thinkers who could see the danger of their age, and who aimed perhaps beyond their reach in trying to avert it.

The career of Layard, on the other hand, especially as an archæologist, at a time when precisely scientific excavation was seldom undertaken, illustrates his reliance on imagination and flair. As a writer on art he showed much the same qualities. Moreover, not only did he despise scientific connoisseurship, but he greatly mistrusted it, believing that no Germans and very few English were above being taken-in and fooled by forgeries. He was probably quite right there. There was an immense demand for pictures of certain Schools, and the demand was met by an assiduous and steady supply. *Expertise* was exceedingly rare, and the great majority of collectors at home and on their travels trusted to their own judgement. The result was, in Layard's words, 'very mischievous'.[1] As he said, since Raphaels have always been in request, so Raphaels have always been made for sale. In the 'forties, when the Eclectic School was still in the fashion, Carraccis flooded the market. Nor was that by any means a new phenomenon. Forgery had begun before many of those forged were dead.[2] With the change in taste towards earlier masters, the practice received a fresh stimulus. 'Picture-dealers', said Layard, 'of Rome, Florence and other cities

[1] A. H. Layard: *Quarterly Review*, vol. 102, 1857.

[2] Thus, in England, Richard Wilson was being forged within five years of his death, so early as 1785, by his Welsh pupil Thomas Jones, who at that time, on his own confession, was forging the still-living Zuccarelli.

frequented by wealthy travellers send their agents through the length and breadth of the land to buy up every work of art whatever its merits.' These were then ingeniously converted wholesale into productions by Bellini, Mantegna, Leonardo, Luini, Perugino and other favourite and highly prized masters. That was written in 1857, and gives an interesting incidental glimpse of the newly developing taste for the late *quattrocento*. Those Masters could not possibly have been described in 1840 as favourite and highly prized. Still less could Fra Angelico, Taddeo Gaddi or Ghirlandajo have been so described, yet by 1857 there was evidently a big profit to be made out of faking them; there was even a market in Giotto by then.

If the wealthy traveller showed any inclination to doubt the dealer's honesty, his suspicions would be lulled and his self-esteem flattered when he was taken into the dealer's confidence and shown several pictures stacked in a corner with their faces to the wall. These, if he were English, would be described as merely 'roba Americana', rubbish for the American market; if he were American, they would be 'roba di milordo', rubbish for an English lord. Then he would be shown an Andrea del Sarto, proper for a person of his discrimination who so evidently was not one of those *ignoranti*. Layard tells a little story about a young American traveller, to whom an Englishman said, 'You have often spoken to me of your father's gallery at New York. What Masters, may I ask, has he got?' 'My father's gallery', was the reply, 'consists almost entirely of Raphaels and Leonardos, but he also has a few Correggios.' Any-

one at all familiar with what remains to-day of the country-houses of Britain will agree that such ambitious attributions were not confined to America. Incidentally, Layard, when discussing the Manchester Exhibition of 1857 in the *Quarterly*, assured his readers that even there, in Manchester, ancient paintings were being manufactured to a vast extent for the American market.

Layard's dislike of connoisseurship was far exceeded by that of William Bell Scott,[1] who went so far as to make a prodigious fool of himself. His hatred of the papal Church was extended to all works made for that Church and to all artists and craftsmen in her service. All Italian painters, with the exception of Michael Angelo, impressed Bell Scott as no more than mental slaves and even as cretins. 'How does the traveller', he exclaimed, 'begin to loathe the Madonna, the Saints Anthony, Francis, Sebastian and all the rest! Why should they not be swept into oblivion?' His contempt for such art was equalled by his contempt for those who ventured to admire it. Such admiration he dismissed as 'the modern dilettante spirit', and asked angrily why this should be indulged by preserving the labours of craftsmen who never had an idea in their brains except such as were brought there by their clerical employers. The modern Italians themselves, who for the most part ignored and neglected their own Old Masters, were praised by Bell Scott for their enlightenment. 'These works,' he sneered, 'shunned by the educated native as the evidence of a past tyranny, are lauded to the skies by foreigners, we

[1] William Bell Scott: *Autobiographical Notes.*

245

English in particular, who have none but dilettante associations with them.' Lady Eastlake may have been carried away on occasion, and said some rather foolish things; but however much, in the fashion of her day, she may have disliked, say, Guercino, she would not have described him as a mental slave. One wonders what would have happened to the ultra-Protestant William Bell Scott had he ever gone to Spain. The difficulties and discomforts, and even the dangers, of travelling about in 19th-century Spain, however, deterred almost everybody. Spanish art, other than Velasquez and Murillo, remained virtually unknown outside its own country, and the astonishing Richard Ford[1] had the field nearly to himself. His only competitor was Sir William Stirling-Maxwell, whose *Annals of the Artists of Spain*, published in 1848, contains the first serious appreciation of Velasquez in English.[2] The best of all 19th-century accounts of that master, however, is by Richard Ford, unexpectedly to be found in the pages of the *Penny Cyclopaedia*. Lady Eastlake could say, without fear of contradiction, 'Murillo and Velasquez are indubitably great masters, but with them the glories of the Spanish school pretty well begin

[1] Richard Ford, 1796–1858; author of the *Handbook for Travellers in Spain*, 1st edn., 1845.

[2] Sir William Stirling-Maxwell, 1818–78. His biography of Velasquez was translated into German 1856 and French 1865. The French translation was by G. Brunet, with a catalogue raisonné by 'W. Büger', which was a pseudonym of Theodore Thoret. Thoret's *Apperçus* contains one of the first French appreciations of Velasquez; its only important predecessor being that of Prosper Merimée, *Gazette des Beaux Arts*, xxiv, 1848. It was Thoret who so rightly called Velasquez 'le peintre le plus peintre qui fut jamais'.

and end.'[1] In the middle of the century El Greco and Goya were still unrevealed to most scholars in Europe.

It was the Italian schools which captured the attention of the more perceptive scholars and collectors. Each in his different way, the Prince, Lord Lindsay, Ruskin and Eastlake had drawn attention to certain aspects of Italian art, and the Manchester Exhibition of 1857 served both to concentrate and to widen the interest; to concentrate it on Schools and Masters previously neglected, and to widen it by giving some hundreds of thousands of people the opportunity of seeing a form of art which they could not at that time find in the National Gallery. The decade following that exhibition saw the first serious and scholarly attempts at a critico-historical arrangement of all surviving examples of Italian art, and also of Flemish; attempts, that is, to provide critics and interpreters of any particular school with something like a *codex* on which they could base their researches. The volumes which embody these first and highly important experiments are known to critical literature as 'Crowe and Cavalcaselle'. The personal histories of Crowe and of Cavalcaselle are almost as remarkable as their work.

In the summer of 1847 Joseph Archer Crowe,[2] then aged twenty-two, was travelling with his father to Berlin, in the hope of studying the Flemish Masters in the Gallery there. In a post-carriage between Hamm and Minden, in Westphalia, he met

[1] *Quarterly Review*, 1854.
[2] Sir Joseph Archer Crowe, K.C.M.G., 1825–96: *Reminiscences.*

247

an Italian revolutionary called Cavalcaselle, aged about twenty-nine, who was travelling to Berlin in the hope of studying the Italian Masters there. They proceeded to Berlin together, and Crowe converted his Italian friend to appreciation of the Flemings through the Van Eyck 'Agnus Dei' panels. Thus began a lifetime's friendship, based on art, between two men whose professions had nothing to do with art whatever. Crowe was a journalist on the *Daily News* and Cavalcaselle was a politician fishing in the turbulent waters of Italian liberalism. After their Berlin visit in 1847, Crowe returned to Fleet Street and his friend to Venice and Milan, where his efforts at fomenting insurrection against Austria caused him to be sentenced to death. More fortunate than his companions, he escaped. The two met again in Paris, in July 1849, where Crowe was correspondent of the *Daily News* and Cavalcaselle was a distressed, tattered and unkempt refugee. Crowe got him over to London and found him employment, mainly as a draughtsman. Their friendship became intimate, and their collaboration in serious research began with visits to private collections, such as those of the Duke of Devonshire, Lord Carlisle and the Barings, searching through manuscripts and working for hours in the British Museum. It was Flemish art which was then occupying their attention.

Their method of work was essentially one of collaboration. They hunted in couples, in the intervals of earning their living, and pooled their ideas. The final results of both their Flemish and Italian researches were written by Crowe, since Cavalcaselle neither spoke nor wrote English at all

PLATE 19

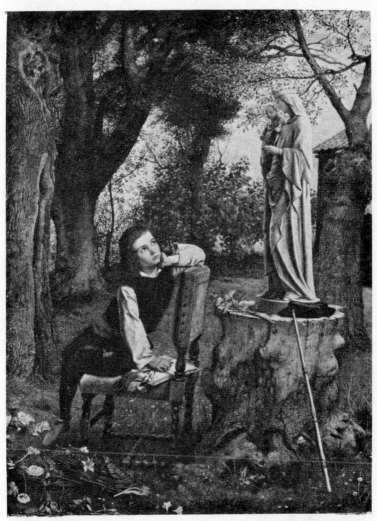

Corporation Art Gallery, Aberdeen.

TITIAN'S FIRST ESSAY IN COLOUR

Painting by William Dyce, 1857

PLATE 20

Oxford Union Society.

Sir Lancelot's Vision of the Sangrael
Mural painting by D. C. Rossetti, 1857

well. Their *Flemish Painters* appeared at the end of
1856, after Crowe's return from reporting the
Crimean War; but before that they had already
begun the Italian masters, working together in the
Louvre. Crowe went to India in 1857, as superin-
tendent of the Bombay School of Design, founded
in the previous year by Sir Jamsetjee Jeejeebhoy, but
the Mutiny turned him into a journalist again. He
came home in 1859, and the Italian volume appeared
in 1865. Ruskin was among the few who adversely
criticised the Flemish volume. He sneered—Ruskin
of all people—at Crowe for being 'rapturous', but he
admitted confidence in the judgement of 'the more
cautious Cavalcaselle'. How he was able to separate
them Ruskin does not explain. *Crowe and Caval-
caselle*, offspring of the English journalist (who
afterwards was a very eminent Commercial Attaché)
and the Italian agitator, is now a universally recog-
nised landmark for voyagers on the sea of criticism,
and in its day it caused a revolution in critical
method. The impetus they gave was responsible for
the work done in the next generation by Morelli, and
after him by Berenson. They in fact, with Eastlake,
founded a new school of historico-critical research.

Crowe, like everybody else, of course met Dr.
Waagen. He met him in Berlin in 1860, and pro-
ceeded at once to see through him. 'I was struck', he
wrote, 'with the aspect of this venerable authority.
His face was beyond measure plain. He was near-
sighted to such a degree that he could not judge of a
picture until he had almost touched it with his nose.'
Crowe was convinced that although Waagen may in
his earlier days really have earned his great reputa-

249

tion as an art-critic, he must have sacrificed by his extremely defective eyesight any such claim, even before he did his work on the Art Treasures of Great Britain. If Crowe be right, Waagen's opinions must be treated with even greater scepticism than they usually excite. Crowe thus met Waagen, but Cavalcaselle knew the great Morelli and was for a time his secretary. The Eastlakes knew him too, and Lady Eastlake wrote from Bellaggio in 1864, 'We have seen a good deal of Signor Morelli here, the Deputado for Bergamo, one of those extraordinarily clever men whom even the slavery of Italy did not extinguish. . . . He is a great statesman and politician by nature, by education a physician, by taste a connoisseur; but with power and memory for everything.' Eastlake and Morelli must without doubt have exchanged ideas and opinions, to their mutual benefit and to the benefit of all students of Italian art ever since.

Although the connoisseurs of the 'fifties may have extended the limits of accepted taste to include the later 15th century, both Italian and Northern, anything earlier than that was still found disagreeable. The 13th-, 14th- and early-15th-century Masters, such as Duccio, Cimabue, Margaritone, Lorenzo Monaco or Taddeo Gaddi, were but chronological curiosities, the remains of barbarism rather than the 'first-fruits of art'. They were Gothic, and, while the Gothic in architecture was wholly to be admired, in painting it was still to be approached with the greatest caution. 'This', said Lady Eastlake,[1] 'was the touchstone of Mr. Ottley's

[1] Lady Eastlake: *Quarterly Review*, 1854.

admirable taste—no Gothic atrocities found a place in his collection.' Despite the example bravely set by the Prince at Manchester and in his own personal collection, this attitude continued to be held by persons of taste for a long time to come. It is curious that, alone among the trecentists, Orcagna was widely admired before 1857. Perhaps the influence of Lord Lindsay had something to do with that. Although the later 15th-century masters were increasingly becoming a connoisseur's taste before 1857, they do not seem to have been taken up by the London dealers. Lady Eastlake while in Italy with Sir Charles in 1854, collecting for the National Gallery, was astonished that dealers had not already come and carried off certain pictures they had just bought.[1] 'Dealers', she said, 'could make a fortune out of the pictures which we saw, but they are too ignorant and can't speak the language.'

The Eastlakes (for in this connection Charles and Elizabeth must be regarded as one composite personality) were undoubtedly among the leading and most courageous collectors in Europe during 'their' tenure of the National Gallery Directorship; but even they did not have everything their own way. Like all Directors of great museums or galleries, they suffered occasional reverses at the hands of the Trustees. One of the most serious of these reverses was over the Michael Angelo unfinished Madonna and Child with S. John and Angels.[2] This incredible

[1] These included the Mantegna "Madonna and Child," N.G. 274; and the Giovanni Bellini "Madonna of the Pomegranate," N.G. 280.

[2] National Gallery Catalogue, No. 809.

rarity was offered to the Gallery by its then owner, a
Mrs. Bonar, for £300 early in the 1850's, and was
refused on the ground that being unfinished it
would not be understood by the public. The
picture was not at that time attributed to Michael
Angelo, but to his master, Domenico Ghirlandajo.
Eastlake and Samuel Rogers, the latter then aged
ninety, but as sharply perceptive as ever, were alone
in voting for the purchase. They were heavily
defeated, and the picture was bought, as a Ghirlan-
dajo, by Henry Labouchere. Very soon afterwards
the attribution to Michael Angelo was put forward,
and by 1857, when the picture was exhibited at
Manchester, was accepted by everybody. This un-
happy defeat was happily reversed some years later,
though not in Eastlake's lifetime, when the picture
was bought from Labouchere's executors in 1870 —
no doubt for a great deal more than £300.

Nor did the Eastlakes, astute though they were,
have everything their own way when buying in the
open market. Their most powerful rival was the
Marquess of Hertford, armed with unlimited wealth
and faultless connoisseurship. When Lord Hertford,
either personally or through 'Monsieur Richard',[1]
elected to go for a picture, competition was useless.
The Eastlakes encountered 'Monsieur Richard' at
Hanover in October 1859, when they were there to
attend the Stolberg Sale and to secure, if possible,
two notable Jacob Ruysdael landscapes for the

[1] Natural son of Lord Hertford, born when his father was 18,
in 1818; afterwards Sir Richard Wallace, Bt. It is evident from
this passage that he was in the habit of buying on behalf of his
father. See *Catalogue of the Wallace Collection*, 1928, pp. x–xx.

National Gallery. 'We have a rival here', wrote Lady Eastlake, 'against whom there is little chance of contending—a well-known son of Lord Hertford. There are only two or three pictures which Lord Hertford or the National Gallery would wish for.' Fortunately 'Monsieur Richard' did not contest the Ruysdaels, and they were secured by Eastlake.[1] A few months later, the Eastlakes visited Lord Hertford's house at Paris and saw the *garde-meuble*, a storey set aside to house the surplus collections; they also saw the tiny *entresol*, in which 'Lord Hertford lived for thirty-six years, thinking it a bore to move into his present gorgeous apartments, which are laden with everything that inordinate wealth can buy'.

Although the collecting of pictures and Old Master drawings was a long-established tradition among English connoisseurs, the collecting of *objets d'art*, and especially of porcelain and bronzes, did not become a habit much before the middle of the century; during the 1850's, however, it developed very rapidly. Ralph Bernal was one of the first English connoisseurs to collect such objects on a grand scale. Porcelain, glass, miniatures and silver were all represented so magnificently that his son Bernal Osborne used to say that the South Kensington Museum had its cradle in his father's house, 93 Eaton Square.[2] When Ralph Bernal died in 1854, an attempt was made to secure the collection for the nation. This failed, and the result was one of the half-dozen outstanding sales of the 19th century. The 4,300 lots, realising between £60,000

[1] National Gallery Catalogue, nos. 627–8.
[2] P. H. Bagenal, *Life of Ralph Bernal Osborne*, 1884.

and £70,000, were dispersed, and severally formed the nucleus of most of the important collections of the next few decades. The collection as a whole had been offered to the nation for £50,000 and its acquisition had the support of the Prince, Layard, Ford and many others. Gladstone, it appears, was interested, but, as Chancellor of the Exchequer, would only go as far as £20,000; to that extent Government did buy, but would not go a penny further. *Punch*[1] thought Government was crazy even to go as far as that. Porcelain and glass formed, in 1855, a new departure in taste for *Punch* and its readers and, since Bernal was a very rich Jew, he and his 'crockery' were considered fair game. *Punch* gave a mock account of the 'Aarons Collection' to be sold by Messrs. Aminadab Brothers of Whitechapel and consisting of cheap and common objects like teacups, tumblers and umbrellas, all with romantic and bogus historical associations attached to them. Not very funny, perhaps, nor very intelligent, but a good measure of the distance by which adventurous connoisseurs were (as they always are) ahead of the general public.

A story more fortunate in its outcome is that of the Soulanges collection. A Monsieur Soulanges, of Toulouse, had a very fine collection, chiefly of majolica and bronzes, which, thanks to the great porcelain manufacturer Herbert Minton, was brought to the notice of South Kensington in 1856. Henry Cole[2] was sent down to Toulouse to inspect and ended up by buying the collection, through guaran-

[1] *Punch*, vol. 28, 1855.
[2] Sir Henry Cole: *Fifty Years of Public Life.*

tors, for £11,000. This seems to have been a purely
private undertaking, and Government was in no
way committed; which, at first, was unfortunate for
the guarantors. When the collection was brought
to England in October 1856 and shown (very
badly) at Marlborough House, it was inspected by
Palmerston. His feeling was wholly for classical art,
and he had no sympathy whatever with medieval or
Renaissance Italy. 'What is the use,' he enquired,
'of such rubbish to our manufacturers?' So the
Treasury refused to support the purchase and the
Soulanges collection was sold to the Manchester
Exhibition Committee of 1857. In the end, the
Museum got round the Treasury and acquired the
collection from the Manchester Committee piece by
piece over a period of years. 'Thus', said Sir Henry
Cole, 'the nation acquired possession of a collection
of medieval art of the greatest value to manufac-
turers, which has influenced pottery and furniture
to a great and perceptible extent.' It is clear
enough that Lord Palmerston and Sir Henry Cole
were agreed upon one thing at least, and it is a point
on which they will certainly have met with general
consent. From whatever motives Mr. Bernal or
Monsieur Soulanges may have formed their great
collections—porcelain, bronzes, majolica, Palissy-
ware, silver, miniatures, German glass, Renaissance
furniture—these were to be regarded not as works of
art, but as exemplars for modern manufacturers.
Since long before the Great Exhibition, the guid-
ance of public taste had been resigned into the hands
of manufacturers, and they, encouraged thereto by
the Schools of Design, were expected to find their

inspiration in the Museums. The Museum and educational authorities tended to lose sight of the beauty that lay in the objects themselves, and to see the objects merely as sources of a second-hand beauty that was admirable only so far as it was derivative. The 1840's had regarded the exhibition of works of art as a means of moral improvement; the 1850's regarded it as a means of commercial advancement.

PAINTING AND PHOTOGRAPHY,
1850–70

TURNER died in 1851. His fame, though not his popularity, was established long before his death, and he remains conspicuous among the great Masters in having conceded nothing after his first period to public opinion, as having grown progressively experimental and revolutionary in old age, and as having made an immense fortune out of his art. It might well be expected that a public which could so misunderstand Constable would have noticed Turner only to deride him. Derision there was, but it was less than Constable had received. Turner, during his last twenty years, was one of the most difficult contemporaries that any generation has had to assess. The chief difficulty was that he was not a contemporary. He was an old man, yet he was immeasurably far ahead of the young. The greatness of his achievement was quite widely conceded, if it was not fully understood, and it is probable that the mid-19th-century respect for individualism had more to do with this than Ruskin's celebrated eulogy in *Modern Painters*. The commonly expressed view of Ruskin as the evangelist of Turner is but half true. He did undoubtedly establish the importance of Turner in the minds of that vast public who thought as Ruskin told them to think. Informed opinion, however, had been long, if sometimes un-

257

easily, aware of this phenomenon called Turner; to repeat an already quoted remark of Lady Eastlake, Ruskin was defending a painter who has as little need of defence as any painter who ever lived. Moreover, it is open to doubt whether Ruskin ever really understood what Turner was saying, or was progressively developing, in his pictures. Having said[1] in the course of an important public lecture that Turner had challenged and vanquished, each in his own field, Vandevelde, Salvator Rosa and Cuyp; and having said that in the extent of his sphere Turner far surpassed Titian and Leonardo, Ruskin said in the next breath that he did not know whether to venerate or lament the strange impartiality of Turner's mind. It was Ruskin's opinion that a really great picture could only be made out of a great subject, and, by implication, that a familiar subject could never be considered a great subject. This singular misunderstanding of not only Turner but of all creative landscape artists arose over Turner's 'Greenwich Park'. Had Turner, instead of painting the Thames and Greenwich Hospital, painted the Seine and Rouen Cathedral, Ruskin would have been better pleased—he admitted as much on the next page of his lecture.

The point in citing this particular passage is to suggest the dangerous quality of the influence which Ruskin exercised over his public, the danger which comes from confused thinking seductively expressed. Apart from the confusion between the pictorial and the descriptive functions of the artist, there was confusion about the qualities of greatness and littleness

[1] Edinburgh Lecture, 'Turner and his Works,' 1855.

which were supposed to derive respectively from strangeness and familiarity. Yet Rouen and the Seine were as familiar to the French, presumably, as Greenwich and the Thames were to the British; and Ruskin claimed for Turner an European and not merely an insular status. In fairness to Ruskin, however, it must be pointed out that he had, with great understanding, described Turner's 'Ulysses Deriding Polyphemus' of 1829 as the *central picture* in Turner's career (the italics are Ruskin's). Deeply sensitive as he was, more so than most of his contemporaries, to Turner's mastery over earth, air, water and paint, Ruskin could yet waste his time over defending Turner in minute factual errors which nobody else would have noticed. Such criticism when applied to Turner is as irrelevant as if applied to Wilson or Claude. But when Ruskin applied it to such of his contemporaries as Maclise, Frith or Leslie, it was perfectly sound procedure because they and their like avowedly aimed at exact accuracy of fact, and the critic was therefore entitled to severity when detecting even small errors.

In his occasional *Academy Notes* Ruskin often pursued that line, but also, in these and other ephemera, he sometimes made observations on the art of his day which are of lasting validity. His Notes on the annual exhibition of the Watercolour Society in 1857, for instance, contain a criticism which is in our own day repeatedly applied to the exhibitions of the Royal Academy, and which is all the more telling for having about it an unexpected air of slightly frivolous humour. Having uttered the tru-

ism that a trivial mind or superficial eye can never produce a living art, Ruskin then continued to say that 'there must be, of course, a certain healthy demand in London every spring for pictures which mean nothing, just as there is for strawberries and asparagus. We do not always want to be philosophical . . . and all this is perfectly right and refreshing. Nevertheless, a Society which takes upon itself, as its sole function, the supply of these mild demands of the British public, must be prepared ultimately to occupy a position much more corresponding to that of Fortnum and Mason'; a potted art, in fact, of agreeable flavour, but not to be thought of as living art. Such criticism from Ruskin no doubt irritated the Academicians, but it is evident that they were often exposed to attacks. The Prince, speaking at the Academy dinner in 1851, had tried to smooth down feelings which had become ruffled, and at the same time had contrived to administer to his hosts a sharp rap on their knuckles. Every aristocracy, he told them soothingly, gets assailed from without; the Academy's experience only showed that it was harder to sustain an aristocracy of merit than one of birth or wealth. This, he added tartly, 'may serve as a useful check upon yourselves when tempted at your elections to let personal predilection compete with real merit'. It cannot have been a comfortable moment for the Academicians when they were accused of narrowness and almost of favouritism from so influential a quarter. Ruskin's remarks, on the other hand, though irritating, could be much more easily brushed aside. We, to-day, may think them only too true of

say, Maclise, Leslie, Paton or even Callcott; we might well think it true also of Landseer.[1] Yet Ruskin deeply admired Landseer. It must be admitted that on the whole Ruskin is not a reliable judge of his own contemporaries. Who is, for that matter?

On the Pre-Raphaelites, however, Ruskin continued through the 'fifties to make judgements which seem nearly a century later still to be valid. These are to be found especially in his Notes on the Academy Exhibitions between 1855 and 1859. By 1855 the Pre-Raphaelite achievement had already passed its climax; revolution had become revelation, and opposition had grown to acceptance. The Brotherhood itself was dissolved or was dissolving, and its standards were beginning to be lowered. The easy appeal to sentiment was beginning to seep through the original embankment of intense and concentrated feeling. Over the sometime violent realism there was already the glaze of gentility. There were, moreover, signs of a decline in another and equally dangerous direction. The early and even the later *quattrocento* painters who had been originally the source of inspiration for the Brotherhood were now becoming models actually to imitate. Ruskin was quick to observe this change of spirit, and said, *apropos* of Dyce's 'Christabel' in 1855, that this was an example of one of the false branches of Pre-Raphaelitism, consisting in imitation of the old religious Masters—in this case, of Sandro Botticelli.

[1] Of his Academy pictures, that is: Landseer's sketches and drawings show him as a considerable artist, but it was not of these that Ruskin was thinking.

There can be no doubt that by the mid-'fifties, the effects of Pre-Raphaelitism, or what still passed for it, were widely evident. Of the Academy exhibition of 1856, Ruskin observed that it was no longer possible to distinguish 'Pre-Raphaelite' works as a separate class. The example of the Brotherhood could be recognised as having set a new standard, and Ruskin could say, with every hope of being justified, that a true and consistent school of art was at last established in the Royal Academy. The central picture of that year was Millais' 'Autumn Leaves', depicting with exquisite enchantment, not the classical Keatsian autumn of fruitfulness, but the sad, Tennysonian autumn of wood-smoke and decay. It is indeed one of the key-pictures of its time, but its temper is no longer Pre-Raphaelite, except in its meticulous execution. The pointed comment which, though entangled in elaborate symbolism, distinguished the Brotherhood in 1850 has been displaced by sentiment, which before long was to become the sentimentality that engulfed Millais himself in the next few decades. It engulfed Holman Hunt, too. His engulfment occurred early, as early, indeed, as 1852, when he began his first version[1] of 'The Light of the World'. He recovered, momentarily but splendidly, with 'The Scapegoat' of 1856. Holman Hunt was less of a poet than Rossetti, less of a painter than Millais, less of a thinker than Madox Brown; he had not the quivering and exquisite sensitivity of Arthur Hughes. Yet in 'The Scapegoat', in that one picture, he achieved an intensity of

[1] At Keble College, Oxford. The St. Paul's Cathedral version dates from 1903.

feeling which no other Pre-Raphaelite ever equalled. The inescapable Æschylean doom of suffering through the sins of others, the hopeless tragedy of exile for the uncomprehending innocent, expressed implications of which the mid-19th century was only too well aware, but which hitherto it had not been able to state with such clarity. The picture was found by about equal proportions of the public to be disturbing, baffling or ridiculous. On the other hand the same artist's 'Light of the World' appealed instantly to that majority who do not like being baffled or disturbed by a painting. That timorous, pathetic, self-pitying Christ could in no circumstances, one might think, illuminate or save the world: but his sentimental appeal (an appeal to weakness which Christ never deigned to make) is unmistakable. Early symptom though this is, it foreshadows the decline of the early, intense, pure Pre-Raphaelitism into a sentimental-romantic otherworldiness; from the actuality with which the young Millais and the young Madox Brown had been so vitally concerned to an actuality from which Burne-Jones much preferred to escape.

There was, however, a moment towards the end of the 'fifties when the first phase and the second phase came together in one remarkable achievement or, perhaps more accurately, experiment. This was the famous decoration of the Oxford Union with mural paintings.[1] The building of the Oxford Union Society by Benjamin Woodward in the Venetian-Gothic urged by Ruskin, was begun in 1856.

[1] In the abundant literature about this, Murray's *Guide to Oxford*, 1860, may be cited as contemporary comment.

Woodward was much in with the enthusiastic under-graduate set that included William Morris and Edward Burne-Jones; he was also intimate with Ruskin, who introduced him to Rossetti. As a result of this introduction, Rossetti found himself very soon playing a part in Oxford life, and by 1857 his influence on undergraduate opinion was already great. When, therefore, Rossetti suggested that the walls of the new debating-hall should be decorated with paintings illustrating the History of King Arthur, in Malory's version, the Union Society gladly accepted his offer. The work was begun in 1857 by Rossetti, Arthur Hughes and Val Prinsep from London, with Morris, Burne-Jones, J. B. Pollen and Spencer Stanhope from Oxford; it was aban-doned when nearly finished in 1858; completed in 1859 by William and Briton Riviere; and within two or three years was invisible. The fading and scaling due to inexpert work were such that, despite careful renovation, the paintings have always been invisible from the floor of the building.

In that experiment, so much enjoyed by all con-cerned and so unsuccessful, there was both revival and foreshadowing. The sense of fraternity and the community of labour recalled the doctrine of the Nazarenes. The volunteer and non-profit-making basis of the undertaking forecast the economic idealism of Ruskin's later writings. Apart from *The Germ*, this Oxford undertaking was the one attempt to realise the full implication of the name 'Pre-Raphaelite Brotherhood'. *The Germ* we can still read for ourselves, but we must take entirely on trust the original appearance of the Oxford wall-

PLATE 21

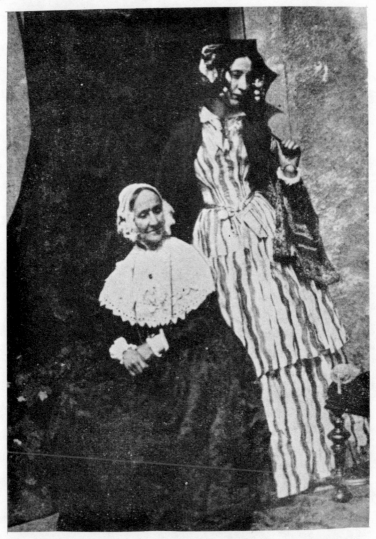

ELIZABETH RIGBY (LADY EASTLAKE), WITH HER MOTHER
Photograph by David Octavius Hill, *c.* 1844

PLATE 22

GARDNER'S BUILDING, BRISTOL, *c.* 1860

paintings. The designs can be dimly traced still, with the help of skilful lighting and photography, but all the colour has long since fled. It must have been magnificent; rather like Millais' 'Ophelia', repeated on life-size scale all round a large hall. Coventry Patmore saw what had so far been done at the end of 1857, and described it in the *Saturday Review*. He found it revolutionary and therefore, as might be expected from him, delightfully exciting. He observed that these differed from the usual run of architectural paintings (referring evidently to the School of Cornelius and to the Westminster Cartoons), in their abandonment of subdued colour and the adoption of a colouring 'so brilliant as to make the walls look like the margin of a highly-illuminated manuscript'. It is amusing, though not surprising, to find that the *Art Union* said not a word about the Oxford paintings. Although that journal reported pretty fully on art activities all over England, and was not without influence, many serious-minded people mistrusted it, and indeed felt that it was only of real use to those who had axes to grind. In any case, the Pre-Raphaelites hated it, and the *Art Union* hated them as much as did Charles Dickens. It would have violently attacked the Oxford paintings had not Ruskin and Coventry Patmore, with their far greater influence, publicly praised them. All it could do was to remain coldly silent.

The subject chosen by Rossetti for the Oxford experiment was the Arthurian Legend. In that fact we to-day may see an allegory of the 19th century itself. It must be remembered that Tennyson was at that very moment drawing attention to that

265

Legend in his *Idylls of the King*, which as they appeared met with an instant and enormous popularity. Rossetti and the Pre-Raphaelites were certainly not swayed by what the public approved of, but it is a fact that Tennyson's *Idylls* appealed to the exacting, critical mind just as strongly as to the popular one. When it was a question of escaping from the frightening implications of the present and the future into the romantic if undefinable past, the intellectual and the common reader united. It must also be remembered that the subject of the paintings was not actually the Arthurian Legend, but Malory's Romance on that subject. Malory himself, writing in the reign of Edward IV,[1] was living in a violently changing world. The Middle Ages had ended abruptly in the squalid treachery of the Wars of the Roses, and the New Age was soon to begin with that subtle realist, Henry VII. It was the age, no longer of Chivalry, but of hard-headed business men and women, like the Pastons of Norfolk. Malory was writing, with more than a hint of nostalgia, about a world already long past, and in his pages the common lusts of brutality and cruelty were sublimated into heroism. Nearly four hundred years later, the Pre-Raphaelites found themselves living in a world that seemed to them gross, material, ugly and cruel. Trying at first, with the machinery of symbolism, to relate the present with certain actual pages of the past, they found, when that first impulse had worn

[1] The *Morte d'Arthur* was completed 1469–70, and printed by Caxton 1485. The last of the early editions was that of William Stansby, 1634. This was reprinted in 1816 and 1817, and was re-edited by Thomas Wright, 1856, the year before the Oxford Union project. Tennyson's *Idylls of the King* appeared 1859.

off, that Legend with no implications was more to their taste. The attempt at synthesis between this world and that had the strength of a mission in 1848, but by 1857 it had become too heavy to be sustained. The revolution was not finally accomplished, because the fervour died. Some, like Millais, forgot all they had achieved and begat a new academism as trivial as that against which they had once revolted. Others forgot the tenets of the Brotherhood and withdrew themselves from the actuality of common experience. For these, Rossetti's choice of Malory was, as it seems to us, inevitably right.

Some ten years earlier, the Arthurian Cycle had been made the subject of another series of wall-paintings, when William Dyce decorated the Queen's robing-room in the new House of Lords with seven allegories drawn from the Arthurian stories. Dyce's approach was wholly different from Rossetti's. He saw the Arthurian Legend as a kind of medieval Homer, with a factual realism that fitted the temper of the 1840's; his solidly defined forms and vigorous movement would have been repellent to the Oxford Arthurians of 1857. It is ironic that the work of the realistic Dyce has not been wholly lost, while that of the other-worldly fraternity has to all intents vanished. Before they faded and vanished, however, they were like the opening of magic casements through which the young men of Oxford, fired with a high and serious enthusiasm, gazed into a new world of beauty and idealism, which seemed to be filled with the figure of a new leader, William Morris. They were gazing with the eyes of Morris

267

into the second half of the century, their own half, and Pre-Raphaelitism had served its final purpose.

There is some danger to-day of over-estimating the immediate effect of authentic Pre-Raphaelitism, that is, before the end of the 1850's. At the Paris Exhibition of 1855, for instance, the English painters whose work attracted most attention were Webster and Mulready. Both,[1] and most particularly the latter, were remarkable painters, but neither was at all Pre-Raphaelite in either feeling or execution.[2] G. F. Watts, never in the least degree affected by Pre-Raphaelitian early or late, was regarded by the more perceptive critics early in the 'fifties as one of the most important of the younger men. *Punch*, which may by then be relied on as a well-informed guide to middle-class tastes and prejudices, enormously admired Frith's 'Ramsgate Sands' of 1854,[3] because it was frankly contemporary, and not medievalist. Pointing in the same direction, *Punch* showed a drawing, about two years later,[4] of a young artist who has painted 'a modern Subject from Real Life', and sold his picture; while two rather moth-eaten rivals, 'very high-art men, who can't get on without medieval costume and all the rest of it', find their own pictures unsold.

Punch, evidently, was not quite sure that it had been right in changing its mind about the Pre-Raphaelites. Derisively hostile at first, it then, as we have seen, grew to admire the earnestness and cour-

[1] Sir Henry Cole, op. cit.

[2] The qualities of Mulready as an artist have not yet been examined with the serious attention that they deserve.

[3] *Punch*, 1854, vol. 26.

[4] Ibid., 1856, vol. 30.

age of the young Brotherhood; by the middle of the 'fifties it was beginning to question that earnestness. In its earlier days, *Punch* was a useful watch-dog against fashionable affectation, but it was not always acutely sensitive in distinguishing between affectation and genuine individualism. In its guying of the medievalists it was less than fair to the Brotherhood's successors, since it did not succeed in penetrating below the mannerisms to the romantic nostalgia that lay only just below the materialistic surface of the age. *Punch* also and equally, it must be admitted, guyed the surviving exponents of the Olden Time convention. As in the 'forties, it still in the late 'fifties [1] went on about the unoriginality of subject-matter at the Academy exhibitions; Tom Jones and Sophia Western, Sancho Panza, Sir Roger de Coverley, Royalists and Roundheads. Millais, of all the original Brotherhood, was the one whom *Punch* continued most to admire; he was Pre-Raphaelite in his attention to detail and in the intensity of his feeling, but he could be quite contemporary in his settings and blameless in his sentiments. Moreover, he had passed quickly and respectably from youthful notoriety to settled fame. His 'Autumn Leaves', in the very year of its exhibition, had become famous enough to be used as a political cartoon with the footnote 'A Great Liberty taken with Mr. Millais' celebrated picture of that name'.[2] And Woolner, writing to Bell Scott in 1855, described Millais as being dissatisfied with the hanging of his Academy pictures that year. 'That celebrity', he

[1] *Punch*, 1858, vol. 34.
[2] Ibid., 1856, vol. 31.

269

said, 'made such an uproar, the old fellows were glad to give in and place him better.'

The paucity of invention about which *Punch* continually complained is the same defect which seems so conspicuous to us nowadays in contemplating the work of even the most competent mid-19th-century painters: a relentless insistence on triviality. They were accused of it sometimes even in their own day; accused, that is, of lowering the taste of the public. Some critics went farther, and accused the public of corrupting the taste of the painters. Layard, for instance, in 1857[1] drew attention to the tyranny of collectors' fashions. 'If a painter', he wrote, 'has gained a reputation by painting a picture with certain effects, every collector thinks it necessary to have a similar specimen of the artist', with the result that the artist becomes repetitive, mannered and in due course trivial. But, as Layard pointed out with some asperity, the artist was at least equally at fault if he deliberately chose 'to prostitute undoubted talents to painting "Baby's Turn" and a succession of babies bobbing at cherries and sucking sugar'. Landseer, Mulready and Webster were particularised as having thus succumbed to the snare of trivial repetition. 'Surely,' exclaimed Layard, 'even if the higher aims of art be altogether discarded, there is something better to be done than painting pictures to amuse nursery-maids.'

There was, of course, a great deal; many painters were trying in their different ways to say so, but they had few listeners. Turner apart, men of the older generation, like Cornelius Varley in the

[1] A. H. Layard: *Quarterly Review*, 1857, vol. 102.

visual world and Samuel Palmer in the spiritual, had
announced the imaginative, and Linnell had echoed
their call, bridging both their worlds. In the
younger generation, a handful of men proclaimed
the high earnestness of their art. Watts and Alfred
Stevens re-interpreted to deaf ears the splendour
and the learning of Venice and Rome. The Pre-
Raphaelite Brotherhood, and Madox Brown with
them, offered an intensity of feeling that proved too
strong for their public and in the end for themselves
—though Rossetti was just able to hand on to Burne-
Jones the key of the imaginative world which he had
received from Palmer, before he drowned himself in
a sea of erotic platitudes. The Royal Academy ex-
hibitions, however, took little notice of these depar-
tures from the orthodox-popular, apart from their
courageous experiment with Millais and Rossetti in
1849 and 1850. Edward Lear, who wrote supreme
common sense as well as inspired nonsense, wrote in
a letter of 1863,[1] which echoed the Prince's rebuke
of twelve years earlier, 'I see you are now going to
have a Royal Academy Commission. I wish the
whole thing were abolished, for as it is now it is dis-
graceful. Thirty men self-declared as the thirty
greatest painters of England, yet having in their
body Frosts, Sydney Coopers, Landseers and other
unheard-of nonentities, while Watts, Linnell, Hol-
man Hunt, Madox Brown and many more are con-
demned to official extinction.' Landseer, as has been
observed before, could be a surprisingly good
painter, though he seldom revealed the fact. On the
evidence of his exhibited pictures, Lear had some

[1] See correspondence in *The Times*, 7th May, 1938.

reason for calling him a nonentity as we now think to-day; but when he said so in 1863, hardly anyone in England except perhaps Layard would have dreamt of agreeing with him.

An example of Landseer's immense reputation, abroad as well as at home, is provided by Lady Eastlake in her account of a meeting between him and Rosa Bonheur.[1] The latter's reputation as an animal-painter in France exactly corresponded with Landseer's in England, and when she visited London in July 1855 she was much fêted as the painter of 'The Horse Fair'. 'It was', said Lady Eastlake, 'the dream of her life to see Landseer, and I sent them down to dinner together.' A day or two later she wrote, 'Yesterday I took her to see Landseer. This was the *comble* of her happiness; her whole sympathy and admiration as an artist, and her whole enthusiasm as a woman, have long been given to Landseer. . . . As we drove away, the little head was turned from me, her face streaming with tears.' This emotional scene no doubt confirmed Rosa Bonheur in Lady Eastlake's affections; Landseer himself was probably as embarrassed as he always was by the romantic goings-on of adoring ladies.

It is worth noting that, more than fifty years before a national collection of modern foreign art began to be formed,[2] Layard had advocated the same thing.[3] In the article in which he discussed such a project, he said of the French School, 'Ary Scheffer, Vernet

[1] Lady Eastlake: *Journals and Correspondence.*
[2] Project recommended in 1915 by Lord Curzon's Committee, and realised at the Tate Gallery the same year.
[3] A. H. Layard: *Quarterly Review,* 1859.

and Delaroche are landmarks in the history of art in
this century.' He did not include Rosa Bonheur; nor,
it may be observed, did he include either Delacroix
or Courbet. Ary Scheffer, who now seems to us to
stand with Delaroche for everything that was most
transient, flabby and commonplace in French acade-
mic art, enjoyed in his own day a reputation far
greater than that of Ingres. Three years after his
death in 1857 he was honoured with a biography by
no less eminent a thinker than Mrs. Grote. This in
its turn was honoured with a review some forty pages
long, in the *Quarterly*, by Sir Coutts Lindsay.
Scheffer, in the opinions of both the biographer and
the reviewer, was an artist of European fame destined
to exert a lasting influence. Errors, Sir Coutts
admitted, there sometimes were; his individuality
was perhaps too extreme, his preoccupation with form
rather too intense. But in the variety of his ex-
pression, Ary Scheffer was not to be equalled by any
painter that Sir Coutts could recall—Giotto, Fra
Angelico, Raphael and even Leonardo were by
comparison limited in their range.[1] This generous
view was not shared by Lady Eastlake, nor by Sir
Charles. Visiting the Paris Salon in 1861, the East-
lakes agreed [2] that 'French Art is now of a class in
which neither the most indulgent nor the most
enlightened eye can see merit'. Such an exhibition

[1] Perhaps Scheffer's political adventures had something to do
with his fame. A confirmed Orleanist, he had handed to Louis-
Philippe in 1830 the *mandat* summoning him to the throne of
Charles X; eighteen years later he had helped Louis-Philippe into
his carriage outside the Tuileries on his way to exile in England—
an exile which Scheffer had no intention of sharing.

[2] Lady Eastlake: *Journals and Correspondence*.

was, they felt, calculated to ruin art for half a generation. 'This awful *embarras des horreurs*,' exclaimed Lady Eastlake, 'the utter fall of modern French art.' One wonders whether Lady Eastlake had noticed two paintings in the exhibition, by an artist called Edouard Manet.

Lady Eastlake's distaste for French Salon Art seems to have been equalled by the illustrious Taine's distaste for English Academy art.[1] This he described as a gnarled and stunted branch dropped from the Flemish School. Even the cherished Landseer was not a true animal-painter; he was rather a narrator, a fabulist, in whose stories animals played the part of humans. The same fault, he pointed out, was to be found among the English figure-painters; to them, the one essential was the anecdote, the little romance, the literary story. With men like Maclise, Leslie or Mulready, said Taine, beauty of line or tone, harmony of colour, are ranked but as accessories. Nothing, he admitted, could be more expressive than their narratives, nothing more penetrating than their observation of human nature. It was only a pity, thought Taine, that instead of using the pen they were determined to use the brush. The great French historian cared even less for the Pre-Raphaelites. Insensitive to the intensity of their feeling, he saw only their preoccupation with minute detail and factual precision, and denied them therefore the quality of artistic imagination.

[1] Taine included some articles on English Art in his *Notes on England*, published in the Paris *Temps* and later in English in *The Times*. The passage here quoted is from a *Times* article of November, 1871.

It must be remembered that when Taine wrote, the revelations of photography were already widely familiar; the camera had begun to suggest that the mere reproduction of exact appearance was no longer a legitimate aim for the artist. For the Pre-Raphaelites it had still been so, though it was never for them the sole aim.

During the 'fifties and 'sixties, both artists and writers on art found themselves increasingly beset by the problems posed by what some called the new art and others the new science of photography. To a generation still believing that art was the imitation of nature, it was indeed difficult to relate painting with photography. In the early days of the new process it was clearly seen as a mechanical form of art or, more precisely, of drawing. Vernon Heath, for example, recorded[1] that in January 1839 he had been present at the Royal Institution when Faraday announced the two discoveries of the Daguerreotype in France and Fox Talbot's Calotype in England. 'Photogenic drawing' was the term adopted by Faraday, who closed his epoch-marking announcement with the words, 'No human hand has hitherto traced such lines as these drawings display. Nature has become man's drawing-mistress.' Seven years later, in 1846, the *Quarterly*[2] was still describing photography as an aspect of drawing, and comparing its best examples (such as the still-unrivalled work of David Octavius Hill) with the work of favourite Old Masters: a Sir Joshua or a Rembrandt, a Teniers or a Hobbema, 'or even, what we had not

[1] Vernon Heath: *Recollections*, 1892.
[2] *Quarterly Review*, vol. 77, 1846.

sufficiently prized before, a Constable'. It is clear from this, with its talk of calotype-drawings and photogenic drawings, that photography was not yet realised as a new and revolutionary means of expression, but rather as another means of more fully expressing the same thing. That is probably why the invention made rather less stir than might have been supposed. It could be fitted into the existing painterly conventions.

Lady Eastlake came to perceive by 1857[1] that photography could not be regarded from the same point of view as painting, but it is apparent that she formed that opinion reluctantly. In portrait-photography, for instance, she felt that while the camera could record the appearance of a face sufficiently well to be of value to friends and relations, it could produce nothing that would recall a work of art. Landscape-photography she found equally unsatisfactory. Hypothetically comparing a scene painted by a Cuyp or a Ruysdael with the same scene recorded by 'the improved science of a photographic artist', she pointed out that what was most striking in the latter was the general emptiness of the scene he gave. She had seen the defect of the mechanical process, absence of selection, because she understood the secret of the artist's process. The camera, by recording everything as an unselective series of details, produced the idea of emptiness; the artist, by

[1] Lady Eastlake: *Quarterly Review*, vol. 101, 1857. This article shows the now standard photographic terms gradually coming into general use, e.g. 'Known in photographic language as a *negative*'; or 'What is called the *positive*'; or 'the use of protosulphate of iron in bringing out or, as it is termed, *developing* the latent picture'.

selecting, or by omitting or by emphasising, could produce the idea of completeness. This negative quality of emptiness, as Lady Eastlake pointed out, was made worse by enlargement; *ex nihilo*, as she rather tritely quoted, *nihil fit*.

If Lady Eastlake could no longer feel that photography should be regarded from the same viewpoint as painting, she fully realised that it was a marvellous invention, and one of great practical value. As a scientific invention, in fact, it seemed complete, so that she could say, 'Short of the coveted attainment of colour, no great improvement can be further expected.' What Lady Eastlake and some others had realised was that photography, no longer photogenic drawing, had become an adult science parallel to, but separated from, the art of painting. It could only develope in a true direction if it realised the limitations inherent in its nature. Lady Eastlake put the matter clearly enough. 'Photography', she said, 'is made for the present age, in which the desire for art resides in a small minority but the craving for cheap, prompt and correct facts resides in the public at large. Photography is the purveyor of such knowledge to the world.' It is a pity that Lady Eastlake did not more fully discuss the relation between the painting of her own day and the functions of the photographer. She might then have been able to persuade some of the more literary artists to abandon the brush and buy a camera. She might also have caused some of them to realise the proper relation between scale and content, had she more often quoted *ex nihilo nihil fit*.

Some very sensible observations on the arts of

photography and painting were made in 1864 by
Lord Salisbury, at that time Lord Robert Cecil and
afterwards the great Prime Minister[1]. He was all his
life a keen amateur chemist, with a private labora-
tory at Hatfield, and his approach to photography
was made with a great knowledge of its technical im-
plications. The idea that photography might ever de-
throne painting from its pre-eminence was promptly
dismissed by Lord Salisbury; as he said (and it
needed saying at that moment), the beauties of
photography lie in something special to itself, and
hardly come into competition with the true beauties
of painting. This needed saying particularly, be-
cause there existed still in 1864 a widespread
popular confusion between the two. The uncritical
public were beginning to find that photography
could produce well and cheaply what the popular
artists had long been providing far more expen-
sively. The public therefore, or a large section of it,
began to think of photography as a substitute for
painting, while the inferior kind of artist saw it as
depriving him of his livelihood. Again to quote
Lord Salisbury, 'Bad artists have lavished upon
photography a good deal of the contempt which,
some thirty years ago, coach-proprietors used to
expend upon the dangerous and inconvenient system
of travelling by railway.'

It is evident that Lord Salisbury believed that good
painting could never be ousted by photography, if
for no other reason than because so few people in
England cared for good painting or knew it when

[1] Lord Robert Cecil, later 3rd Marquess of Salisbury: *Quarterly
Review*, vol. 116, 1864.

they saw it. He did not actually say that, however; what he did say was, 'Whatever our merits as a nation may be, we are not distinguished as worshippers of the beautiful.' He also said, in the next sentence, 'An art which, like photography, lives by the patronage of the million will adapt itself to the million's tastes.' The more popular forms of both painting and photography could look after themselves, and Lord Salisbury was not concerned to defend either of them. There was, however, a deeper matter with which he was very much concerned. This was the cause or causes that impeded the recognition of photography on its own merits by what he called 'the select few who know themselves as persons of taste'. This, he believed, was no more than mere unfamiliarity. Here, indeed, Lord Salisbury's views upon a specific point could be extended to art-criticism in general. Admiration is largely a matter of familiarity reached through education, for the eye admires only what it has been habituated to admire. As we have seen in the years since 1900, and as was seen in the fate of the first Impressionists and of Constable, there is always some true, creative developement of art that is disparaged by even the highest artistic authority simply because it meets with no eyes that have been educated to receive it. This, obviously, is inevitable, since no eye can be already educated to something it has not yet seen. Lord Salisbury was perfectly aware of that. 'An art', he said, 'has not had a fair trial until it has had an opportunity of appealing from the neglect of one generation to the verdict of the next. Time will do this service to photography.'

279

Lord Salisbury's opinion that photography would not dethrone painting was, it must be admitted, qualified by one important factor. He spoke of photography in terms of the conditions that then governed the new invention. There was no knowing what might happen if two longed-for developements could be brought about; one was an instantaneous process upon a dry plate, the other was colour. The first, he was encouraged to think, might be available before long; of the second he saw no prospect for many years to come. Of one thing he had no doubt: if colour-photography were ever to be introduced successfully, 'the camera', he said, 'would have undisputed possession of all actual scenes and existing objects, and the easel and canvas would be restricted exclusively to imaginative painting.' Apart from the use of photography being made by the Impressionists at that very moment, there was much in what Lord Salisbury said that should have come true. Unfortunately, after nearly ninety years there remain many painters who have failed to note the distinction.

PLATE 23

WAREHOUSE IN STOKE'S CROFT, BRISTOL
Designed by E. W. Godwin, 1863

PLATE 24

RAILWAY STATION IN ROMANTIC STYLE: SHREWSBURY

RAILWAY STATION IN FORMAL STYLE: KING'S CROSS

LATER VIEWS ON ARCHITECTURE

Taste at any one moment in time reacts violently against the conspicuous characteristics of a hundred years earlier. The salient feature of traditional Georgian architecture had been its repudiation of the picturesque, its reliance upon nice judgement and its fastidious and calculated avoidance of emotion. Since formerly direct statement of fact had been a prime requirement, it was perfectly natural that the leaders of the 1850's, despite the premature triumph of Paxton, should move in precisely the opposite direction. The leader of those leaders was Ruskin. His doctrine, first announced in the *Seven Lamps*, was reaffirmed and more clearly formulated in his Edinburgh Lectures of 1853.[1] The doctrine, put simply, is that ornamentation is the principal part of architecture. All the rest is but building, and can be transformed into architecture only by decoration. To effect that transformation Ruskin, never handicapped by an exaggerated sense of humility, did not hesitate to call the Deity Himself into partnership. To achieve the picturesque effect, to deify the inhuman plainness of the Age of Reason, any means seemed justifiable. To make a building fit for the habitation of Man or for the worship of God, by impressing upon it the character of a remote age, was beginning to be seen as the final solution to the problem which especially

[1] *Lectures on Architecture*, delivered at Edinburgh, 1853.

agitated the 'forties and 'fifties: the problem of
putting the arts into service. There were very few
who would not have agreed that the arts must be
servants rather than masters; and most men would
have agreed on the masters under which the arts
should work out their servitude—Morality, Ethics,
Education. By no means everyone, however, agreed
on either the method by which, or the degree to
which, the process of pressing should be carried out.
A. H. Layard,[1] for one, as we have seen, affirmed the
reverse doctrine to that of Ruskin, and maintained
that architectural merit consists first in suitability to
purpose; that it is, in fact, the engineer's structure,
devised with reference to its immediate object alone,
'beautified' by the genius of the great architect.
Layard was foremost in adverse criticism of modern
public buildings, of the Greek temples, Palladian
palaces and medieval guild-halls used for museums,
institutions and public offices, giving no hint from
outside of whatever their specific function might be.
He did, on the other hand, being a logical man,
praise highly the South Kensington building[2] de-
vised by the engineer Captain Francis Fowke for the
Science and Art Department out of the old 'Bromp-
ton Boilers', and the building, also by Fowke, for the
Manchester 1857 Exhibition. Although Layard
did not specifically say so, there can be little doubt
that Paxton's Crystal Palace must have won his full
approval. What Layard chiefly attacked was the
vice common to other ages as well as his own, of

[1] *Quarterly Review*, 1859.
[2] Francis Fowke, 1823–65; architect and engineer to the
Science and Art Department at South Kensington.

designing the outside of a public building before thinking about its inside or its function—a consideration which the disciples of Ruskin would brush aside. W. H. Leeds [1] was another who also strongly dissented from Ruskin about the degree of importance which should be attached to ornament, though he did not go nearly as far as Layard. While rather distrusting embellishment, and greatly disliking too much of it, Leeds at the same time was at one with the taste of his generation in finding plainness or simplicity distasteful; 'mawkish' and 'inane' were among the adjectives used by Leeds in describing the architecture of the Regency, while a typical late-18th-century London street-frontage was but 'a wearisome succession of brick boxes'. Leeds was far from being alone in that view, nor would he have been alone in it ten years earlier. He did, however, hold unusual views about certain London churches, and liked very much both St. George's Bloomsbury and St. George's Hanover Square, neither of them very easy churches to admire in an age of Gothic revivalism; he found them both to be possessed of elegance and nobleness and to be of more than ordinary merit. To most of his contemporaries their classicism could only appear as almost impiously unsuitable.

The definition of suitability in church building was of peculiar interest in the 1850's, and was to a large extent tied-up with a deliberate attempt to check the disturbing fluctuations of taste by impress-

[1] William Henry Leeds, 1786–1866. A business-man and a prominent architectural critic, writing many articles in the *Quarterly*, the *Foreign Quarterly* and the *Penny Cyclopædia*.

ing a permanent character on at least one depart-
ment of public architecture, if on no other. There
was a good deal more than a tendency to equate the
Gothic style with devotional feelings and, therefore,
to stigmatise Renaissance and neo-Classic as utterly
un-sacred. R. H. Cheney, who has already been
quoted, attempted an assault on this accepted
association of ideas, by pointing out that for the last
two centuries church-building had simply followed
the prevalent taste of the day, whatever that taste
had been. Since the character of no one period can
claim to be sacred in itself, or can be condemned in
itself for not being sacred, it was wrong to exalt or to
condemn, for those particular reasons, either Gothic
or Renaissance churches. Cheney's plan for tolera-
tion is really very striking. It was a bold thing to
say in the mid-'fifties, denying the authority of the
Seven Lamps, that Gothic architecture had no more
intrinsic power to predispose towards devotion than
that shared by any other object striking enough to
exalt the imagination; and that none of the many
styles adopted by the Church has any essential
connection with Christianity or can claim to be
called emphatically Christian. 'The Italians', said
Cheney, 'cannot understand what we mean when we
complain that their gay basilicas do not look like a
church. To their eyes they look like nothing else.'

It was all very well for Cheney to affirm that
churches built in the accepted taste of the day would
be just as inspiring of devotion as those built in a
taste forcibly imposed. But prevailing taste still
eluded recognition. Either Paxton or Layard might
have opened wide the eyes of their generation and

have wrought a revolution which was, perhaps, actually nearer to happening than we suspect. So, rather more unexpectedly, might Cardinal Wiseman. But as long as there was a Ruskin pouring out his captivating prose, the public was not prepared to take lessons in taste from a glass-house builder, an archæologist or a Roman Catholic prelate. Yet they might have derived some profit through listening to Cardinal Wiseman on the subject of public architecture. The Cardinal was concerned about many things other than about being an archbishop *in partibus infidelium*, and on most of them he was worth paying attention to. He was fortunate in possessing neither the fanatical intolerance nor the boisterous capacity for upsetting people possessed by Pugin, his co-religionist and so often his opponent. Easy-going though he may have been, the inescapable fact yet remained that he was the head of the recently re-established Roman Catholic hierarchy. That fact alone provided a stiff barrier of resistance and disapproval; for whenever he spoke in public on any subject there was already a pre-convinced body of opinion set against him. Lady Eastlake, rather surprisingly, was of that body. When Wiseman lectured at the Royal Institution in January 1863 on 'Points of Contact between Science and Art', the Eastlakes were there, having dined first with Sir Henry Holland, the acting-President. Lady Eastlake described the Cardinal as appearing preceded by a number of demure-looking ecclesiastics, among whom was 'our late Archdeacon Manning —the palest and thinnest creature imaginable'. She was careful to emphasise the Cardinal's aptitude for

285

telling amusing stories, and equally careful to say that his lecture was evidently, like his sermons, intended for an illogical audience. 'Brevity', she added, 'was as little studied as close reasoning, for instead of one hour he was just two.'

More to the point here was the lecture Wiseman delivered in April 1864 on London architecture,[1] in which he said much that must have appealed to Layard and but little that can have been approved by Ruskin. That lecture is now long forgotten, but it is well worth a moment's attention in this context. Wiseman began by recalling his archæological youth in Rome, between 1825 and 1830, with other young men coursing across the Campagna in search of long-lost cities, hunting for the sites of Apiolae, of Politorium and of other primæval Latian cities, 'unseen except by the unheeding herdsman for centuries'. He continued in discussing the remains of Athens and Rome, of Segeste, Agrigentum and Paestum, of the cities of the Nile, of Palmyra, Baalbek and Persepolis, of Ellora and the Indian cavern-temples. What, he enquired, becomes of demolished cities? Their memory, he answered, is preserved only by the survival of their public works, Pompeii being the sole exception to the rule. But, in his view, it was precisely those public works that were most worthy to survive, for they are to be regarded as the visible expression of the principles of a matured culture.

The contention having been stated, Wiseman pro-

[1] Nicholas, Cardinal Wiseman: *Judging from the Past and Present, what are the Prospects for Good Architecture in London?* Lectures delivered in the theatre of the South Kensington Museum, 12th April, 1864. Published by John Murray, 1864.

ceeded to apply it to his own time and country. Since the contention was that in public buildings must be shown a consistent and national character of art, rather than a merely ephemeral and capricious style of building, the application of it was a thought difficult. 'Have we', asked the Cardinal, 'any pretensions to an architectural system which all of us recognise as belonging to our age and country? Have we forms and models that have sprung from our institutions?' The answer that in the end he gave was No, but he was within an ace of finding a satisfactory Yes. It was implied when he said, 'It is to the commercial element of our social condition that we have to look for the growing prospects of London architecture.' In an age of courageous enterprise and almost fabulous prosperity, it seemed proper that public works and buildings should reflect the industrial source of the nation's greatness. Wiseman had the courage to say that the palaces and aqueducts of Ancient Rome had their modern equivalents in warehouses and railways. As to the former, he is justified in modern eyes in that the great brick warehouses of London or of, say, Bristol, are among the few types of mid-19th-century architecture which command critical admiration to-day. As to the latter, he was sorrowful, but not despairing. The project, which so soon became an unhappy reality, of an iron viaduct across Ludgate Hill in front of St. Paul's, was bitterly denounced by many influential men. Wiseman did not denounce the project itself before he had seen the design. 'Roman Emperors', he said, 'would have treated railways, no doubt, as they did aqueducts.

287

... They would have compelled them, whenever they came out into public view, to harmonise with the architecture and to become even monumental.' The Railway Company, thought Wiseman, would gain immortal honour if it could only ensure that the bridge should in itself be beautiful and of fine proportions. Alas, the Company did not listen, and in place of honour has gained immortal odium.

The functional architecture of Imperial Rome was again invoked in 1864, in connection with the project to build what has now become known as the Albert Hall. After the death of the Prince Consort at the end of 1861, the Queen caused a Committee to be appointed under Lord Derby to decide on the form of the national memorial in his memory. The Committee recommended that this should consist in part of a great central hall of Arts and Sciences, and in part of a personal memorial in sculpture to be erected in the Park.[1] The recommendation found favour, but, as was inevitable, there was a wide difference of opinion about the style in which the Hall was to be designed. Many people looked naturally to Gilbert Scott as the right man; but others, who not impossibly may have been encouraged by Wiseman's expressed views, looked towards the engineer-plus-architect type of building as represented by the work of Francis Fowke and as advocated by Henry Cole. Gilbert Scott's preference was for an oblong building in an early-Gothic manner, 'with a tinge of the Byzantine'. Fowke and Cole, however, were determined on a circular building after the manner of the

[1] Sir Henry Cole: *Fifty Years of Public Work.*

288

Colosseum at Rome, and went off together to Nîmes and Arles to view the Roman amphitheatres there. Their counsel prevailed, and the responsible Committee decided to imitate the proportions of the amphitheatre at Nîmes, on a slightly smaller scale. There is some reason to think that it was intended to combine this neo-Roman plan with a Gothic elevation by Scott, which would indeed have been a novel method of having it both ways. However, according to Sir Henry Cole, it was not possible to erect such a façade within the expenditure contemplated, so Captain Fowke designed the façade described as being in the Italian Renaissance style. All these discussions took a long time, and it was not till 1867 that the foundation-stone was laid by the Queen.

This, coming on top of the Foreign Office controversy, was another indication that Ruskin and his followers were by no means having everything their own way. The competition for a new Foreign Office building in 1857 was won, after some rather curious negotiations, by Gilbert Scott with a design combining French and Italian variants of the Gothic. Before this could be carried out the Government fell and Lord Palmerston became the head of a new Administration. Lord Palmerston, an old-fashioned classicist, hated Gothic, on the not unreasonable ground that it was totally unsuited to modern conditions; it was, in his view, dark, inconvenient and unadaptable. He is reported to have said in the House of Commons,[1] 'We all know that our northern climate does not overpower us with an excess of sun-

[1] Sir Henry Cole: op. cit.

shine. Then, for Heaven's sake, let us have buildings whose interior admits, and whose exterior reflects, what light there is.' The Gothic design was, after much controversy, abandoned, and Scott had now to reconsider. Palmerston, in this celebrated affair, appears as the link between the severely practical ideals of urban Regency architects and the abortive but promising attempts in the 'fifties to reintroduce just those same ideals. Palmerston, and also Wiseman, derived their views (perhaps unconsciously) from the type represented in this connection by Decimus Burton, and demanded a secular building for a secular purpose. Their opponents seem to have derived theirs, through Ruskin, from the Cambridge Camden Society of 1839 and to have demanded an ecclesiologically Christian building for any purpose.

Out of the Foreign Office affair there came an unexpected but now well-known link between Gilbert Scott and what might at one time have become the new architecture of the railways. The St. Pancras Station Hotel in London was adapted from his rejected Gothic design for the Foreign Office. The early railway-architects might well have failed to understand the admiration it aroused among a generation which they could have expected to be more 'modern' than their own. Scott probably derived greater solace from the acceptance of his design for the Albert Memorial in Hyde Park, which marks the western extremity of the Great Exhibition building of 1851. According to Henry Cole, the Committee under Lord Derby favoured another design, but Scott's was insisted upon by the Princess Royal. Cole himself objected to Scott's design as

not being suitable for an out-of-doors treatment. Despite the intrinsic beauty of the Monument, that remains a valid criticism; it is a shrine rather than a monument.

When Cardinal Wiseman described the aqueducts of Imperial Rome as beautiful objects stalking across the country in their naked simplicity, and railway viaducts connecting two hills as graceful additions to the landscape, he may have pleased a few people, but most certainly he shocked many more—apart from those who, after 1850, were determined to be outraged by anything uttered in public, on any subject, by a Roman Catholic prelate or priest. Layard, though he might not have had the courage to say what the Cardinal said, was probably pleased to hear the splendid architectural engineering of Imperial Rome upheld by the representative of Papal Rome. Lady Eastlake, too, may have approved, though not when in her romantic mood nor when denouncing the tyranny of Austria or Naples. The mood in which she may have agreed with Wiseman was that in which she likened the modern Rome of 1858 to certain aspects of England and Scotland, and complained of 'the same odious freewill in architecture' to be found in both.[1] Lady Eastlake was not an authoritarian; rather was she a liberal and a romantic. Also, like many of her fellow-intellectuals, she was inconsistent. Finding the authoritative architecture of the 18th century distasteful, as did most of her contemporaries, she yet found the romantic muddle of Elizabethan taste even less agreeable. The Elizabethan–Jacobean mode was, as has

[1] Lady Eastlake: *Journals and Correspondence.*

291

been said before, much in favour with the Olden-Time of the 'forties, and it continued in favour for at least another couple of decades; one of its minor manifestations may be seen in the design of alms-houses, schools and the smaller hospitals of the 'sixties. A writer in *The Quarterly*[1] in the middle-1850's implied that admiration of that mode was still a newish taste, and not one to be adopted un-critically. Nobody could call that unfair; indeed, in professing to detect a harmony in Elizabethan building, he was rather more than fair. Lady East-lake, in the same journal in the same year, but a few months earlier,[2] had been very much more severe about the Elizabethans. True, her comments were based on the Elizabethan Court in the reconstituted Crystal Palace at Sydenham, but her opinions were not. Her detestation of Tudor barbarism was based on wide experience, and the period reconstruction at Sydenham was but the excuse for a skirmish. Her arrows flew about. 'It is certain that Queen Eliza-beth was the natural predecessor of the Puritans, inasmuch as she erected bad architecture while they pulled down good;'—a barb which probably stung Joseph Nash and the Olden-Timers. She described the Elizabethan as a transition style, heir to the ex-piring weakness of the Gothic with its incrustation of ornament, and borrowing from the Renaissance only its freedom—the 'odious freewill' of her com-ment on Rome three years later. 'Arched arcades', she summed it all up, 'which remind us of a careful structure of mottled soaps.'

[1] *Quarterly Review*, vol. 98, 1855.
[2] Ibid., vol. 96, 1855.

Nevertheless the taste that Robert Kerr rather peculiarly described as 'the dainty Elizabethan'[1] continued in its popularity with the lovers of the picturesque, as when Joseph Nash had published his *Mansions of England in the Olden Time* in the 'forties. So much so, that in 1858 a publication closely resembling Nash's was able to enjoy an immense success. This was S. C. Hall's *Baronial Halls of England*.[2] It was lavishly illustrated with lithographs after drawings by J. D. Harding, Müller, Prout and Cattermole, among others, and nearly seventy houses, compared with Nash's fifty-three, were described and depicted. Many of these already figured in Nash, all were of the same period, and their inhabitants were in nearly every case clad evocatively in the dress of 'The Olden Time'. In a few cases, however, Hall's illustrators were allowed to clothe their figures in modern dress, a concession which Nash had never allowed.

Hall was avowedly playing to popular taste; Lady Eastlake tilted against that taste; Cardinal Wiseman ignored it, and thought ahead; Ruskin played cat-and-mouse with it and steered it where he would. Real architectural criticism of the most distinguished and lasting value came from James Fergusson. His authority in the 'sixties was similar to that of Joseph Gwilt in the 'thirties. Gwilt has already been discussed, but before Fergusson's major work is considered attention is claimed for an instant by a conjunction, early in the 'fifties, of himself and the

[1] Robert Kerr: *The Gentleman's House*, 1864.
[2] S. C. Hall: *Baronial Halls and Ancient Picturesque Edifices of England*, 2 vols., 1858.

omniscient John Wilson Croker.[1] Fergusson had
severely criticised Sir Robert Smirke's newly com-
pleted building of the British Museum, and Croker
thought he had been too minutely merciless. 'We
ourselves', said Croker in his habitual first-person
plural, 'are no great admirers of the edifice; it must
be admitted to be inferior to what its destination, its
site and above all its cost might have led us to
expect.' Incidentally, he also pointed out that it was
the Trustees of the British Museum who had insisted
on the Classical mode. Having done so, they were
right, in Croker's view, to select Smirke, whom both
Fergusson and Croker held to have surpassed every
Continental architect in that style. Poor though the
British Museum may have seemed at the time, Fer-
gusson carried wide agreement with him when he
said, as quoted approvingly by Croker, 'I do not
know of anything in the works of classic architec-
ture on the Continent superior to Sir Robert
Smirke's;' it was certainly not, he added, found
in the Paris Bourse or Madeleine, nor anywhere in
Berlin or Munich.

James Fergusson's great contribution to architec-
tural criticism was his *History of the Modern Styles of
Architecture*, published in 1862 as a sequel to his
Handbook of Architecture of 1855. The points of
difference between his views on 18th-century archi-
tecture and those of Gwilt twenty-five years earlier
are interesting; Fergusson was writing more than
half-way through the 19th century, while Gwilt was
still not far removed from the Regency and under
the spell of the Picturesque. That spell had lost its

[1] J. W. Croker: *Quarterly Review*, December 1852.

potency by the 'sixties, but Fergusson could still feel something of its enchantment. With Gwilt, he could admire Vanbrugh for the scenic and dramatic qualities, though he felt that it was drama in bad taste. Nevertheless, 'even the bad taste of Vanbrugh', he decided, 'was infinitely preferable to the tameness of Colin Campbell.' In thus damning Colin Campbell as a bore, Fergusson damned by implication Lord Burlington, whom Gwilt had admired, and all the Palladians—including Sir William Chambers, the last of them. There he differed markedly from Gwilt, but he fully agreed with him in destructive criticism of the Adam brothers. 'They acquired', he said, 'a reputation for a knowledge of classical art which their buildings by no means justified.' In this respect, Fergusson found the Adams inferior to Chambers, of whom, be it remembered, he already had a low opinion. 'When', he continued, 'they did use Classical Orders or ornaments, they were of the thinnest and most tawdry class.' That is what Gwilt had meant when he talked of the miserable taste of the Adams.

One may listen to-day with great profit to Fergusson's opinions, whether one agrees with them or not. He followed no leader, and his likes and dislikes, formed on a wide base of critical experience, were expressed with a coolness which is very welcome after the passionate heat of Ruskin. In an age of enthusiasms, he represented a spirit of almost ironic reason. By 1860 it was possible for a man of his perception to see both the Classical and the Gothic Revivals with some approach to objectivity. He tended, admittedly, to see the sham in both

rather than the good in either, as he showed in a derisive passage about the Grecian church of St. Pancras, Marylebone, and the Gothic church of St. Luke, Chelsea, both erected in the early 1820's. St. Pancras had originally been praised for its Athenian correctness, and St. Luke's for its Gothic purity; by 1860 the one was being condemned as pagan and therefore detestable, and the other was being rejected by the purists as un-Gothic. Both, as Fergusson did not hesitate to point out, were intended for a form of worship rather different from that practised in their original models. 'The one', he said, 'is not a Temple, though it pretends to be; the other is not a Medieval church, though its architect fancied it might be mistaken for one.' In another passage of impartial condemnation, Fergusson derided equally 'a Church which has become pseudo-Catholic in order that its architects may be saved the trouble of thinking', and 'town-councillors willing to spend money that they may be housed like Roman senators'.

Fergusson's criticism, despite its sarcastic quality, was really constructive, as is shown by his analyses of the Houses of Parliament and of the Oxford Museum. He appeared at the right moment, when it had become evident that a modern style characteristic of mid-19th-century culture was not going to emerge. That culture on its scientific side was inquisitive, inventive and progressive, but spiritually it was split in halves. The enormous material prosperity induced a complacency among the unthinking, which in turn induced doubts and pessimism in many of the best minds of the day. Doubts about the present in-

evitably breed a nostalgia for some period of the past, and when such nostalgia becomes widespread only an extraordinarily strong continuation of the creative artist and the courageous patron will enable the present to have an adequate chance of expressing itself. Breath-taking developements in all forms of architecture, ecclesiastical, civil and domestic, might have followed easily from the highly specialised ventures of Joseph Paxton and Francis Fowke. It is not too absurd to imagine that a good deal might have been achieved had Cardinal Wiseman been a public-works authority, or even a builder and contractor, instead of an archbishop. The disappointing fact remains that these things did not happen. Convinced at last of their inability to impress the character of their culture on their own age, the men of the 1860's resigned themselves to eclecticism, and to accepting a variety of styles on a scale unheard of since the Jacobean epoch. Among the most widely accepted varieties of style, listed by Robert Kerr in 1864, were the Elizabethan, the Rural Italian, the Palatinal-Italian, the French-Italian, the English Renaissance, the Medieval or Gothic, the Cottage and the Scotch Baronial. The architect with such a range to choose from ran little risk of being charged with detestable plainness or mawkish simplicity.

Robert Kerr must be allowed a word. His solid and important work *The Gentleman's House*, of 1864, bore the sub-title *How to Plan English Residences, from the Parsonage to the Palace*. The authoritative voice of the mid-19th-century spoke in Kerr when he insisted that an English gentleman is better suited by an English house than by an

Italian or a Grecian one. It spoke again when he condemned the Palladian palaces of the 18th century as extravagant, ostentatious and unsuitable. The charge of unsuitability is a critical pitfall into which even men like Fergusson or Kerr were apt to fall, by assessing the achievements of one age by the values of another. In accusing Vanbrugh, Kent, Colin Campbell, Carr of York and the other Palladians of 'reckless waste of space and all-prevailing pretentiousness', Kerr not only sank to the Utilitarian level, but also was guilty of a deficient historical sense. He ignored all the changes of a hundred years in the structure of society, since he did not observe that what the mid-19th century condemned as the vice of Pretentiousness was what the mid-18th century had valued as the virtue of Stateliness. The Battle of Gothic and Classic no longer raged round Kerr as it had raged round architects and critics of a generation earlier. Such distinctions no longer meant very much in the eclectic 'sixties. What Kerr was concerned with were the essential qualities which must be possessed by the Gentlemen's House in whatever style it might be built. These qualities were three: quiet family comfort, thorough convenience for the servants, and elegance without ostentation. Kerr, whether as critic or as architect, was perfectly attuned to the taste of the mid-19th-century gentleman. Ostentation might be a vice, but its opposite extreme was equally one; simplicity, whether of architecture or of decoration, no longer signified a merely boring lack of imagination—it had become a social offence. 'If', said Kerr, 'we see a family of wealth and rank

298

dwelling within flat brick walls, we say there is an incongruity.' Kerr joined with Ruskin in demanding that a house be fairly adorned; no matter how, so long as it was adorned. He joined with his Regency predecessors in demanding that it be substantial, comfortable and convenient. He joined, though perhaps unwittingly, with the Adams in demanding that it should cling to elegance. But above all, he joined with his own epoch, an epoch which needed to silence its doubts by the loudness of its prosperity, when he demanded that a Gentleman's House should avoid 'that poverty of dress which is not self-denial but inhospitality'.

A final word must be allowed to a hitherto unquoted member of the Eastlake family. During the second and third quarters of the century there was no corner of the field devoted to the Fine Arts in which the name of Eastlake did not at some time crop up. Charles and Elizabeth have appeared many times in the preceding pages, but not often in connection with architectural criticism. That was left to Sir Charles Eastlake's nephew, Charles Lock Eastlake the younger. Historians find themselves twice in his debt; first, because he published his aunt Elizabeth's very valuable *Journal and Correspondence*, and, secondly, because he wrote the history of the Gothic Revival down to his own day. Eastlake's *Gothic Revival*, having been published early in the 'seventies,[1] is just outside the scope of this book. Yet it is a work of such importance, and of so close a

[1] Charles Lock Eastlake: *A History of the Gothic Revival*, 1872. This contains a valuable appendix showing the principal Gothic buildings erected in Great Britain, 1824–70.

relevance, that reference to it cannot be omitted. No student of 19th-century architectural thought can ignore it, limited though it be. It was deliberately limited, because its author wrote with the unshakeable assumption that Revived Gothic, whether English, French or Italian in its derivation, was the only true national form of architecture for England.

That bland assumption was made by C. L. Eastlake as early as page two of the Preface to his *Gothic Revival*. It was, he said, his intention to record the progress of the Revival, and thus to provide a link between the past and future history of English Architecture. He interpreted the phrase 'English Architecture' somewhat illiberally, since he omitted the 16th, 17th and 18th centuries, except for such buildings as were Gothically inspired, and ignored the whole of the Renaissance tradition. English architecture meant the Gothic, and that was all that C. L. Eastlake was concerned with. 'The renewal in this country', he said, 'of a taste for Medieval architecture represents one of the most interesting and remarkable phases in the history of art.' He was quick to see the apparent paradox of a taste considered as romantic in the world's history being adopted by a civilisation so materialistic as that of 19th-century England. But in attempting to explain he showed precisely that same pessimism that can be detected among architectural critics of the 'forties. C. L. Eastlake followed the argument used even by his aunt Elizabeth, that the Middle Ages were but the childhood of art. But where she talked of painting, he talked of architecture, and could therefore with even less plausibility invoke lack of

technical accomplishment in support of his contention. Instead, he invoked the opinion of Macaulay, and quoted his saying that in an early stage of society men are children with a greater variety of ideas, among whom we may find the poetic temperament in its highest perfection. After childhood, there follows the age of intelligence, science, philosophy; the age of sophistication and of subtle analysis, but of little poetry. This was, in fact, the merely chronological view of civilisation, as progressing continuously through the centuries towards the present time, with a setback called the Dark Ages, from which the Middle Ages were to be seen as an emergence into another childhood. Having adopted that view, C. L. Eastlake could solve his paradox in only one way. In the present age there was too much intelligence, science and philosophy, too much theory and too much subtle analysis. Men could no longer imagine, or work by inspiration; they could work only by precedent, under the influence of the past, and must return to their childhood. By dint of earnest study and endless experiments, said Eastlake, the grammar of the ancient art may be mastered and used, 'not in the measured accents of a scholastic exercise', but fluently as our mother-tongue. Then, he concluded, we shall possess a really national architecture. Then, and not till then, will the Gothic Revival be complete. Thus Eastlake identified the Gothic with the national expression, since only the medieval past was good enough for the future. It was an admission of defeat.

ORNAMENT AND FLOWERS

THE younger Charles Lock Eastlake is remembered chiefly by his *History of the Gothic Revival*, but he also has another claim on our memory in his *Hints on Household Taste*. That was published in 1868, and is a remarkable revulsion from the taste of the mid-century as exemplified at the Great Exhibition. Revulsion from that taste, indeed, was surprisingly violent even while the taste was at its height, and a good example of the reaction was provided by W. H. Leeds as early as 1854,[1] when he described his own generation as having become smitten with a rage for 'decoration and polychromatic embellishment'. He and one or two others must be allowed to divert our attention for a moment before we come back to C. L. Eastlake.

The taste which Leeds already so much disliked was itself, of course, a reaction from the classic simplicity of the Regency. It was a perfectly natural and inevitable return, in accordance with the laws of the history of taste, to the rococo of a hundred years earlier. That rococo had, after 1800, been banished to the attics, and the classic furniture of Thomas Hope had taken its place downstairs. The 'twenties and 'thirties began already to see the first reaction against the Regency, and a marked symptom of that may be found in Pugin's *Gothic Furniture*, of

[1] W. H. Leeds: *Quarterly Review*, vol. 95, 1854.

1826–7. Nevertheless, 'Regency' furniture was being made right down to the end of the 'thirties, based generally on the design-books of the 'twenties[1] rather than on the pure doctrine of Thomas Hope, and at the opening of Victoria's reign the curving lines of this last Regency survival were in conflict with the spikes and straight lines of Pugin Gothic. By 1850 the full, exuberant Rococo Revival was in full swing, alongside and sometimes merging with the Gothic, and very far distant were the days of Thomas Hope or Henry Holland—the days when, in Leeds's words, 'insipidity went by the name of simplicity'. The pendulum, however, seems to have swung both too far and too fast for the comfort of Leeds and one or two other severe critics. They quickly discovered that in escaping from 'mawkish simplicity' they were in danger of becoming lost in a jungle of intricate conceits designed with an extravagance which its enemies found the more hideous for the excellence of its workmanship. This revived rococo of 1850 not unnaturally brought back in its train a taste for the genuine kind, so that the people who bundled their parents' Regency furniture up into the garrets ransacked those same garrets for what Leeds called 'antiquated gimcracks'.

Taste, in furniture and decoration, was indeed errant between the 'thirties and the 'fifties. The Gothic mode for interiors remained on the whole exceptional long after it had become commonplace

[1] E.g. Richard Brown: *Rudiments of Drawing Cabinet and Upholstery Furniture*, 1822; and Peter Nicholson: *Practical Cabinet Maker and Upholsterer*, 1827, reissued as late as 1835. See Ralph Edwards, *Country Life*, December 1937.

for exteriors, while the Grecian-Regency continued to survive indoors when its place in architecture had long been taken by Italian-Renaissance. The already quoted Grimston Park, for instance, which was designed by Decimus Burton as late as 1840, had chimney-pieces, cornices, columns and fittings in the classical Regency mode, while its carpets and hangings had a strong feeling of the French Rococo of Louis XV, and were probably designed about ten years later, when Lord Londesborough bought the place. Nor were those the only varieties of taste. Lady Eastlake recorded[1] that between 1830 and 1840 her husband had designed and entirely executed in oils the decoration of a room in Bellenden Ker's house in Regent's Park in the Pompeian style, fashionable in the late 18th century. This, said Lady Eastlake, was done 'as a specimen of the ornamentation compatible even with small English interiors'. The Regency taste in its pure Grecian form was not often revived in England after the 'thirties, despite Decimus Burton, but it survived in the United States till at least the middle of the 'forties. In Boston, Baltimore, New York or Philadelphia throughout the 'thirties books of designs for architecture and furniture were being produced entirely in the Grecian taste of about 1810,[2] the inspiration being partly English derived from Thomas Hope and partly French derived from the Bonapartist-millionairish designs of Percier et Fontaine. Hope's

[1] Lady Eastlake: *Memoir of Sir Charles Eastlake.*

[2] E.g. Asher Benjamin: *Practice of Architecture*, Boston, 1833; Minard Lafever: *Beauties of Modern Architecture*, 1835; John Hall: *Cabinet Maker's Assistant*, Baltimore, 1840. See article by Helen Comstock, *Connoisseur*, June 1944.

influence survived with remarkable vigour, though
so very late, in the designs of Thomas Webster's
Encyclopædia of Domestic Economy, published in
New York in 1845. Till at least 1840, moreover,
American manufacturers were applying Grecian
styles with great seriousness to objects of everyday
use, and about 1839 Messrs. Stratton and Seymour
produced a large cast-iron radiator[1] in that taste
which Thomas Hope would have been proud to
have designed.

Taste was errant; it wandered, on both sides of the
Atlantic, between the Regency and the Gothic and
between those and the form of rococo that we now
call Early Victorian. So errant, that sooner or later
it was inevitable that an attempt would be made to
establish principles, and if possible to deduce rules
for future guidance. The inevitable duly happened
in 1856 with Owen Jones's famous *Grammar of
Ornament*.[2] Basically the reasoning was Ruskin's, as
laid down in the *Seven Lamps* of 1849; that is, that
true beauty in ornament and decoration will only be
found in designs based on the forms in Nature. But
at the same time Owen Jones enunciated another
principle and tied it up with the first. This was the
deeply pessimistic theory that we can find inspira-
tion only in the past, that the present has nothing to
teach us and that the future is not our concern.
There was, he was quite certain, but one way to
establish a truly admirable taste, and that was by

[1] *Connoisseur*, loc. cit. This radiator is now in the Cooper Union
Museum for the Arts of Decoration, New York.
[2] Owen Jones: *The Grammar of Ornament*, pubd. in folio, 1856,
and re-published in quarto, 1865.

returning to Nature for fresh inspiration and then grafting that knowledge on to the accumulated experience of the past. Owen Jones's pessimism, however, was not unrelieved, for optimism was occasionally allowed to break through. He really did believe, for instance, in the existence of general principles of Taste which could be formulated; and he believed that both manufacturers and the public could be trained to recognise those principles. It must be admitted that he took a somewhat over-sanguine view of the public's willingness to learn.

Owen Jones's great work was, by its title, a *Grammar* of Ornament. It implied, that is to say, that by giving hundreds of examples it would be possible to establish the rules underlying all the distinctions and varieties. The book itself was magnificent, with a hundred plates in colour, all of which were technically superb and many of which were and still are of the greatest beauty. Nearly 3,000 decorative motives were illustrated, ranging from those of Savage Tribes to the Flowers and Leaves of Nature, and including the whole of Classical, Egyptian and Oriental antiquity; the Byzantine, the Persian and the Chinese; the Celtic, the Medieval and the Renaissance. But more significant than this vast range of inclusion are the exclusions; there was nothing of the baroque or rococo, nothing of Adam or of Louis XVI, nothing of the Empire or the Regency; and there was nothing of his own day, no indication that there could be such a thing as a contemporary style. Only the distant past was invoked as authority. The thoroughness of Owen Jones's actual method was characteristic of an age

accustomed to serious thinking, and although he said nothing that, since the appearance of *The Seven Lamps*, was any longer new, he said it tersely and lucidly in the form of Propositions. There were thirty-seven of these, and more than half of them were concerned with the use of colour on a most intricate chromatic system; the others were concerned with beauty of form. Among his more general principles, three are particularly worth repeating. First, echoing Ruskin's contention that ornament is the very soul of architecture, he laid down the law that 'construction should be decorated; decoration should never be purposely constructed'. Readers of Anthony Trollope may here remember that Mrs. Vesey in *Barchester Towers* never made the mistake in regard to her dress of 'constructing a decoration' instead of 'decorating a construction'; *Barchester Towers* was published in 1857, only one year after the *Grammar of Ornament*. The second was that all ornament and decoration should be based upon a geometrical construction, from whatever source it may have been originally derived. The third, deriving from the second, was that although flowers and other natural objects must always be a prime source of inspiration, they must never be naturalistically employed; in Owen Jones's own words, the decorator must use conventions which will convey the intended image to the mind without destroying the formal unity of the object to be decorated. 'We have already,' he observed, 'in the floral carpets, floral papers and floral carvings of the present day sufficient evidence to show that no art can be produced by such means.'

307

Owen Jones and Leeds were far from being alone in their disapproval. In fact, as was remarked at the beginning of this chapter, it is surprising how many influential people did disapprove of this lavish, exuberant, gay and brightly-coloured taste; but they did not succeed in lessening its popularity for at least the space of a generation. Here, surely, despite the pessimism of Owen Jones and the disgust of Ruskin, there was actually in being an expression of a true contemporary taste, a Romantic taste without reference to the past, fully expressing the mid-19th century, rich, assured and vigorous. Early-Victorian taste, whether we admire it to-day or not, has exactly those qualities and others which mark the early-Victorian Englishman; his materialism, shown by the attention paid to well-upholstered comfort; his romanticism, shown in the fondness for bright colours and elaborate hangings; his class-consciousness, shown by the anxiety to produce an appearance of luxury; his pushfulness, shown by the self-assertive nature of the most popular kinds of design and schemes of decoration; and finally the extent to which the middle-class had become dominant, shown by the total absence of aristocratic restraint. It was useless for Ruskin to expose the vulgarity of cheap decoration; for Owen Jones to proclaim that true taste must be sought only in the past; for Leeds to deplore the new rage for many-coloured embellishments; for Redgrave[1] to be pedantic about unsuitability. They could not alter, and could hardly even mitigate, the fact that although contemporary

[1] Redgrave: *Report on Design*, prepared after the close of the 1851 Exhibition.

taste was errant in various different directions, it managed in each of its wanderings to reflect the emotions and aspirations of its own day.

It is not always easy to detect the point of view from which some of the critics criticised. Ruskin, for example, disapproved of the bronze leafage ornament on the lamps of London Bridge, and then added, 'But it does not follow that because it is in bad taste here, it would be so on the lamps of the Ponte della Trinità;[1] this argument seems to be insecurely based on the assumption that any Florentine has more leisure to look about him than any Londoner, and that it is a waste of time and money to provide ornament or decoration for anyone who does not live in conditions of repose. However, that opinion at least is not inconsistent with the general direction of Ruskin's thought at the end of the 'forties. When, on the other hand, we read the younger C. L. Eastlake,[2] we find him being inconsistent with himself. As much as anyone of his day, he hated the 'mawkish simplicity' and the 'insipidity' of the 18th century, yet equally he hated the rococo as being a display of intricacy for its own sake; hating such a use of ornament, he nevertheless greatly admired the 16th and early 17th centuries, than which there have been few periods in our æsthetic history more devoted to vulgar ornamentation. C. L. Eastlake betrayed another and more entertaining piece of inconsistency when, having disapproved of garlands and bouquets as being unsuitable for the design of drawing-room carpets, he

[1] *The Seven Lamps* ; Lamp of Beauty.
[2] C. L. Eastlake: *Hints on Household Taste*, pubd. 1868.

309

declared that gasoliers and moderator-lamps designed on strictly medieval principles were perfectly suitable in modern houses. By the time Eastlake wrote his *Household Taste* in 1868, there was beginning to be felt the first reaction against the ebullient rococo of 1850, just as ladies' fashions in dress were beginning to move away from the intricately flounced crinoline which also had been inspired by the fashions of Louis XV. Eastlake's bias towards the Jacobean just hit the beginning of this reaction, and ensured him an immense popularity in England and America. At the same time, it rather encouraged than checked the advance of one of his chief detestations, the professional decorator.

Eastlake did not fail to point out the paradox between the old, familiar snobbery of taste and the new habit of obedience to the fashionable decorator.[1] 'Most educated people,' he said, 'women especially, conceive that they possess the faculty of distinguishing good from bad design in familiar objects. The general impression seems to be that it is the peculiar inheritance of gentle blood, and independent of all training.' That this belief existed, and still exists, is undoubted; but it has seldom resulted in more than a determination to be in the new fashion before that fashion has become a convention *de rigueur* among one's social inferiors. From this circumstance arose the authority of the fashionable decorator, as opposed

[1] This habit was equally common among the well-to-do middle-class in Paris. On the other hand, the elegant world that frequented the Empress Eugénie at Saint-Cloud and the Tuileries exercised a much higher degree of personal supervision than did their counterparts in Belgravia or Grosvenor Square.

310

to the commercial upholsterer, and the habit of obedience to his dictates.

The decorator, however great his authority may have been, still occasionally left scope for individual expression. Such expression generally found its outlet in collaboration with the gardener, in the greatly increased use of cut flowers and pot-plants as decorations in a drawing-room or a boudoir. Even this charming fashion found disfavour with the more austere critics of prettiness, one of whom[1] compared it with the passing fancy of 'a Russian *petite maîtresse* cooped-up in her airtight palace for the long months of an arctic winter'. Such a fashion, however pretty in effect, seemed to such a critic incongruous and unsuitable, and must therefore be rejected by all persons of good sense. That particular critic did, however, admit that the chief beauty of the Crystal Palace had been the fine elm-tree enclosed within its glass walls. 'The eye', he said, 'acquiesced in the apparent incongruity and enjoyed the beauty without self-reproach.' The suggestion of self-reproach in the contemplation of prettiness shows how strongly the Utilitarian spirit still survived. Self-reproach, however, did not afflict Lady Eastlake when she found herself among luxurious furniture, bright colours, flowers and lights; there was nothing she enjoyed more.

Lady Eastlake described[2] an evening party at Devonshire House in May 1850. She and Sir Charles had had some difficulty in getting there; there was an immense crush of carriages in Picca-

[1] R. H. Cheney: *Quarterly Review*, vol. 98, 1855.
[2] Lady Eastlake: *Journals and Correspondence*.

dilly that night, as there were also parties at Lans-
downe House and at Miss Coutts's,[1] (the last being
in honour of the Duke of Wellington), and the
Eastlakes' carriage was held up interminably. Her
description of the scene inside Devonshire House
must be repeated, though it must also be abridged. In
the hall by the famous crystal staircase was, somewhat
unexpectedly, a billiards-table where the Duke of
Argyll and others were playing, and crowds of guests
leant over the stairs looking down on them from
above. There was 'a blaze of intense yet soft light,
diffused round everything and everybody by a
multitude of gas-jets on the walls. A perfect fairy-
land, marble, gilding, mirrors, pictures and flowers;
couches ranged round beds of geraniums and roses,
every rare and sweet oddity lying about in saucers,
bouquets without end, tiers of red and white
camellias in gorgeous pyramids. The dresses too
were beautiful and so fantastic they would have
passed for fancy-dress a few years ago . . . with head-
dresses with long creepers of flowers interwoven
with diamonds hanging as low as the dress behind.'
And of another party, at Stafford House in 1854,
Lady Eastlake wrote, 'All was marble, bronze, gild-
ing, pictures, flowers, gorgeous hangings and car-
pets.' Admittedly, very few people lived in the
style of the Duchess of Devonshire or the Duchess of
Sutherland, but nevertheless in Belgravia and Ken-
sington, in the suburbs and in the residential parts of

[1] The house of Miss Coutts, afterwards Baroness Burdett-
Coutts, lay immediately to the west of Devonshire House at the
corner of Stratton Street and Piccadilly. Lansdowne House lay
immediately behind, forming the south side of Berkeley Square.

the big provincial cities, it was a golden age for the professional decorator and for the highly skilled greenhouse-gardener.

The whole subject of gardening and garden-ornament had enjoyed a very much increased popularity since about the beginning of the 'forties. To take 1842 as a sample year, with the no doubt respectable authority of the Rev. T. James,[1] we find that, whereas in 1809 there were no horticultural societies in England, and in 1810 only one, by 1842 there were more than two hundred. There were, moreover, at least twenty monthly publications devoted to botany or horticulture, and countless exhibitions of particular plants and flowers. The gardener may be said to have become identified with the florist, with his eye on the drawing-room as much as on the flower-beds. The Rev. Mr. James listed what he considered the particular drawing-room pets of the fancy, which included old favourites like the polyanthus, ranunculus, geranium, chrysanthemum and hyacinth, and more recent innovations like the iris, the gladiolus and the fuchsia. This activity was fully approved of by Mr. James, but what he did not approve were the names for flowers or plants chosen by either botanists or florists; the former showed extreme pedantry, the latter extreme vulgarity, and all, he considered, showed extreme silliness. This evidently had irritated him for twenty years, and not without reason, since in the year 1821

[1] *Quarterly Review*, vol. 70, 1842. Reviewing Paxton's *Pocket Botanical Dictionary*, 1840; Mrs. Loudon's *Gardening for Ladies*, 1841; J. C. Loudon's *Encyclopædia of Gardening*, 1842; and other similar works.

a new carnation had appeared on the market topically christened 'Afflicted Queen'. Something of a pedant himself, he was irritated by innovations such as calling the Pelargonium the Geranium, the Aenothera the Godetia, or the Glycine the Wistaria, which, in 1842, was a new Americanism. Mr. James did, however, approve of indoor gardening as a form of decoration, particularly if kept within hygienic limits; for this he recommended the apparatus called the 'Ward case', which was designed to eliminate the dangerous fumes given off by plants.

This now-forgotten horticulturist was so true to type, so characteristic of the 'forties, here in his admiration for science practically applied to a ladies' drawing-room hobby, that it comes as no surprise to find him marrying horticulture with sociology; and doing it in such a way as to convince the Utilitarians among the *Quarterly's* readers that what was pleasing to the cultivated eye might also be of material value to the community. Here at least there was no room for pessimism, so long as each class performed its proper functions in the scale of values allotted to each by tradition. So long as the nobleman continued to take an interest in his avenues and hot-houses, and his lady in her conservatories; so long as the squire saw to his labourers' allotments, the citizen set up his cucumber-frame in the back-yard, and his wife the lilac and almond in her front garden; so long as the mechanic reared his prize-winning auriculas and the cottager grew his sunflowers and sweet williams, so long would this country be destined to overcome all her difficulties and dangers. It is an idyllic picture, very far removed from that of Blake's dark, satanic

mills, or from that of the traditionally hungry
'forties. Idyllic though it might be, however, Mr.
James was very sure that it was the best picture to
show to the intelligent foreigner who wished to see
what every-day England really was like. The con-
viction gradually grows that he was thinking very
much like the garden-designers of the mid-18th
century whom he so readily condemned, and that he
associated a garden with the expression of some
abstract idea; no longer, as in the past, that of Senti-
ment, but, more fittingly, that of Universal Good.
When we, to-day, consider the 1840's in general, the
idea of Universal Good does seem something of an
abstraction if expected to emerge from the cultiva-
tion of gardens. Yet the fashion for the Abstract
Idea was precisely what the 19th-century horticul-
turists derided in their 18th-century predecessors.
R. H. Cheney, for example, condemned[1] the
Georgians for doing what his own contemporaries
themselves were doing—turning the garden into a
school for moral precepts. It was easy for Cheney
and others to make fun of the garden inspired by
Pope or Shenston; to say, 'Here a portico was owned
by Friendship and earwigs; there a grotto promised
Somnus and a severe cold'; but the garden of Idea
was not abolished by merely changing the ideas.

In the actual design and planting of gardens, taste
in the middle of the century underwent the same
revolution as had overtaken taste in interior decora-
tion and ornament. The green, unrelieved expanse
of trees and grass now seemed dull, insipid and
empty, and the early Victorian romantic drawing-

[1] R. H. Cheney: *Quarterly Review*, vol. 98, 1855.

room demanded a view from its draped and cur-
tained windows of intricate parterres filled with
brilliant flowers. A crowded, rococo interior of 1850
must have its counterpart in a garden cut-up into
flower-beds and filled with trellises, rockeries, basket-
work and rustic summer-houses; a garden as richly
exuberant as the decoration of the boudoir and, like
the boudoir, creating at first sight an air of material
prosperity. There was no longer any room for
Sentiment or Contemplation, and the 18th-century
fondness for dead and blasted trees carefully pre-
served among the living suggested not a thought-
provoking contrast but merely a feeling of desola-
tion and neglect—the very associations which a
gentleman should avoid in his garden as much as in
his house. The new horticultural tastes also, and
equally, reflected the new tastes in architecture. To
a generation which disliked Palladian houses the
formal lay-out and long vistas which these demanded
were inevitably just as distasteful; and the various
romantic ideals pursued by the Early-Victorian archi-
tects all required a setting that combined richness of
effect and brilliancy of colour with an intimate
relation to the house. This intimacy was really the
full carrying out of what some of the Regency
gardeners had begun to do, bringing the garden
into the house. Partly this was done by the use of
french-windows and verandas, partly by so design-
ing the garden that all its qualities were immediately
visible from indoors. With the fashion for conser-
vatories and for boudoir-gardening, and with the
florist in collaboration with the decorator, the pro-
cess was complete.

PRINCE ALBERT, THE QUEEN AND THE EASTLAKES

A FEW days before Christmas, 1861, Prince Albert died; he was only forty-two. His death transformed the Queen, almost overnight, from a still-young and vigorous woman into a middle-aged and morbid widow. It deprived statesmen of a counsellor on whose advice they had come to depend in every branch of external and internal affairs. It deprived the mass of the growing population of a powerful friend far more understanding than the Queen or most of her other advisers ever were. It deprived the progressive movements in industry and commerce, in science and in philosophic thought, of one of their most precious elements. And it removed from fashionable Society a man to whom Society had been at the worst unkind and at the best indifferent. Historians and biographers have dealt with the Prince in nearly everyway conceivable. He has been treated ponderously as a major Royalty to whom an official biography was due; frivolously, as an eminent and earnest early-Victorian; with sympathy, as a man misunderstood; with scholarship, as a leading statesman; or with insular hostility, as a German princeling.

In one respect, however, the Prince still awaits his due: no historian has yet devoted himself to the task of describing his activities in the field of art. As an

enlightened and selective collector of the Early Masters, and therefore as a formative leader in a new phase of connoisseurship; as a generous patron and encourager of contemporary art, such as it was; as a man to whom music, and music-criticism, were matters of the first importance—this side of his character still awaits a modern evaluation. For a contemporary evaluation, the bas-reliefs on the Albert Memorial contain several buried clues.

The Prince was often accused, probably not without reason, of being aloof and frigid in his manner. He was only too well aware of being a foreigner in a country not famous for its tolerance of foreigners, and the unimaginable difficulties of his position kept him ceaselessly on his guard. Nobody found it very easy to win the Prince's confidence, but those who worked in the fields of the Fine Arts, of the Applied Arts and of Music probably found it easier than other people did. The years between 1840 and 1861 are the reign of Victoria and Albert conjointly, in every sense except the purely constitutional. In political affairs, sometimes Victoria and sometimes Albert was dominant. In the esteem of statesmen it was Albert, in the affection of the people it was Victoria who took first place. But it was Albert who was the more aware of social wrongs and the more active in trying to mitigate them. He saw in England's enormous industrial wealth the opportunity of raising the moral standard of living, and was deeply convinced that the arts should, and moreover could, be applied to that end.

When the young Prince Albert was first established in England, those in authority did not perhaps

quite know what to do with him, beyond seeing that he performed his official and ceremonial functions satisfactorily. It showed great perception on the part of Downing Street that he should have been brought for the first time into the transaction of public business as Chairman of the Fine Arts Commission in 1841. Whatever his fellow-Commissioners may have expected, they found, as we have seen, a chairman wide awake and with very positive ideas about the purposes and principles of mural painting, and one in whose clear and active brain there was no room for the usual vague conventionalities that might be expected from a Royal chairman with a good many other things to think about.

Towards the end of the Prince's short life it had come to be generally accepted that his interest in the Fine Arts was dominant over his other interests. That may not have been quite true, but after 1851, and particularly in the few years remaining to him after 1857, he did command an unusual degree of authority in that field. Yet not until the summer of 1850 had he spoken on the subject of art in public. The occasion was the famous Mansion House dinner, convened for discussion of the forthcoming Great Exhibition. That dinner has already been referred to, and there is no need to repeat again here the Prince's remarks about art in industry. In the same speech, however, he made a remarkable profession of his faith in the Dignity of Man, and in so doing formulated the belief of the leading men of the leading nation on earth. 'Man', said the Prince, 'is approaching a more complete fulfilment of that great and sacred mission which he has to perform in this

world. His Reason being created after the image of God, he has to use it to discover the laws by which the Almighty governs his creation and, by making these laws his standard of action, to conquer nature to his use; himself a Divine instrument.'

The Exhibition of 1851 was conceived of by the Prince as an assertion of modern man's fitness to be, by the exercise of his reason, such an instrument. He saw that mighty undertaking as an act of dedication to the service of the spiritual by means of material betterment. In that dedication he saw England taking the initiative and pointing the direction in which all other nations should move, not behind her, but with her. The Exhibition was to give at the same time both a test of the point of developement at which mankind had arrived, and also a new starting-point 'from which all nations will be able to direct their future exertions'. It was right, the Prince added pointedly, to thank the Almighty for the blessings which He has bestowed on us; but those blessings (which in England in the middle of that century seemed to be so lavishly bestowed) could only be realised 'in proportion to the help we are prepared to render each other', not only help between individuals but, as is clear from the context of the 1850 speech, help between nations.

There is a marked tendency among the Prince's biographers, both past and present, to omit discussion of his position in the art-world of his day. Yet without giving that side of his activities its due weight, it is not possible fully either to reconstruct the position he occupied in the life of this country

or to assess the quality of his mind. The Prince's active interests as a collector and connoisseur have already been referred to. The measure of his concern with contemporary art can be taken from his speech at the Royal Academy dinner of 1851; to say what he said at that time and in that company, knowing that he would be fully reported, needed considerable courage—though it must also be remembered that in the summer of 1851 his recent triumph in Hyde Park had raised him to a position of authority and popularity such as he had not previously enjoyed. The Prince's theme in that speech was the constantly valid one of the influence of Press-critics on popular taste. Having admitted that criticism is necessary to the developement of art, he roundly said that ignorant praise of bad work is an insult to good work. He presented the problem as being made up out of three factors; on one side 'a vast array of artists of every degree of talent and skill'; on another 'as judge, a great public for the greater part wholly uneducated in art'; and on the third 'professional writers, who often strive to impress the public with a great idea of their own artistic knowledge'. The problem posed by the Prince was far from new even then, and is not unknown to-day. His next remark, made in an even higher degree of plain-speaking, rings a still more familiar bell. 'Works of art,' he pronounced, 'by being publicly exhibited and offered for sale, are becoming articles of trade, following as such the unreasoning laws of markets and fashions; and public and even private patronage is swayed by their tyrannical influence.'

The Prince was not entirely just in that con-

clusion; or, rather, he was over-simplifying both question and answer. It is a problem of permanent importance in the history of taste. Does fashion follow the market, or does the market follow fashion? Whatever be the answer, both are invariably affected, sooner or later, by the tastes either of an influential côterie or of a few conspicuous and intelligent individuals. Under the conditions governing patronage in the 19th century, artists had to exhibit their work before they could find a patron. By exhibiting his work, the artist appealed ostensibly to the public, but in fact to the critics. When the Prince spoke of 'the tyrannical influence of markets and fashion' he may have had Ruskin in mind; Ruskin's influence unquestionably affected the market, and nobody at that time could acquit him of being tyrannical. But there were many critics besides Ruskin, writing for the more eminent periodicals and newspapers. It is doubtful whether those who read them thought that they were tyrannical or would willingly have dispensed with their services; for services they were. A large public now had opportunities, such as had not occurred in the past, of looking at works of art; but it was less experienced in that direction than the public of to-day, and even more in need of guidance. Critics and writers on art are always fallible and sometimes biased, but the Prince was perhaps a little sweeping in his denigration of them. As to 'markets and fashions', there would be no market at all if there were no changing fashions in taste to keep it always supplied.

The Prince pleaded in many of his speeches for improvements in general education, especially at the

universities and great schools. He was among the very first to plead that education in the fine arts be included in the ordinary curriculum, together with such other novelties as physiology and psychology, political economy, physics, chemistry and mechanics —none of which branches of knowledge were recognised or provided for in any of the great seats of learning. The Prince made this revolutionary suggestion at Birmingham in 1855, thinking that mathematics and classics were hardly enough to equip a young man in the progressive and expanding world of the 19th century. He was wise to say this at Birmingham, for he would be certain to meet with a warmer response there than at Cambridge.

Throughout the previous chapters we have encountered the Eastlakes on many varying occasions. We have seen Charles Eastlake very close to the Prince, particularly in the matter of the Westminster Palace frescoes and in his election as President of the Royal Academy. Both the Prince and Eastlake were men of acute intelligence; both possessed, what is now a rarer virtue than it was then, nobility of mind; neither of them was either able or willing to play for popularity; and each was able to assess the qualities of the other. It was remarked in an earlier chapter that Charles and Elizabeth Eastlake were more than a partnership; they were a joint personality. When it fell to Lady Eastlake to write the obituary-article on the Prince for the *Quarterly*,[1] it was both the Eastlakes who composed it. That article does not appear to have been used very often by the Prince's biographers, nor by those who have

[1] Lady Eastlake: *Quarterly Review*, January 1862.

written the history of the epoch. Though written under the stress of bereavement, it is an important document. The relevant passages in Lady East-lake's *Journals and Correspondence* are more emotional but not less valuable. On hearing of the Prince's sudden and quite unexpected death, she wrote, 'I am overwhelmed by this incalculable affliction which has fallen on us all. . . . Little did I think to survive that noble creature'.[1] The article, it must be remembered, was published anonymously, like all *Quarterly* articles; and the anonymity was strictly preserved. In January 1862 she recorded that the editor, John Murray, had sent her a letter from Sir Charles Phipps, the Queen's Private Secretary, saying that he had read 'with deep emotion the article upon the Prince Consort, written by someone who has studied deeply and well understood that great man's uncommon mind'. It appears that at the Queen's particular request the veil of anonymity was lifted, for her eyes alone. When, four years later, Lady Eastlake was herself widowed, the Queen's letter of condolence had a very much more personal and sympathetic character than was usual in such cases beyond the circle of her royal relations and her few intimate friends.

After the Prince's death, the Queen found herself having to deal with several matters, outside the field of statecraft and politics, with which he had been intimately concerned and about which she had hitherto known very little except through his interpretation. One of these was the Royal Academy. It

[1] Lady Eastlake was only ten years older than the Prince.

appears that in 1862 Lord Elcho[1] had been inter-
fering in the internal affairs of the Academy, and had
got the House of Commons to consent to a Com-
mission of Enquiry. 'The Queen', wrote Lady East-
lake[2] 'feels the absurdity of this as much as we do
and [has written to Sir Charles that she] will not
appoint the members of the Commission until she
knows whom he approves. She sends him the names
proposed, and marks those she objects to, request-
ing him to do the same.' It is quite evident that the
Queen was animated by the spirit of the Prince, to
whom the Academy had been a matter of much
closer concern than it ever really was to her. It is
again evident when, according to Lady Eastlake, the
Queen intervened directly in the affairs of the Royal
Fine Arts Commission. This was also in 1862, when
apparently the Commissioner of Works, William
Cowper,[3] took it upon himself to inform Eastlake
that the Fine Arts Commission was to come to an
end. The Queen promptly directed that it should
continue, and it did.

Eastlake's death occurred at Pisa, on the 24th
December, 1865, almost exactly the fourth anniver-
sary of the Prince's death. The Queen's letter to
Lady Eastlake was dated from Osborne three days
later; it contained the words '. . . one to whom she
[the Queen] had looked upon many occasions, and
never in vain, for assistance and advice in questions
connected with the Fine Arts'. The relation be-
tween the Queen and Eastlake was almost as close

[1] Afterwards 9th Earl of Wemyss, 1797–1883.
[2] Lady Eastlake: *Journals and Correspondence*.
[3] Afterwards Lord Mount-Temple, 1811–88.

after 1861 as had been that between Eastlake and the Prince. Indeed, Lady Eastlake wrote in 1863, 'My husband has been to Windsor again: he is more and more impressed with the duty of working for the bereaved Queen—and she does give him plenty to do!'

A final glimpse of royalty and Eastlake is provided by Lady Eastlake in 1870; we find the Queen unexpectedly surrounded by intellectuals, at a gathering more appropriate to the Prince's tastes than to her own. 'I had the honour', wrote Lady Eastlake, 'to meet Her Majesty one afternoon lately at the Deanery, Westminster. She had been reading my Memoir of Sir Charles, and was most kind and gracious about it ... a few notable men, Froude, Tyndall, Lecky and others, were there.' Surely nobody but the Dean and Lady Augusta Stanley could have arranged such a tea-party.

The last word may be with Sir Henry Cole[1]. In June 1862 he went to Windsor to discuss the National Memorial to the Prince. 'The Queen came in ... looked calm and collected ... asked me if I thought the suggestion for the Memorial was practical. She said she had no taste .. used only to listen to him ... was not worthy to untie his latchet.'

[1] Sir Henry Cole: *Fifty Years of Public Work*.

INDEX

327